GEORGE —

TO A FELLOW TRAVELLER —
MAY ST. JOSEPH, PATRON SAINT
OF CARPENTERS AND TRAVELLERS,
AND OUR LADY LIGHT YOUR
WAY. WE HAVE ENJOYED MEETING
YOU AND SPENDING SOME TIME
TOGETHER. WE LOOK FORWARD
TO YOUR NEXT VISIT AND
HAVING YOU UP TO SANDPOINT.
GOD BLESS YOU —
Tim, KIRSTEN & 2015

P.S. YOU ARE GOING TO LOVE THIS BOOK.

GUADALUPE MYSTERIES

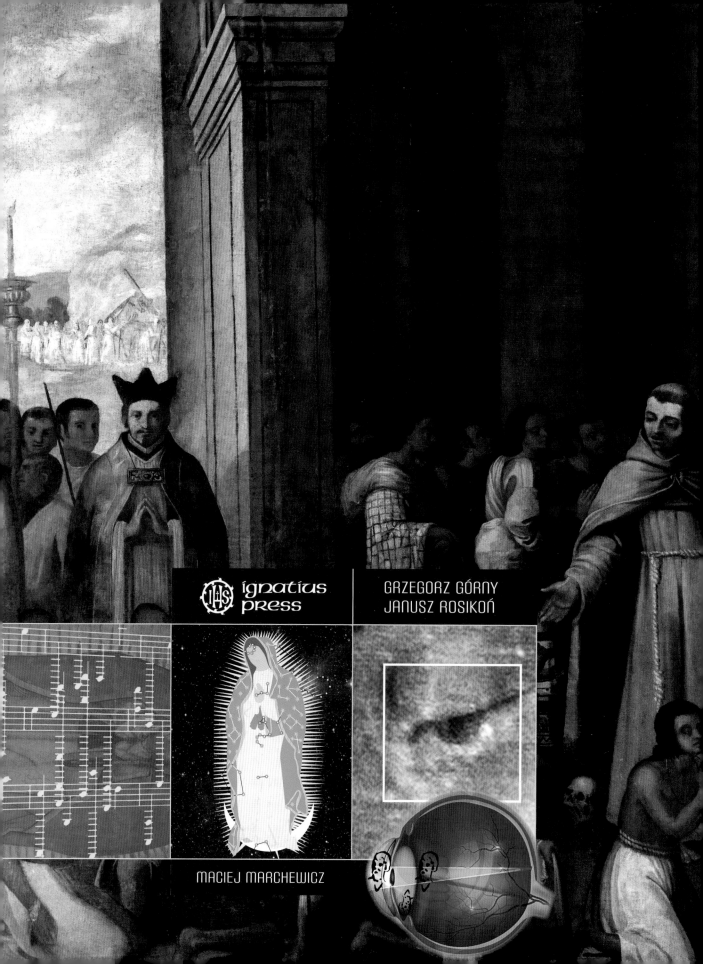

GUADALUPE
MYSTERIES
Deciphering the Code

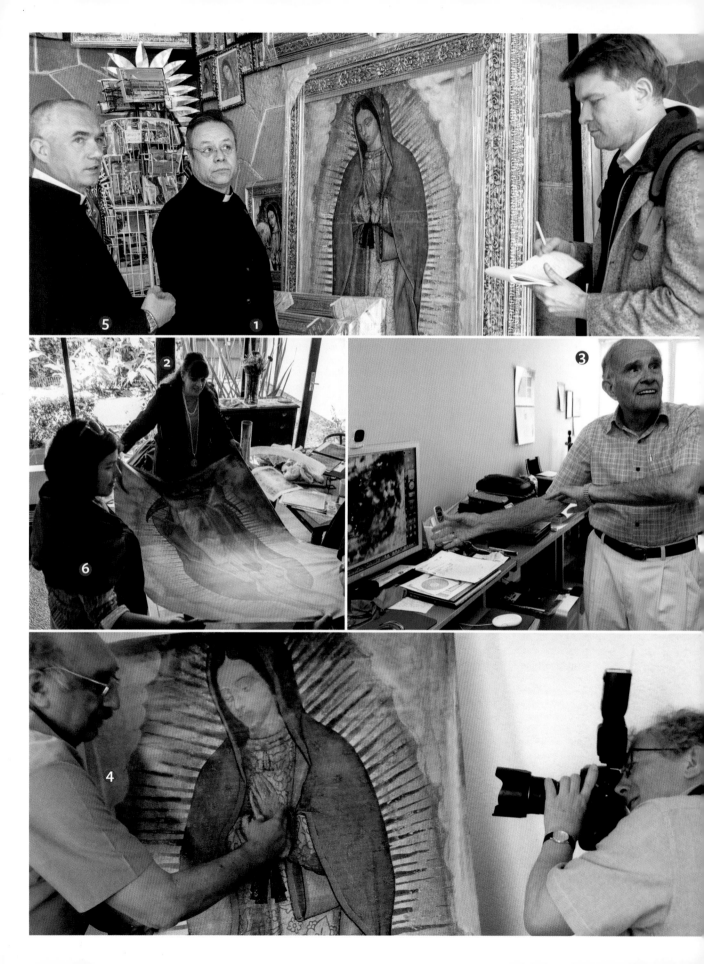

PROLOGUE

The Shrine of Our Lady of Guadalupe in Mexico is the most visited pilgrimage center in the world. It is estimated that about twenty million people from all over the world visit it every year. What draws them there?

The answer to this question is on a piece of cloth made of agave, on which the image of Our Lady of Guadalupe is depicted, and which came into being under extraordinary circumstances in the capital of Mexico on December 12, 1531. This image brought about the evangelization of Latin America in an incredibly short time. While the audacious and cruel Cortés conquered Mexican territory by force of arms, the spiritual conquest of Mexico was accomplished by this image of the gentle and humble Handmaid of the Lord. The invaders captured Indian territory, but Our Lady captured the hearts of the native people, not for the Spanish Crown, but for the Faith. Mexicans are faithful to her to this day.

The extraordinary image of Our Lady of Guadalupe turned out to be a strong impetus for the birth of a new nation, of two ethnic groups and two cultures: Spanish and Indian. The image is so closely connected with the history of Mexico that it is unimaginable without it. What is more, we can regard it as a constituent act of a civilization–the Latin American civilization.

The remarkable, even staggering, five-hundred-year popularity of the image of Our Lady of Guadalupe is due to both its content and its form. The message conveyed by this ordinary Mexican mantle determined the Christianization of the whole continent. Today, millions of people from all over the world are moved by the message about the victory of the civilization of life and love over the civilization of death.

Equally important, and perhaps even more important, particularly to today's people for whom science is the highest authority, is the form of the image. It contains many mysteries that have only recently been revealed due to scientific discoveries and technological developments. The image is full of mysterious phenomena, which are considerable challenges for contemporary researchers.

While working on this book, scholars acquainted us with the Guadalupan mysteries. Numerous experts in various fields familiarized us with the results of their research. Thanks to them we have sought to decipher the code that has been speaking to mankind for centuries.

You are welcome to accompany us on this quest.

5

DURING THEIR VISIT TO MEXICO, Grzegorz Górny and Janusz Rosikoń met many of the scholars engaged in research connected with the image of Our Lady of Guadalupe, some of whom are in the photographs opposite: Fr. Eduardo Chávez (1), Laura Castillo (2), José Aste Tönsmann (3) and Fernando Ojeda (4); as are Fr. Jarosław Szymczak (5) and Beatriz Gonzales (6), who helped the authors with this book.

CONTENTS

10 A SINGULAR APPARITION

JUAN DIEGO'S MISSION: The story of a poor Indian's encounter with Our Lady, and the origins of the most extraordinary image in American history.

38 THE GUADALUPE CODE

MARY'S MESSAGE: How the Indians and the Spaniards interpreted the symbols in the image of Our Lady of Guadalupe, and the consequences for Latin America.

84 A BLOOD-SOAKED EMPIRE

BLOODTHIRSTY GODS: The history of the Aztecs, who created a genocidal dictatorship based on the necessity of human sacrifices to stave off the end of the world.

110 TWILIGHT OF THE GODS

CLASH OF CIVILIZATIONS: The extraordinary Spanish conquest of Mexico and how a few Europeans defeated the most powerful state on the continent.

152 PATRON OF MEXICO

VIVA LA VIRGEN DE GUADALUPE!: The impossibility of understanding a country where there is a continuous struggle between the civilization of life and that of death, without taking Our Lady and Christianity into account.

200 A CHALLENGE FOR SCIENCE

PYTHAGOREAN THEOREM : Scientific discoveries of mathematical, geographical, astronomical, and musical data in the image of Our Lady of Guadalupe.

230 MYSTERY OF THE EYES

HIDDEN IMAGE IN THE EYES: The modern computer techniques that have revealed principles of optics and a group scene in Our Lady's eyes.

252 INDESTRUCTIBLE MATERIAL

THE MYSTERIOUS TILMA: Scholars endeavoring to explain why material that usually decomposes after a few years is still in perfect condition after several centuries.

5	PROLOGUE
8–9	TIMELINE
274–275	CHRONOLOGY OF RESEARCH
276–277	BIBLIOGRAPHY AND NOTES
278–279	ACKNOWLEDGMENTS

TIMELINE

Consecration of Templo Mayor in Tenochtitlán

Founding of Santo Domingo, the first Spanish city in America

Cortés' expedition landed on the Yucatán Peninsula

Arrival of the first missionaries in Mexico

Pope Paul III published the bull *Sublimus Dei*

Death of Hernán Cortés

Birth of St. Juan Diego

1474 · **1485** · **1487** · **1492** · **1496** · **1511** · **1519** · **1521** · **1524** · **1531** · **1537** · **1541** · **1547** · **1548**

Birth of Hernán Cortés

Christopher Columbus' first expedition –discovery of America

First public defence of Indian rights by Fr. Antonio de Montesinas in Hispaniola

Conquest of the Aztec Empire by the Spanish conquistadors

Appearance of Our Lady of Guadalupe and the building of the first chapel on the site of the apparitions

Francisco de Montejo's conquest of the Mayan Kingdom

Death of Juan Diego

Mexico proclaimed independent

Mexico loses the Mexican-American War

Outbreak of the Mexican Revolution

Bomb explodes in the Basilica of Our Lady of Guadalupe

Beginning of Institutional Revolutionary Party rule

Second Cristeros uprising

José Carlos Salinas Chávez' photograph of the image

1821 · **1828** · **1848** · **1904** · **1910** · **1917** · **1921** · **1926** · **1929** · **1929** · **1929** · **1932** · **1938** · **1936** · **1951**

The Feast of Our Lady of Guadalupe established as a public holiday in Mexico

Pope Pius X raised the church in Tepeyac to the status of a basilica

Anti-clerical Constitution passed

First Cristero uprising, the image removed from the basilica and hidden

Alfonso Marcue Gonzales' photograph of the image

Richard Kuhn examines the tilma fiber

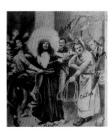

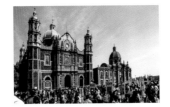

Antonio Valeriano writes *Nican Mopohua*

Second church built on the site of the apparitions

The Image protected by glass

Publication of Luis Becerra Tanco's research concerning the image

Our Lady of Guadalupe proclaimed patron of Mexico City

Publication of Miguel Cabrera's research reults concerning the image

Publication of José Ignacio Bartoloche's research concerning the image

First independence uprising led by Fr. Miguel Hidalgo

1548 · **1553** **1554** · **1582** · **1622** · **1629** **1635** · **1647** **1649** · **1666** · **1709** · **1737** **1746** · **1757** **1767** · **1789** · **1791** **1810**

Appearance of the *Codex Escalada* with the oldest image of Our Lady of Guadalupe

Gregorian calendar introduced

A series of great floods in Mexico

Nican Mopohua printed

Baroque church built on the site of the apparitions

Our Lady of Guadalupe proclaimed patron of the Viceroyalty of New Spain

Expulsion of the Jesuits from Spanish territory

Nitric acid spilt on the Image

Pope John Paul II's first pilgrimage to Mexico, publication of research by Philip Callahan and José Aste Tönsmann

John Paul II's third pilgrimage to Mexico

End of the Institutional Revolutionary Party rule, Vicente Fox elected president

Founding of the Higher Institute for Guadalupan Studies (ISEG)

Massacre of students in Tlatelolco

1968 · **1976** **1979** **1990** · **1993** · **1999** **2000** · **2002** · **2003**

Building of the new Basilica of Our Lady of Guadalupe

Pope John Paul II's second pilgrimage to Mexico, Juan Diego's beatification

Pope John Paul II's fourth pilgrimage to Mexico

Pope John Paul II's fifth pilgrimage to Mexico, Juan Diego's canonization

9

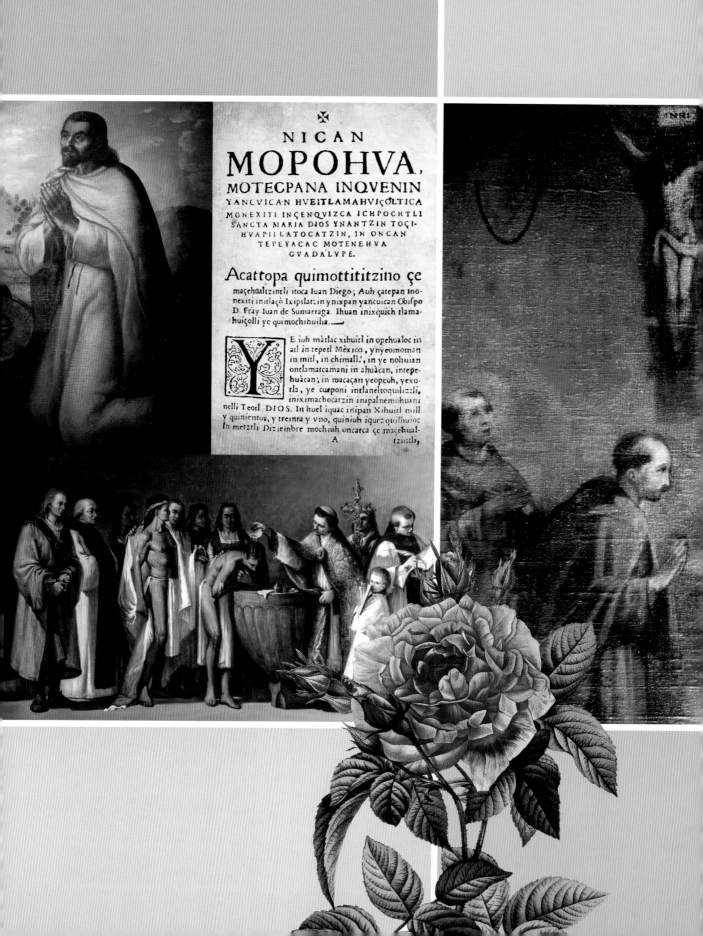

✠

NICAN
MOPOHVA,
MOTECPANA INQVENIN
YANCVICAN HVEITLAMAHVIÇOLTICA
MONEXITI INÇENQVIZCA ICHPOCHTLI
SANCTA MARIA DIOS YNANTZIN TOÇI-
HVAPILLATOCATZIN, IN ONCAN
TEPEYACAC MOTENEHVA
GVADALVPE.

Acattopa quimottititzino çe
maçehualtzintli itoca Iuan Diego; Auh çatepan mo-
nexiti initlaçò Ixiptlatzin ynixpan yancuican Obispo
D. Fray Iuan de Sumarraga. Ihuan inixquich tlama-
huiçolli ye quimochihuilia. ———

YE iuh màtlac xihuitl in opehualoc in
atl in tepetl Mèxico, ynyeomoman
in mitl, in chimalli, in ye nohuian
ontlamatcamani in ahuàcan, intepe-
huàcan; in macaçan yeopeuh, yexo-
tla, ye cueponi intlaneltoquiliztli,
iniximachocatzin inipalnemohuani
nelli Teotl DIOS. In huel inipan Xihuitl mill
y quinientos, y treinta y vno, quiniuh iquezquiluioc
in metztli Diziembre mochiuh oncatca çe maçehual-
A tzintli,

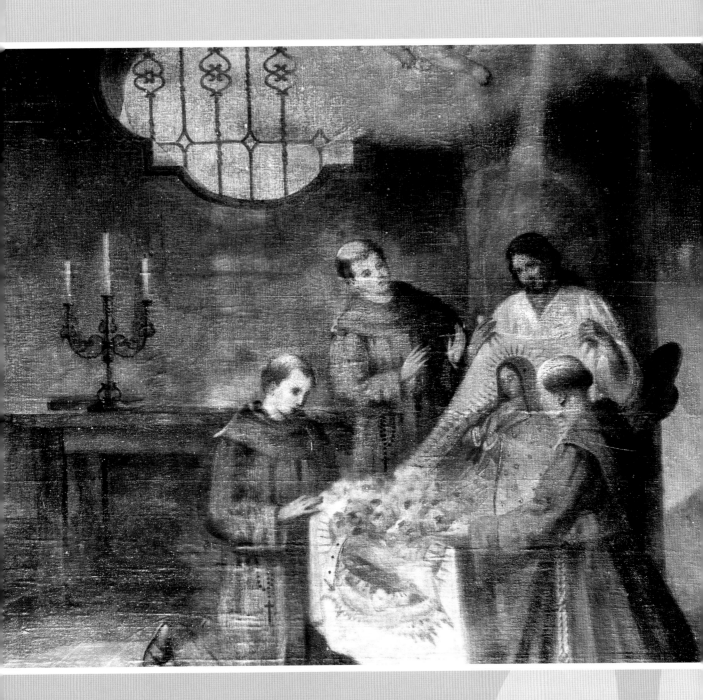

A Singular Apparition

A Singular Apparition

SCULPTURE
COMMEMORATING
the appearance of
Our Lady's image on
Juan Diego's tilma.
Bishop Juan de
Zumárraga kneeling
before it.

THE CASTILIAN ROSE
unknown in Latin
America in 1531.

On December 12, 1531, a certain fifty-seven-year-old Indian saw an apparition on the summit of Tepeyac Hill, near the Mexican capital, an encounter that changed the spiritual landscape of America in a short time, and also the course of history.

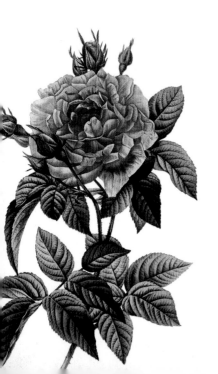

Cuauhtlatoa (Talking Eagle) was born in 1474 in Cuauhtitlán, twelve miles from Tenochtitlán. He came from the Chichimeca tribe, which was under the cultural influence of the Toltecs, a tribe that was at its height between the sixth and tenth centuries. Chronicles mention him as a "macehuala" (a simple man) from an Indian people. When he was thirteen, the Great Temple in the Aztec capital was consecrated, and thousands of people were sacrificed. Together with his kinsmen he had experienced the collapse of their world, the twilight of the gods; he was then a mature man of forty-seven. He belonged to the tribe that was the first to be baptized (most probably in 1524) by the first Franciscan missionaries to Mexico. He then changed his

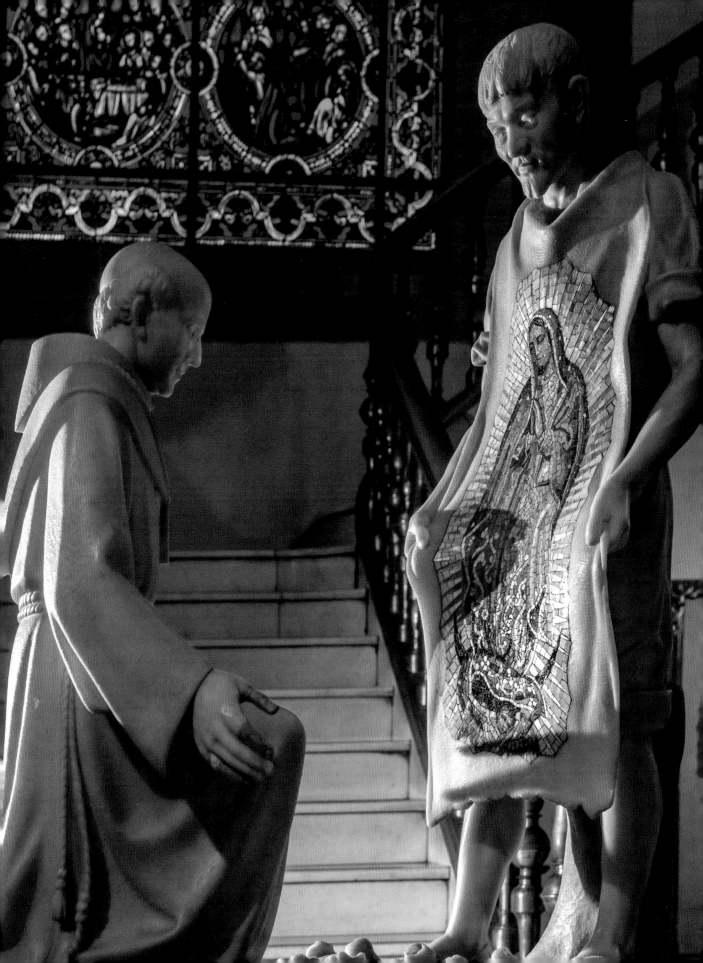

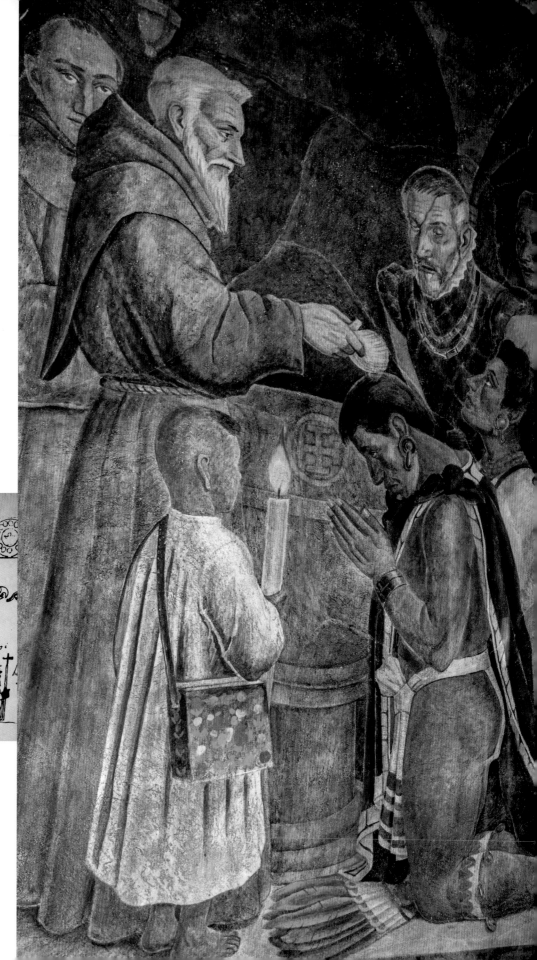

A FRANCISCAN MONK baptizing Juan Diego and his wife, Maria Lucia.

A RELIGIOUS PROCESSION and a Catholic bishop. An illustration from an Aztec codex of 1531.

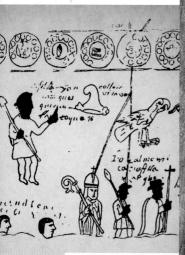

14

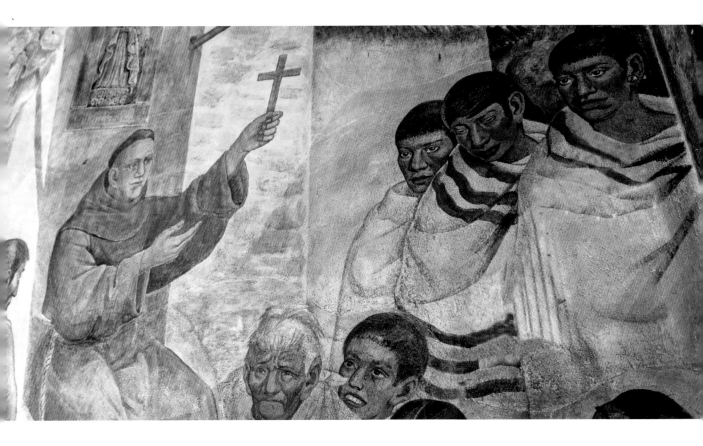

name to Juan Diego. He was baptized with his wife, Maria Lucia, who died in 1529.

The Franciscans were known not only for defending the Indians, but also for pioneering a new form of intensive missionary work amongst the natives. A contemporary Mexican historian, Alejandra Moreno Toscano, wrote that the missionaries at that time were very independent and very creative in testing new evangelization methods. They were not bound by ready-made solutions from the Iberian Peninsula but tried to respond to challenges as they arose. They never treated Indians as people of a lower category. What is more, they were solicitous about educating them from the outset, for they saw them as future priests, arguing that since they received the sacraments they could also administer them. The missionaries' attitude arose from the conviction that no one would convert the Indians more effectively than the Indians themselves. Hence the missionaries did not contend with local cultures, but cultivated and studied them; they even translated essential religious works into local dialects.

A FRANCISCAN MISSIONARY, cross in hand, evangelizing Indians.

15

INDIANS HARVEST maize, the staple food for the pre-Christian indigenous population.

The missionaries were solicitous not only about the natives' spiritual formation, but also about their education. The Church opened educational institutions, where the teaching was on a high level, e.g., the colleges of Santa Cruz and San José de los Naturales in Tlatelolco. The customs, rites, and religious practices of the natives were studied, laying the foundations of Mexican ethnography, the pioneer of which was a Franciscan friar, Bernardino de Sahagun.

The greatest obstacle to the evangelization of America was, however, the ruthless conduct of the conquistadors. Hence the Indians became ever more despondent, and ever more distrustful of whatever came from Europe. Hitherto they had always seen diseases as signs of the discontent of their gods. With the coming of the Spaniards, epidemics spread among the tribes and decimated the population, which was not resistant to bacteria and viruses brought from across the ocean – tuberculosis, influenza, pneumonia, measles, and smallpox. At the coming of the Europeans there were twenty-five million Indians in the territory conquered by Cortés, but by 1531 there were just seventeen million.

BAPTISM OF INDIANS, 16th-century canvas (Guadalupe Shrine, Spain).

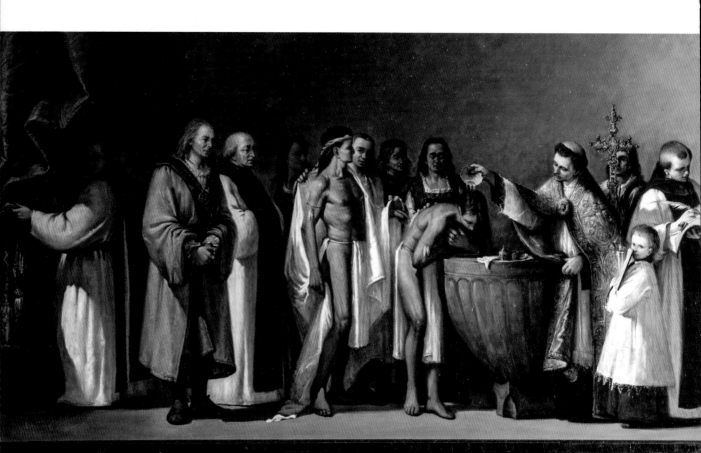

BISHOP OF CHIAPAS – Bartolomé de las Casas – and Indian friend.

SMALLPOX EPIDEMIC (16th-century print). The disease was brought from Europe and decimated the Indian population.

17

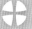

The situation in which the natives had found themselves increased their doubts and despair: their homeland had been conquered, their gods had betrayed them, deadly diseases were spreading, and they had to bear humiliations daily. They were certain that they were witnesses to the collapse of the whole cosmic order. On top of all that there was an ancient conviction that the present world, called the Fifth Sun (Fifth Era) had to end. It was believed that this would happen at a time called the Fourth Move. This was to be preceded by alarming signs, which had indeed appeared. In 1530 there was a great earthquake, while a year later a comet appeared and eclipsed the sun. The defeatist mood did not favor the acceptance of a new faith.

But the missionaries did not give up. They introduced a post-baptismal catechumenate into their pastoral work. In the early Church, at the time of the Roman Empire, catechumens went through an initiation stage in the truths of the Faith, which culminated in Baptism. In America, the Franciscans proceeded the other way round: they first baptized willing natives and then catechized them. This process took a number of years, as it

MIGUEL NORENA'S 19th-century low relief depicting Fr. Bartolomé de las Casas converting an Aztec family.

DESTRUCTION OF PAGANISM, CULTIVATION OF CHRISTIAN CULTURE

IN JUNE 1531, Bishop Juan de Zumárraga sent a letter to the Franciscan general chapter, in session in Toulouse, in which he boasted of his achievments: "Five hundred idols' temples razed to the ground, over 20,000 statues of demons broken into pieces and burned." Christian missionaries saw everything that was connected with pagan cults as works of the devil. They were particularly averse to the Aztecs' bloodthirsty religion, which they regarded as truly demonic.

José Manuel Gallegos Rocafull, a contemporary Spanish thinker, wrote that the first European missionaries in Mexico were hostile toward Indian cults, temples, and gods. They were of the opinion that pagan buildings, sculptures, and codexes ought to be destroyed, so that all trace of them might diappear. On the other hand, however, as Gallegos Rocafull noted, the monks were solicitous about local cultures. They showed great solicitude for the preservation of Indian languages, dialects, customs, and practices. They were true to indigenous traditions and showed respect for the intellectual heritage of the Indians. At the same time, they sought to adapt their message to the Indian mentality.

A British historian, Arnold Toynbee, established that the missionaries did not strive to deprive Indians of their identity, but quite the contrary, as they transformed numerous local dialects into written languages, with grammar, literature, and dictionaries. So the Church created and developed a special system that protected pre-Columbian languages. Hence at the beginning of the 19th century barely 3 million people in South America spoke Spanish.

Paradoxically, it was not until many Latin American countries had gained independence that their Hispanization accelerated. For the Spanish language then became obligatory in schools and in the army, while a lack of familiarity with it entailed social marginalization.

INDIANS in folk costumes dancing in front of the Basilica of Our Lady of Guadalupe in 2014.

A CHRISTIAN cross with Aztec ornaments.

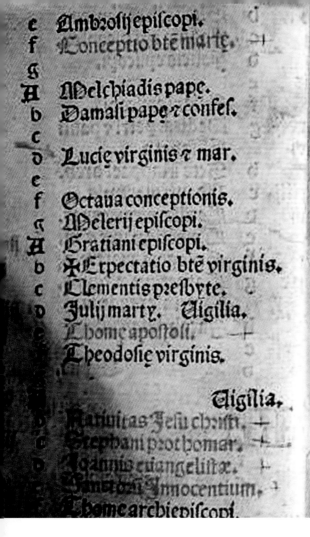

BR. PEDRO DE GANTE'S *Doctrina Christiana en Lengua Mexicana*, first published in Mexico City in 1547 (there were several editions in the 16th century).

20

pertained to people outside the Christian culture, to whom many things were new and surprising.

With the catechization of Indians in mind, a new kind of sacred architecture arose in Mexico, the open chapels that recalled amphitheaters and were capable of accommodating large numbers. The first of its type was built by a famous Franciscan missionary, Br. Pedro de Gante. He, a relative of Holy Roman Emperor Charles V (also King Charles I of Spain), established beside it the first art school for Indian boys, San José de los Naturales.

One Saturday morning, December 9, 1531, something happened that changed the fate of America. The aforementioned Juan Diego was on his way from Tulpetlac, where his uncle Juan Bernardino lived, to the Franciscan mission at the Church of St. James in Tlatelolco for his weekly catechetical instruction. On his way he passed by Tepeyac Hill, where there was once a pre-Columbian temple dedicated to the mother goddess, Tonantzin, which was destroyed by the conquistadors. Diego then had an experience that is

ILLUSTRATIONS FROM Br. Pedro de Gante's 16th-century catechism.

related in the oldest extant work on the subject, *Nican Mopohua* (*Here It Is Told*), written in the Indian Nahuatl language.

The author of the work was an Indian scholar and colonial official, Antonio Valeriano, who was born between 1522 and 1526, and died in 1606. He received an excellent education at the Franciscan Santa Cruz College in Tlatelolco. Valeriano came into direct contact with Juan Diego, who told him about the events of December 1531. *Nican Mopohua* was first published in 1649 by Luis Laso de la Vega as part of his longer work on the subject, *Huei Tlamahuicoltica* (*The Great Happening*).

Nican Motecpana is another important work on this subject, a continuation of Antonio Valeriano's work. It was written between 1590 and 1600 by

BR. PEDRO de Gante, of Flemish descent, was a relative of Holy Roman Emperor Charles V.

THE OLDEST printed book on the apparitions of Our Lady of Guadalupe, edited by Luis Laso de la Vega, published in 1649 in the Nahuatl language, entitled *Huei Tlamahuicoltica* (*The Great Happening*).

Fernando de Alva Cortés Ixtlilxóchitl, an eminent Mexican historian who lived from 1568 to 1648, a direct descendant of the rulers of Texcoco. He added many details to the work of his predecessor.

So let us return to Juan Diego heading for his Saturday catechetical instruction. He himself recalled that he suddenly heard celestial music that came from the top of Tepeyac Hill. He climbed up the hill and saw a young woman in clothes that radiated an extraordinary light. The woman called him her beloved little son and told him that she was the Virgin Mary, Mother of the one true God, Who was the Giver of life, the Lord of heaven and earth, and the Creator of man. She asked Juan Diego to tell the bishop of Mexico City that she desired a chapel to be built at the foot of the hill. The Madonna assured him that she would come to the aid of those who requested it there.

That same day Juan Diego told Bishop Zurmárraga of Mary's request, but the bishop seemed not to believe him and asked him to come back later. So Juan Diego returned to Tepeyac Hill, where he again met Mary. He asked her to charge someone of noble birth with such a responsible task, someone the bishop would believe. But she told him to try again the next day. ▶

CODEX ESCALADA (1548), contains the oldest illustration of the image of Our Lady of Guadalupe.

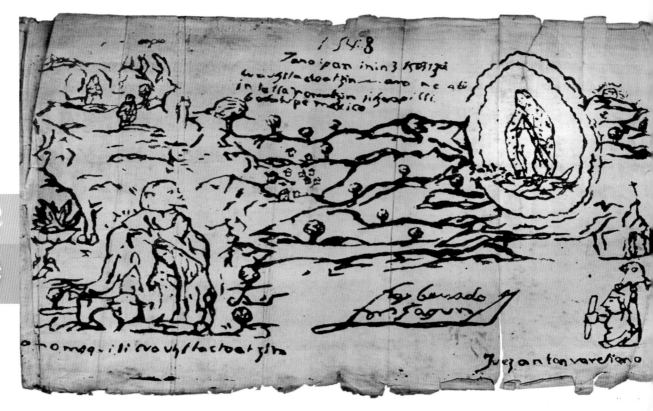

THE *NICAN MOPOHUA* is one of the oldest written accounts of the apparitions in December 1531. It was written in the Nahuatl language by Antonio Valeriano, who knew Juan Diego personally.

NICAN MOPOHUA

THE *NICAN MOPOHUA* is the most important historical source on the Marian apparitions in Mexico in December 1531. The title comes from its first words in the Nahuatl language, "Here is recounted". The author of the work (1553 – 1554) was an Indian, Antonio Valeriano, who knew Juan Diego personally. Over a long period of time, critics of the apparitions, questioning their credibility, and even negating Juan Diego's existence, claimed that the *Nican Mopohua* was written over 100 years after the alleged apparitions at Tepeyac Hill. The fact that a manuscript of the work did not exist, and that the *Nican Mopohua* had not been published by Laso de la Vega until 1649, weighed in favor of their view. The situation did not change until the end of the 1980s, when Ernesto Barrus discovered the oldest manuscript of the *Nican Mopohua* – from the 16th century – at the New York Public Library. It turned out that it had ended up in the United States in 1847, when American soldiers occupied Mexico. A general, Winfield Scott, had sent a collection of valuable manuscripts to the United States, one of which was Antonio Valeriano's work. This discovery in New York silenced the critics of the apparitions who had until then maintained that there was absolute silence for over 100 years about the apparitions, i.e., that there was no historical evidence from 1531 to 1649 as to their authenticity. Another important discovery was that of the *Codex Escalada* in 1995. It is the oldest historical account of the apparitions (1548). It contains not only a description of Juan Diego's encounter with Our Lady, but also illustrations, including the oldest drawing of Our Lady of Guadalupe.

THE OLDEST MANUSCRIPT of *Nican Mopohua* from the mid-16th century, at the New York Public Library.

TEN YEARS AFTER THE CITY OF MEXICO was conquered, with the arrows and shields put aside, when there was peace in all the towns, just as it sprouted, faith now grows green, now opens its corolla, the knowledge of the One by whom we all live: the true God. At that time, the year 1531, a few days into the month of December, it happened that there was a humble but respected Indian, a poor man of the people; his name was Juan Diego; he lived in Cuauhtitlán, as they say.... And as he drew near the little hill called Tepeyac it was beginning to dawn. He heard singing on the little hill, like the song of many precious birds; when their voices would stop, it was as if the hill were answering them; extremely soft and delightful; their songs exceeded the songs of the coyoltotl and the tzinitzcan and other precious birds. Juan Diego stopped to look. He said to himself: "By any chance am I worthy, have I deserved what I hear? Perhaps I am only dreaming it? Perhaps I'm only dozing? Where am I? Where do I find myself? Is it possible that I am in the place our ancient ancestors, our grandparents, told about, in the land of the flowers, in the land of corn, of our flesh, of our sustenance, possibly in the land of heaven?" He was looking up toward the top of the hill, toward the direction the sun rises from, toward where the precious heavenly song was coming from. And then when the singing suddenly stopped, when it could no longer be heard, he heard someone calling him, from the top of the hill, someone was saying to him: "Juan, Dearest Juan Diego." Then he dared to go to where the voice was coming from, his heart was not disturbed and he felt extremely happy and contented.... And when he reached the top of the hill, [he saw] a Maiden who was standing there, who spoke to him, who called to him to come close to her. And when he reached where she was, he was filled with admiration for the way her perfect grandeur exceeded all imagination.[1]

FROM *NICAN MOPOHUA*

NICAN MOPOHUA was first printed in 1649 as part of the *Huei Tlamahuicoltica*.

25

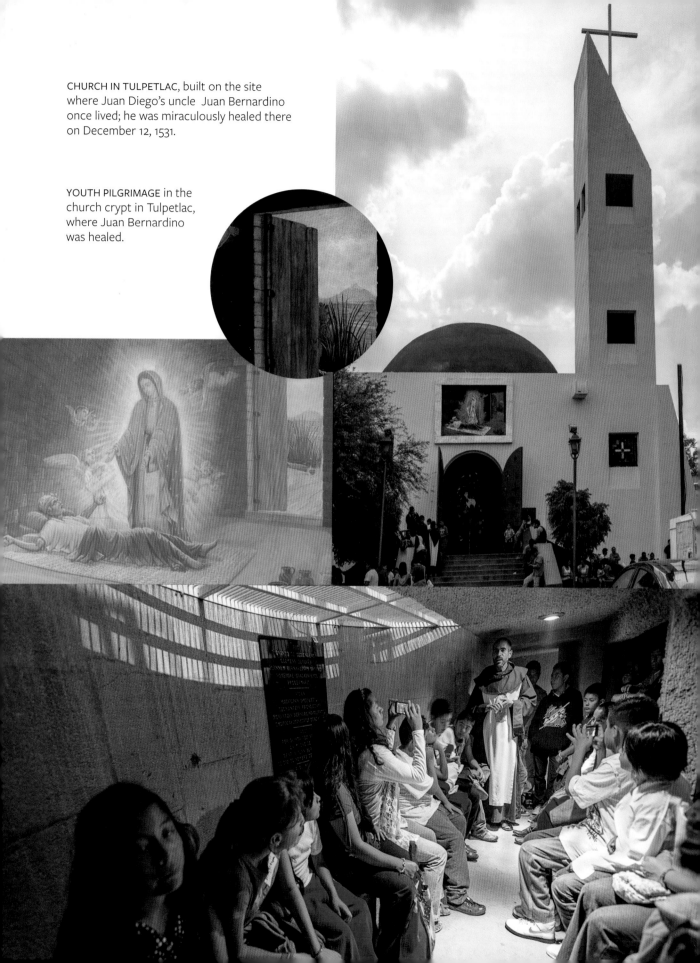

CHURCH IN TULPETLAC, built on the site where Juan Diego's uncle Juan Bernardino once lived; he was miraculously healed there on December 12, 1531.

YOUTH PILGRIMAGE in the church crypt in Tulpetlac, where Juan Bernardino was healed.

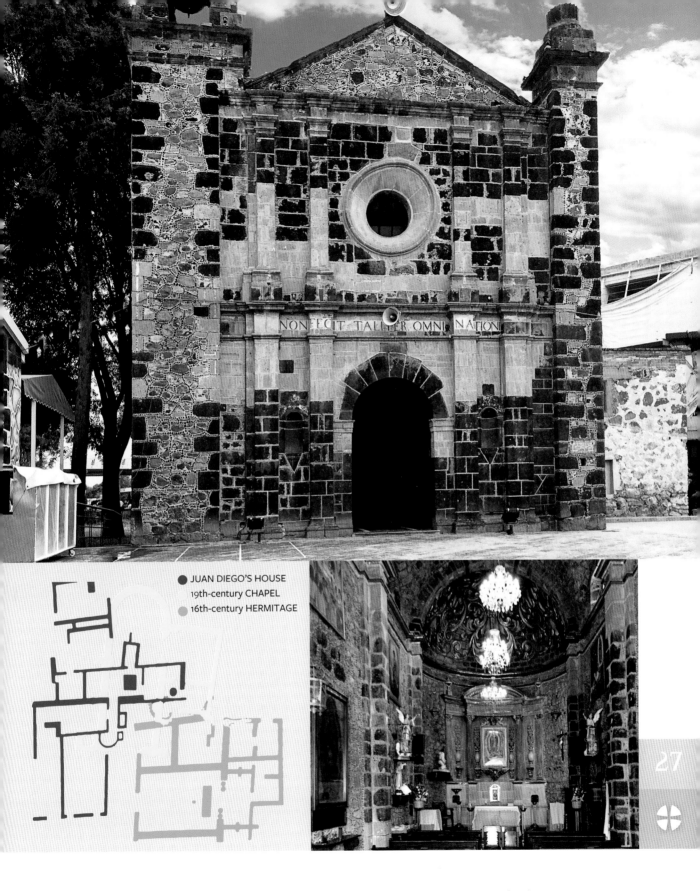

CHURCH IN Cuauhtitlán, built on the site where Juan Diego was born in 1474. After his canonization, the church became a center for devotion to the saint.

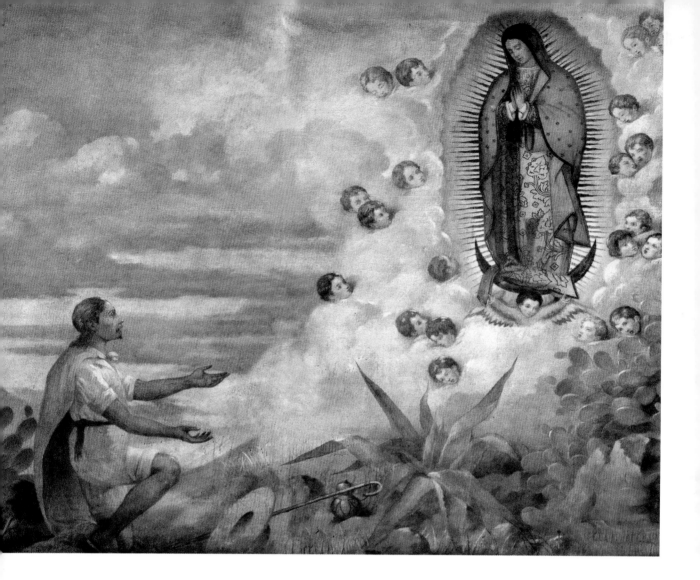

JUAN DIEGO
encounters Our
Lady (Tepeyac
Hill).

So, on Sunday, December 10, Juan Diego made his way to morning Mass at the Church of St. James in Tlatelolco, after which he had another audience with the bishop and repeated Mary's request. This time the bishop listened attentively, asked him about various details, and finally demanded a sign that would prove what he had said.

The moment Juan Diego left the bishop's palace, the bishop summoned several servants and instructed them to follow him. But losing sight of Juan Diego near Tepeyac Hill, they returned without further information about him. Meanwhile Juan Diego met Mary for the third time, and she assured him that he would receive a sign for the bishop – but he had to return to her the following day.

The following day, however, December 11, he did not appear at Tepeyac Hill. It turned out that his uncle Juan Bernardino, with whom he lived, was ▶

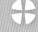

PORTRAIT OF Juan Diego by Miguel Cabrera, the most outstanding painter in New Spain.

29

OUR LADY and Juan Diego, who is setting off on the assignment she entrusted to him.

RO Rᵗᵒ DEL V. JUAN DIEGO, A QUI-
Ò DE APARECERSE EN ESTE SITIO N.
Maria de Guadalupe, y en cuya tilma eſtampô
ra la milagroſa imagen, que adoramos en eſte
12 de Diziembre del año de 1531. Muriò con
dad en el ſervicio de la Sᵗᵃ Imagen el año de

JUAN DIEGO'S ROUTE

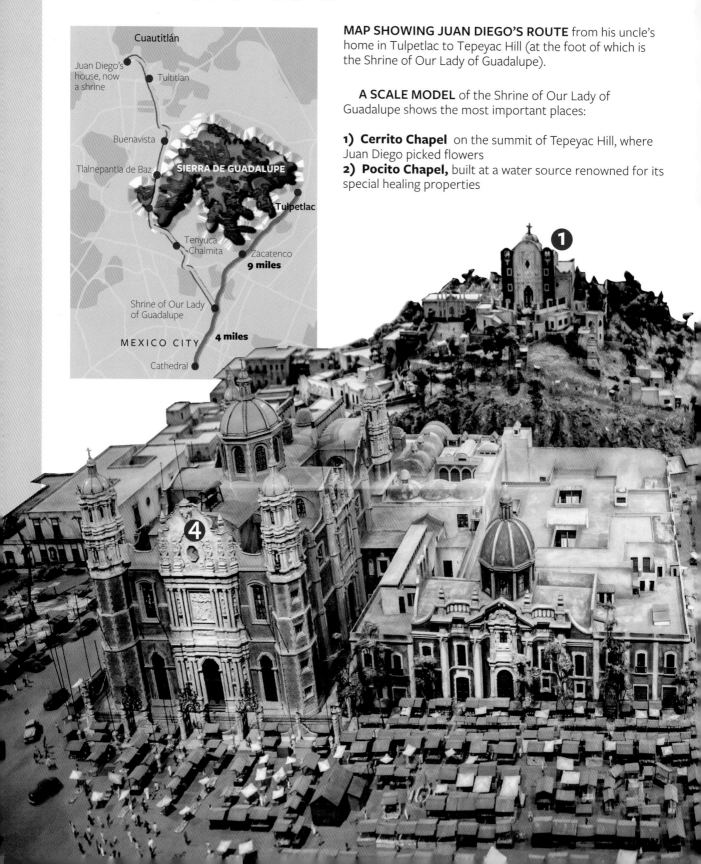

Cuautitlán

Juan Diego's house, now a shrine

Tultitlan

Buenavista

Tlalnepantla de Baz

SIERRA DE GUADALUPE

Tulpetlac

Tenyuca Chalmita

Zacatenco
9 miles

Shrine of Our Lady of Guadalupe

MEXICO CITY **4 miles**

Cathedral

MAP SHOWING JUAN DIEGO'S ROUTE from his uncle's home in Tulpetlac to Tepeyac Hill (at the foot of which is the Shrine of Our Lady of Guadalupe).

A SCALE MODEL of the Shrine of Our Lady of Guadalupe shows the most important places:

1) **Cerrito Chapel** on the summit of Tepeyac Hill, where Juan Diego picked flowers

2) **Pocito Chapel,** built at a water source renowned for its special healing properties

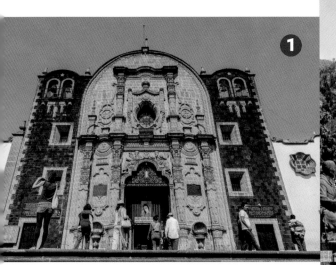

3) **Old Indian Parish,** where the first chapel (built in December 1531) and Juan Diego's final home once stood

4) **Baroque Basilica** of Our Lady of Guadalupe, where the image was housed from 1709 to 1976.

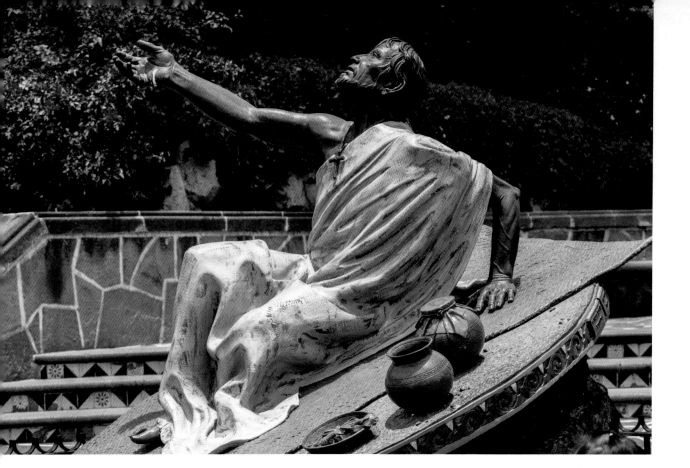

SCULPTURE – the healing of Juan Bernardino of a fatal illness.

very ill and needed urgent medical help. Hence he went to find a doctor instead of going to Tepeyac Hill.

At dawn the next day, Tuesday, December 12, Juan Diego set off to Tlatelolco to bring a priest to his dying uncle. He had to pass by Tepeyac Hill, where he was to have met the Madonna. He then faced a dilemma: whether first to find a priest or first to meet Our Lady and then go to the bishop with a sign from her. He decided first to fulfill his Christian duty in regard to his relative. In order not to come across Our Lady, he decided to take a somewhat indirect route around the hill on the east side. He did not anticipate that she would bar his way.

Embarrassed, he admitted that he had not met her because of his seriously ill uncle, and that he was going for a priest to hear the old man's confession, to prepare him for the next world. He said sadly that all were born to await the hardship of death. There was a note of fatalism in his voice, characteristic of Indians at that time. As Fr. Eduardo Chávez noted, in their eyes an old man represented the tradition and the culture of a whole society, and his death meant the end of their own history, the loss of their identity.

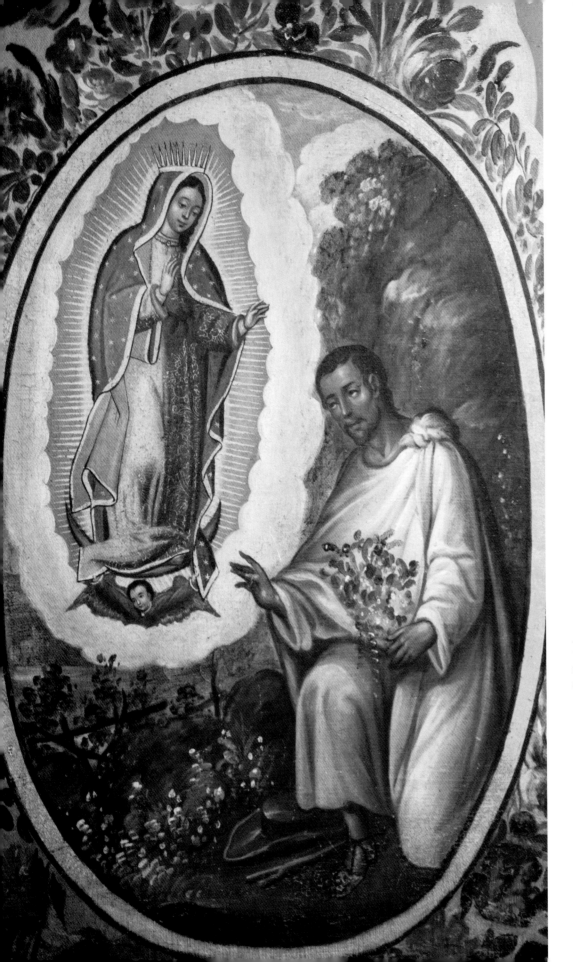

JUAN DIEGO picking and arranging flowers at Our Lady's request.

33

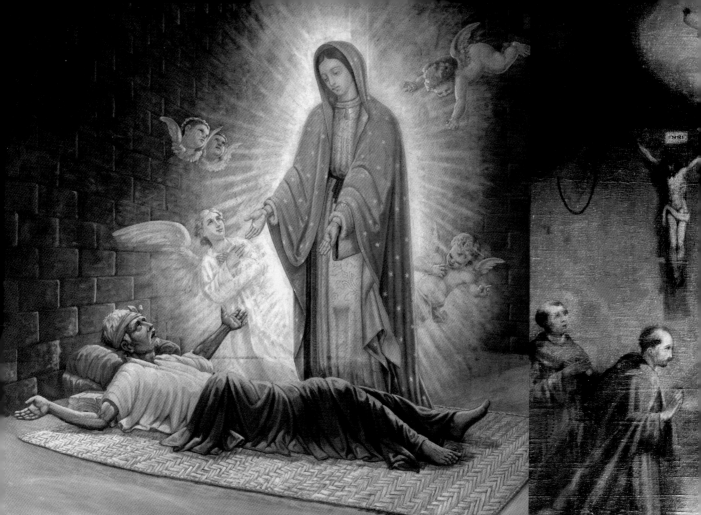

OUR LADY healing
Juan Bernardino
in Tulpetlac.

Mary comforted Juan Diego and told him not to worry as at that very moment his uncle had been healed. She also told him to go to the top of Tepeyac Hill, pick some flowers, and bring them to her. Juan Diego climbed to the summit, though he recalled that just two days earlier he had seen only thistles and cacti there as the ground was rocky and infertile. Hence, what he saw surprised him: although it was December, and frosty, a lot of various flowers were in bloom, including Castilian roses. Juan Diego picked some flowers, wrapped them in his cloak, his tilma, and took them to Mary. She carefully arranged them and put them back in the tilma. She then told him to take them to the bishop.

Juan Diego appeared at the bishop's residence for the third time. The servants, who had earlier lost him when they were following him, tried to stop him from seeing the bishop and even tried to take that which he had concealed in his tilma. He finally managed to see the bishop and tell him of his recent meeting with Our Lady. When he had finished, he unwrapped his tilma,

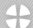

ELV. P.S. Juan Gonzales Capellan y Conffeffor del Illuff.º V.º S.º D.º Fray Juan de Zumarraga, primer Obiſpo y Arçobiſpo de Mexico, en cuya familia eſtaba de Interprete de la Lẽgua mexicana quando ſe aparecio Nueſtra Señora de Guadalupe. Fue el primero que hecho Matricula en Theologia en eſta Real Univerſidad, vno de ſus primeros Conciliarios, ſu tercer Rector Iuez azeſor, y Canonigo de eſta Santa Yglelia. Renuncio el Canonicato por ir a la Converſion de los Indios y ſe retiro al Hermita de Nueſtra Señora de la Piedad, donde vivio 24 años, h.x. ſiendo v̄da muy penitente con admirable recogimiento. Murio a 9 de Henero de 1589 y le enterraron en el diẽ en la Yglelia Cathedral antigua le traſladaron a la Nueva, y delpues en 30 de Henero de 1710, depolitaron ſus huelos en la Capilla de S.ᵗ Chriſtoual lado de la Epiſtola, enfrente del V.ᵉ Gregorio Lopez ſu Contemporaneo.

whereupon the bishop and all those present fell to their knees. The flowers had fallen on the ground, and an image of Our Lady was visible on the tilma.

The bishop had the image put in his private chapel and invited Juan Diego to stay at the palace until the following morning. The next day, December 13, they went to the foot of Tepeyac Hill, where the apparitions had occurred. The Indian pointed to the place where a chapel was to be built. They then went to the village of Tulpetlac to see Juan Bernardino, who had been completely cured. The old man told them that the Lady of Heaven had visited him the day before – at exactly the same time that Juan Diego was with Mary – and had restored his health. She had instructed him to tell the bishop about everything, including that she had disclosed her name to him: "Perfect Virgin, Our Lady of Guadalupe".

To the Indians, it was highly significant that Our Lady had revealed her name to Juan Bernardino and not to his nephew, because for them an elderly person was a bearer, a keeper, of ancient culture. Tradition legitimized his

THE APPEARANCE of Our Lady's image on Juan Diego's tilma in the palace of the bishop of Mexico.

BISHOP ZUMÁRRAGA praying before the image of Our Lady of Guadalupe.

35

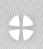

authority. He used the word "Guadalupe", which was not part of the vocabulary of any of the Indian peoples and which surprised the Spaniards, who knew that there was a Marian shrine of that name in Extremadura, Spain. Some friars, e.g., the Franciscan Bernardino de Sahagun and the Hieronymite Diego de Santa Maria, even protested against the use of the name. Eventually, it was decided that the name had to remain since Mary herself had used it.

In the course of two weeks, the Indians from Cuauhtitlán built a chapel at the foot of Tepeyac Hill, as requested by the Lady of Heaven, and the extraordinary image of Our Lady of Guadalupe was taken there in a solemn procession. Bishop Juan de Zumárraga, who led the celebrations, most certainly could not have imagined the awe the image would evoke in the natives, for he had no idea that it encoded a message, which would bring about the conversion of nine million Indians to Christianity in just eight years.

OUR LADY of Guadalupe is one of the most frequent motifs in the history of Mexican art.

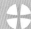

NEZAHUALCOYOTL – king of Texcoco and a monotheist.

THE SEEDS OF **MONOTHEISM**

Pre-Columbian religions, including the Aztec, were largely polytheistic. The Toltec tribe was an exception, for it came to believe in one god, Ometeotl. To the Toltecs, all the other gods were but manifestations of Ometeotl, though he showed no interest in the people.

The renowned king of Texcoco, Nezahualcoyotl (1402–1472), held the Toltec heritage dear. Texcoco was part of a triple alliance with Tenochtitlán and Tlacopan. Nezahualcoyotl became famous as an outstanding sage, a poet, and a patron of the arts. His descendant Fernando de Alva Cortés Ixtlilxóchitl wrote that Nezahualcoyotl became convinced that there was only one God, the Creator of heaven and earth, of all things visible and invisible. Nezahualcoyotl ordered a great temple to be built and dedicated to the "Unknown God". The same inscription can be seen on one of the Greek altars at the Areopagus in Athens, which St. Luke wrote about in the Acts of the Apostles.

Franciso Xavier Clavijero, an 18th-century Mexican chronicler, wrote that Nezahualcoyotl rejected the polytheism of his contemporaries. He privately told his sons that the many gods worshipped by their own people did not exist, hence their cults were meaningless. He warned them, however, not to show aversion to idols in public, for by doing so they might lose the respect of their people and possibly their obedience. Nezahualcoyotl prohibited human sacrifice, but when his subjects strongly protested he reverted to the practice, allowing only prisoners of war to be sacrificed.

STATUE OF OMETEOTL, an Aztec god – designer, creator of the universe and of all the gods.

According to modern historian Fr. Eduardo Chávez, St. Juan Diego came from a region that was under the influence of the kingdom of Texcoco. He was therefore familiar with monotheism, which might have made the acceptance of Christianity easier for him than for other natives.

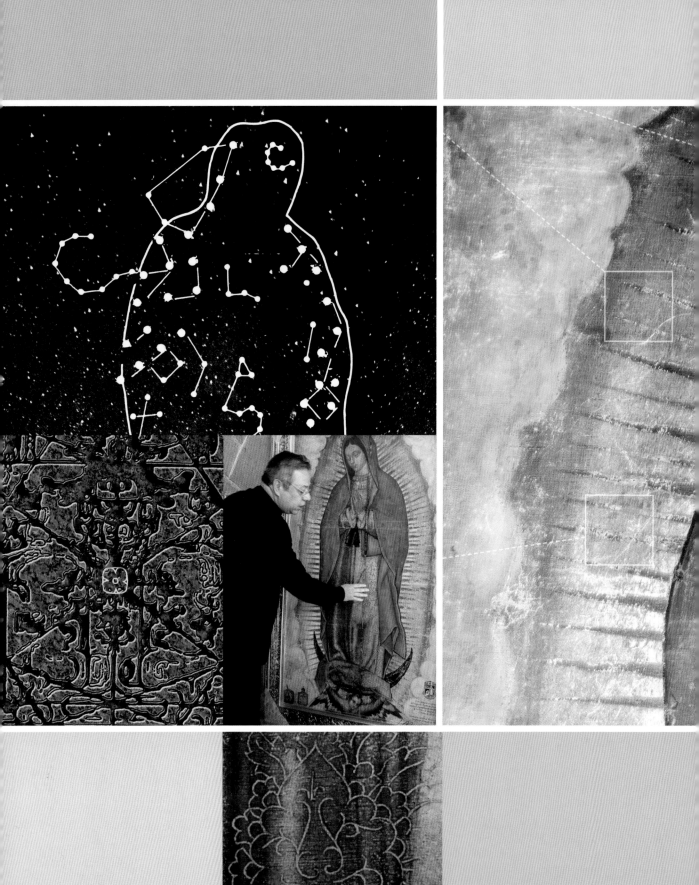

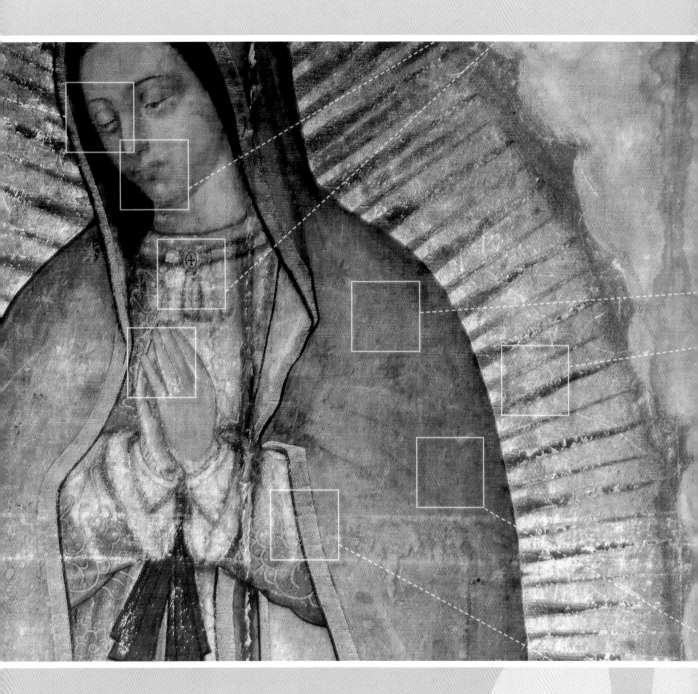

The Guadalupe Code

The Guadalupe Code

FR. MARIO
ROJAS SANCHEZ,
a Mexican
researcher, says
the jasmine is
the quincunx
flower of Aztec
mythology.

The Image of Our Lady of Guadalupe was like a coded message. One part was clear to the Spanish, the other to the Indians. But the whole was a message to the new nation that was arising.

Initially the missionaries did not see the significance of the Tepeyac image. It took them a long time, perhaps because they were too disorientated and bewildered as the Indians suddenly began to request Baptism in large numbers; not one by one, or whole families, but whole tribes. They often walked to Franciscan or Dominican monasteries from distant regions, frequently from places where no missionary had ever been, where the Gospel had never been preached.

The friars were amazed. It is estimated that there were about forty Catholic missionaries in Mexico at the time of the Tepeyac apparitions. Despite their efforts, evangelization proceeded with difficulty until 1531. Subjugated and humiliated by the invaders, decimated by disease, the natives were not attracted to the new religion. Although the conquistadors' pride and arrogance offended them, their unbridled craving for gold offended even more. Gold was not of great value in pre-Columbian cultures – the ornate feath-

40

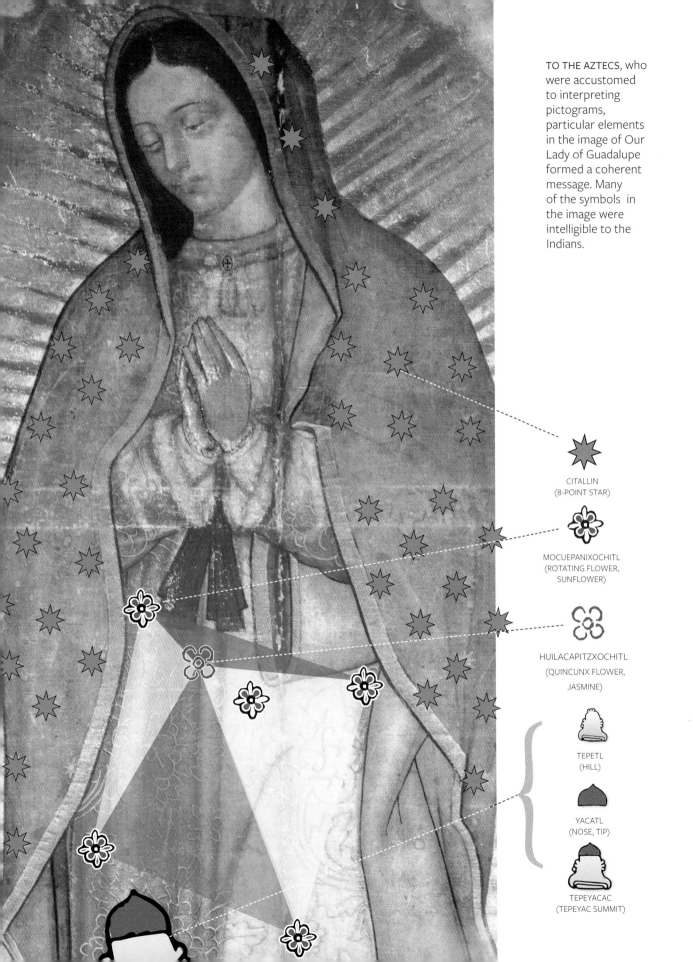

TO THE AZTECS, who were accustomed to interpreting pictograms, particular elements in the image of Our Lady of Guadalupe formed a coherent message. Many of the symbols in the image were intelligible to the Indians.

CITALLIN
(8-POINT STAR)

MOCUEPANIXOCHITL
(ROTATING FLOWER,
SUNFLOWER)

HUILACAPITZXOCHITL
(QUINCUNX FLOWER,
JASMINE)

TEPETL
(HILL)

YACATL
(NOSE, TIP)

TEPEYACAC
(TEPEYAC SUMMIT)

THE TILMA ACQUIRES A NEW MEANING

THE INDIANS attached great importance to the fact that Mary's image was on a tilma, as they used tilmas to take their newborn children to temples to be dedicated to a god. Today too we can see fathers and mothers at the Shrine of Our Lady of Guadalupe offering their infants in tilmas to Our Lady

Also of great importance was the fact that at Aztec marriages a woman's shirt, a huipilli, and a man's tilma were tied together, as a sign of their mutual bond. Hence Mary's use of a tilma signified a mystical marriage between Our Lady and the Mexican people. It signified giving up former idols and entering a new covenant with God.

There is another aspect. A tilma not only protected an Indian from the cold and the sun, it was also used for carrying food. Hence from the time of the the apparitions Mary was seen as a safeguard in times of trouble and cares, as well as the bearer of lifegiving food, that is, Jesus Christ. Fr. Eduardo Chávez noted that the Virgin Mary of Guadalupe – thanks to her image on St. Juan Diego's tilma – proclaimed the Gospel in a manner that was rooted in Indian culture.

ILLUSTRATION IN an Aztec codex – a wedding, symbolized by a couple tying their clothes together.

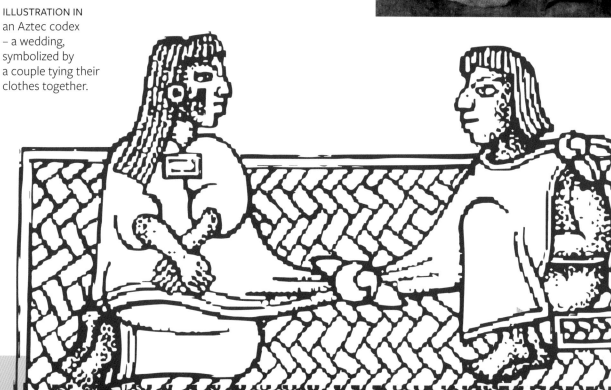

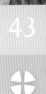

ers of rare birds were of much more value. Hence they were surprised that Europeans saw gold in a way that verged on idolatry.

Suddenly there was a flood of converts. Br. Gerónimo de Mendieta, a Franciscan chronicler, the author of *Historia Eclesiástica Indiana*, a pioneering work, witnessed the events. He wrote that the Indians initially came in groups of two or three hundred at a time, but their numbers grew until there were thousands. They came from various tribes – often from places that were several days on foot away – the old and the young, the ill and the healthy. Those who were baptized returned with their relatives so that they too might receive the sacrament. The Franciscans were amazed by the vast number of converts.

Day by day the handful of missionaries had to meet the expectations of tens and even hundreds of thousands of Indians. Contemporary chroniclers relate

BAPTISMAL FONT at the Church of St. James (Tlatelolco), where St. Juan Diego was baptized.

AFTER THE Guadalupe apparitions, 9 million Indians were baptized in less than a decade.

that the Franciscans who baptized the Indians were so tired that they were often unable to raise their hands when administering the sacrament. There was a lack of friars to cope with the crowds that came from all directions. At times some of them had to baptize from four to six thousand daily. One day two priests baptized over fifteen thousand in Xochimilco.

The missionaries were stunned by so many conversions. They were the more disorientated as the Indians did not see Baptism as a sort of magic, and they did not limit the Christian religion just to the ritual sphere; a desire to transform their lives followed conversion. That was particularly evident in a sphere where the Church had hitherto had its greatest failure, that is, polygamy. Previously the Indians had many wives and had not accepted arguments to change this practice. Even when they had been prepared to accept Christianity, they had rejected monogamy. It

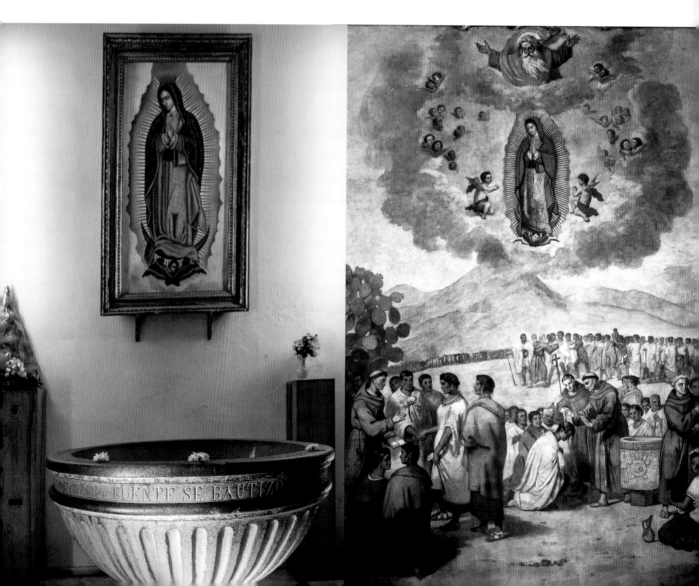

was with great difficulty that the missionaries convinced the first eight couples to enter into a sacramental union, which took place on October 14, 1526.

After 1531 the Indians spontaneously began to abandon polygamy and to enter Catholic marriages. The missionaries were amazed that the Indians had begun to accept monogamy though the majority of them had not had any religious instruction on the subject. The phenomenon took on a mass character. Br. Toribio de Benavente, nicknamed Motolinia by the Aztecs, recalled in 1541 that churches were unable to accommodate all the couples who wanted a Catholic wedding. There were days when even five hundred couples were married.

The Indians suddenly desired to live Christian lives in all spheres of life. They acknowledged their own sinfulness, the need to battle against their own weaknesses, hence they saw the need for confession. Gerónimo de Mendieta wrote that the Indians sometimes walked for several days, at times covering eighty miles, just to make confessions at missionary centers. They travelled in large groups, numbering several thousand, which included women, children, and the elderly. Sometimes children were born during the journeys. The converts' zeal evoked great admiration among the friars, who had not come across such religious zeal in Europe. Such scenes reminded them of the mass conversions of pagans as related in the Acts of the Apostles. Hence they pinned their hopes on the American continent, seeing there the future of Christianity.

INDIAN PILGRIMS in folk costumes at the Shrine of Our Lady of Guadalupe.

BR. TORIBIO DE BENAVENTE, a Franciscan missionary and chronicler in Mexico.

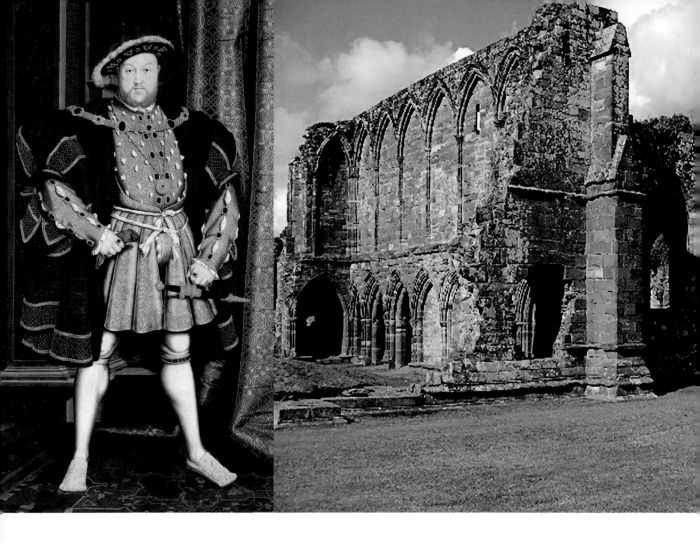

KING HENRY VIII separated the Church in England from the Apostolic See, established the Anglican Church, and appointed himself as its head.

FURNESS ABBEY after the dissolution of the monasteries; many monasteries in England suffered the same fate.

Fernando de Alva Ixtlilxóchitl (c. 1568 – c. 1648), a New Spain chronicler of Aztec descent, wrote that the Indians, in large numbers, renounced their former beliefs and destroyed the images of their former gods, as they saw them as depictions of demons. Br. Toribio de Benavente was very impressed by their faith, simplicity, and humility. He wrote that they could be a model of Gospel poverty, as they did not desire fame, positions, or wealth, being content with a few modest things. They realized the ideal of which Jesus spoke, that is, not to be solicitous about food or clothes, but about the Kingdom of God. Many of them served the Church, helping the missionaries and proclaiming the Gospel to their compatriots. Their example also strengthened the faith of the missionaries.

Br. Geronimo de Mendieta had similar feelings about the Indians as he saw many of them cry when receiving the sacraments. He fervently disputed with the conquistadors who undermined the authenticity of conversions, for they thought that the natives became Christians out of expediency.

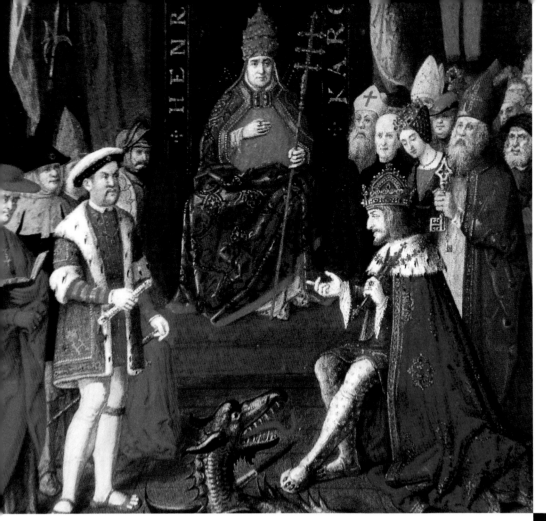

KING HENRY VIII, Pope Leo X, and Emperor Charles V during a meeting.

Some missionaries also had doubts as to the sincerity of the Indians, but they did not air them publicly, at least not while Bishop Juan de Zumárraga was alive. He was well aware that the large number of conversions was changing the religious map of the world. The bishop was impressed not only by the number of conversions, but also by their quality, to which he was a witness. Both he and the bishop of Michoacán, Vasco de Quiroga, pinned their hopes on the Indians to renew Christianity. They thought that thanks to the Indians it would be possible to rebuild a pure form of Christianity, akin to that of apostolic times, which was lost in later centuries.

The Reformation was in progress in Europe at the time of the apparitions at Tepeyac Hill. The year 1531 turned out to be particularly difficult for Catholicism. First, on February 11, a general assembly of the clergy in England proclaimed King Henry VIII head of the Anglican Church. Shortly after, February 27, German Protestant princes set up the Schmalkaldic

BISHOP VASCO de Quiroga, a great defender of Indian rights in the 16th century.

BAROQUE
FAÇADE of the
Metropolitan
Cathedral in
Mexico City.

CATHEDRAL
IN MEXICO
CITY – because
of continual
subsidence it
was listed in
2000 as one of
the 100 most
endangered
buildings in the
world.

League against the Catholic emperor Charles V, which ruined any chance of maintaining Church unity. The Reformation saw five million Catholics become Protestants in a short time. During the same period, however, the Church had gained nine million new believers in the Western Hemisphere, as that number of Indians was baptized between 1532 and 1538.

History does not know of a similar precedence. That which took several centuries on the Old Continent, took but several years in the New World. No one doubted that the mass conversion of Indians to Catholicism was largely due to the apparitions of Our Lady of Guadalupe. Fernando de Alva Ixtlilxóchitl, a historian of Aztec descent, wrote that his ancestors had a false faith and had worshipped demons in the form of false gods. Everything suddenly changed, however, because of Our Lady's apparitions and her miraculous image. This chronicler was certain that the image was not the work of a human hand. Those two events were like lights in the darkness to the Indians, a light that showed them the right path.

The rate and the huge number of collective conversions aroused admiration in some Europeans but suspicion in others, while successive bishops of Mexico were of the former disposition. Bishop Juan de Zumárraga, from the time of the apparitions, experienced a second youth. Though he was then sixty-two, he flung himself into the hurly-burly of pastoral work. He died seventeen years

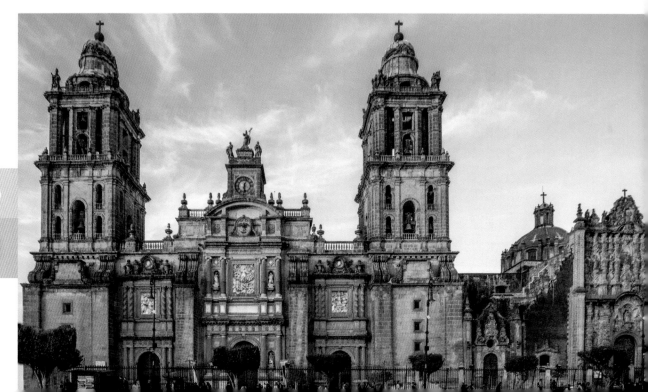

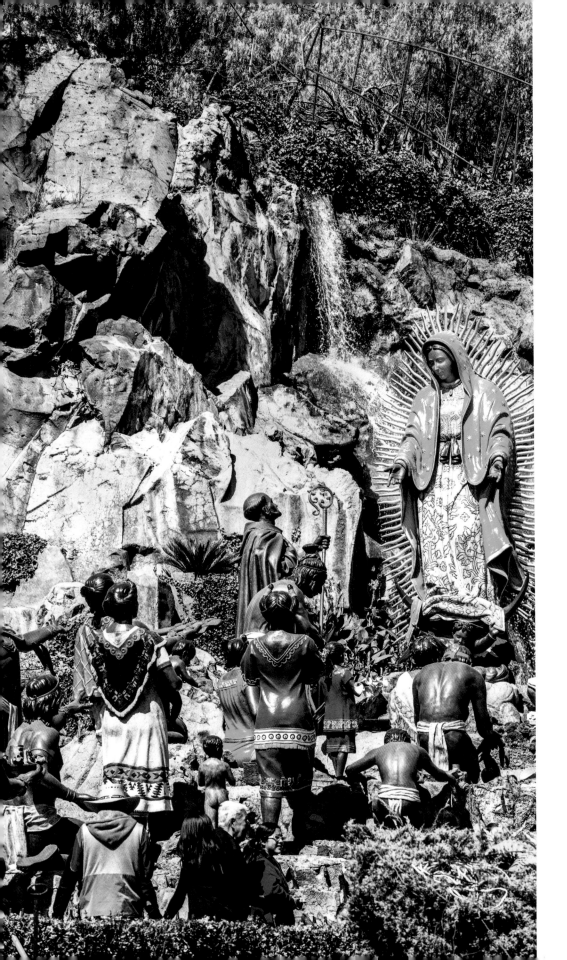

GROUP SCULPTURE on the slopes of Tepeyac Hill; it depicts a Mexican procession bearing valuable gifts for Our Lady of Guadalupe.

49

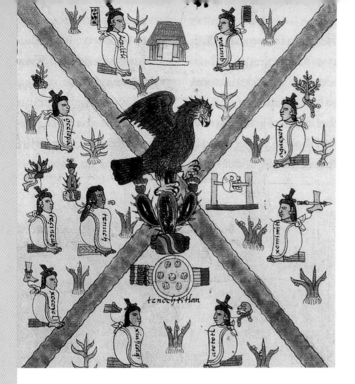

AZTEC **CODICES**

THE ETHNOGRAPHERS who had studied the symbols depicted in the image of Our Lady of Guadalupe saw it as a codex. In the Aztec culture codices were documents painted by artist-scribes who, with the aid of pictographs, not only portrayed specific events but also gave them a deeper meaning.

Polish Mariologist Wincenty Łaszewski, writes:

> Aztec art was not naturalistic. Its task was not to reflect the world as a person saw it, for it was not at all as our eyes perceived it. To the Aztecs the surrounding world was a text which they were unable to fully comprehend. Only an inspired artist-scribe, one who "communicated with his heart" and "found things through his mind", could interpret the world in the right way, and communicate it to others as a painted codex that presented a true and sacred reality. So there were attempts to interpret the meaning of the world, hidden to the human eye, and present it, using, amongst other things, contexts and similiarities, which could reveal significant connections.[2]

Hence the Indians looked at the image of Our Lady of Guadalupe as they looked at other pictographic works of art. They saw an intelligible system of signs that aimed at communicating a message.

THE GODDESS Tonantzin, whose temple was once on Tepeyac Hill.

ILLUSTRATION FROM the Aztec *Codex Mendoza* of 1541–1542.

later (June 3, 1548), one month after Pope Paul III appointed him as archbishop. In his last letter, he wrote that he was very happy, as he had confirmed as many as four hundred thousand Indians during his last few days. As Confirmation was reserved to bishops, he had to anoint people at ceremonies that lasted for days.

Archbishop Zumárraga's successor was a Dominican, Fr. Alonso de Montúfar, who, like his predecessor, was a great devotee of Our Lady of Guadalupe. This led to a conflict with the Franciscans, for they were very suspicious about the apparitions. They thought that the cult initiated by Juan Diego was really a disguised devotion in honor of a pagan goddess, Tonantzin, who once had a temple on Tepeyac Hill.

On September 8, 1556, Br. Francisco de Bustamante gave a homily in the Franciscan monastery chapel in Mexico City, attacking the cult of Our Lady of Guadalupe as idolatrous and accusing Archbishop Montúfar of propagating

PUBLICATION OF documents from the first two local synods (1555 and 1565) of the Church in Mexico.

SECOND ARCHBISHOP of Mexico, Alonso de Montúfar, a Dominican.

51

AZTEC SYMBOL of perfection and transcendence, at the site of the first chapel of Our Lady of Guadalupe.

52

A CROSS, the most important Christian symbol, the shape of which forms part of a quincunx.

idolatry. The matter became well known, for the accuser was the order's provincial, the accused was the diocesan ordinary, and the accusation was in the presence of the viceroy and the central authorities of New Spain. So it was not surprising that the following day the archbishop ordered an inquiry. It turned out that many Franciscans were opposed to the cult, e.g., Br. Antonio de Huete and Br. Alonso de Santiago, but no facts came to light that might have pointed to even the slightest trace of idolatry.

During the inquiry there were many accounts that proved that the cult was very much alive a quarter of a century after the apparitions. One of the witnesses, Juan de Masseguer, related that the whole population deeply revered the image of Our Lady from the very beginning. Indians from all social classes made pilgrimages to it. Some were so zealous in revering the image that the monks had to restrain them.

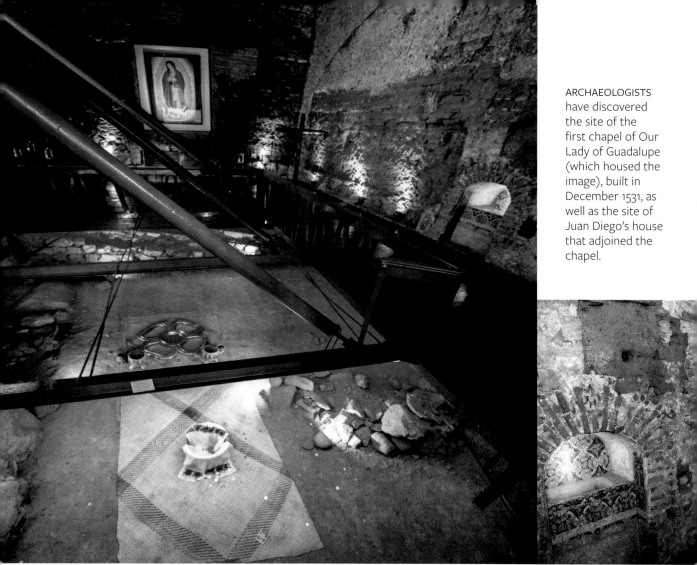

Pilgrims visited the chapel that had been built for the image at the foot of Tepeyac Hill within two weeks of the apparitions. Shortly afterward, Juan Diego asked Bishop Juan de Zumárraga if he could live there. So a small house was built beside the chapel. He frequently prayed before the image, but first and foremost he told numerous pilgrims about the apparitions.

His uncle Juan Bernardino died in 1544, at the age of eighty-six. Juan Diego died four years later at the age of seventy-four. Both were interred in the chapel. However, the image of Our Lady made a greater impression on the Indians than the accounts of the eyewitness.

The image was comprehensible to the indigenous people of Mexico, a clear pictorial message. Research by the American anthropologist Helene Behrens, in 1945, confirmed that the symbols in the image match those of an ancient Aztec language, Amoxtli.

53

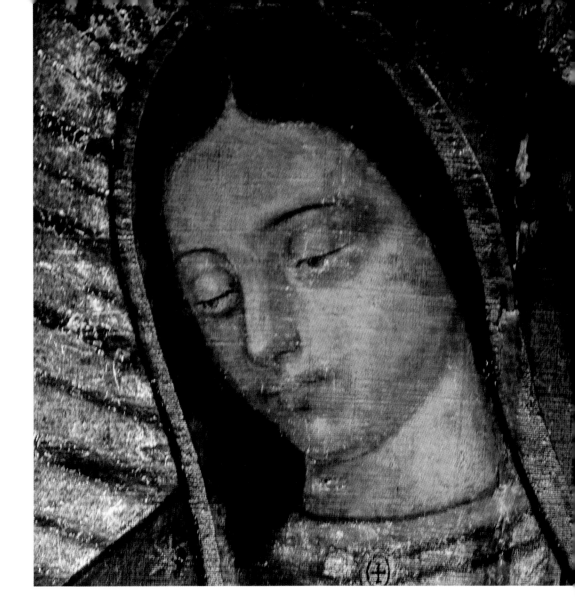

THE MADONNA'S loose hair in the image signified virginity in the Aztec culture.

The woman in the image is not masked, unlike all the gods that were known to the Indians; hence she is human. Despite this, she is the most powerful of all gods, as she stands on the moon, herself covering the sun, wearing a heavenly mantel, bluish green, which in the Aztec culture was reserved solely for rulers. So the woman is a queen. She is surrounded by clouds and mist, which point to her divine origin and mission. Hence she came with a message from another world.

In the image, Mary's hair is loose, which in Aztec culture signifies virginity. Around her waist is a black sash tied with a bow, which signifies a pregnant woman. Over her womb is a quincunx flower, symbolizing divinity and transcendence. The flower is of five parts – four elements meeting in the center. This was the Aztec ideal of harmony and beauty, while the number five symbolized man

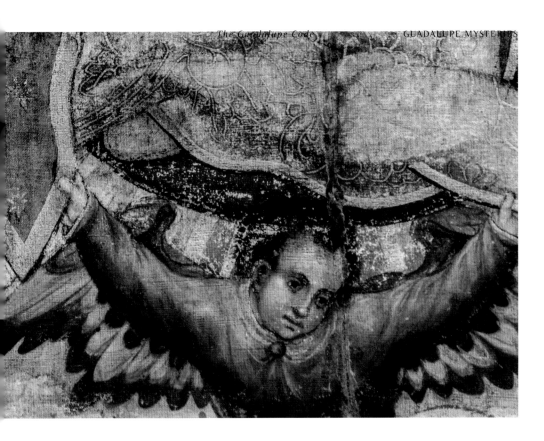

AN ANGEL holding Mary's mantle in his right hand, and her tunic in his left. The mantle and the stars symbolize the sky, while the flowers on her tunic symbolize the earth.

meeting God. So the pictorial message, clear to the Indians of the time, says that the lady in the image is a virgin, who bears the true God in her womb.

There are various symbols on Mary's tunic. To the Spanish they were insignificant adornments, but they were of enormous significance to the Indians. Fr. Eduardo Chávez, an expert on the subject, wrote that the message in the image is in the form of pictures. To the Indians, who used pictograms on a daily basis, it was a perfectly intelligible code.

So what did the image say to the Indians? According to Fr. Chávez, who has interpreted Aztec pictographic symbols, the message was unambiguous: a new era in human history, which could be called a civilization of love, had begun in Our Lady's womb, for she had given birth to the one true God.

Moreover, as other scholars, such as Mario Rojas Sánchez and Juan Romero Hernandez Illescas, have noticed, Mary's mantel is blue. To the Aztecs, blue signified heaven, the seat of the gods. There are stars on the mantel. Research on the arrangement of the stars, which occurred in 1981, showed that the arrangement of the stars on the tilma match the one that was over Mexico in December 1531; one can see constellations such as the Great Bear, Canes Venatici (Hunting Dogs), Scorpio, and Coma Berenices (Berenice's Hair). But the arrangement is not geo-

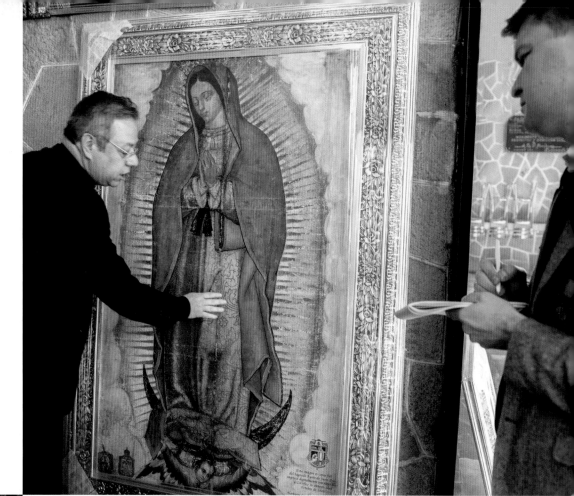

FR. EDUARDO CHÁVEZ explaining the meaning of the Aztec and Spanish symbols in the image to Grzegorz Górny.

FR. EDUARDO CHÁVEZ'S BOOK, *The Truth about Guadalupe* (preface by Norberto Cardinal Rivera Carrera).

centric, i.e., as if the observer were on the earth, but heliocentric, as if the observer were on the sun, thus the observation point is in the middle of the quincunx – the flower with four petals.

To the Aztec priests of the solar deity cult, initiated into arcane astrology, deciphering the message on the tilma was easy: the true God, Lord of the universe, was in the woman's womb, and knowledge of this was being communicated from the other world. Though other symbols were intelligible to ordinary Indians, the map of stars was intelligible only to the priestly class.

Communicating the Christian message, not only to the simple people but also to the higher castes, accelerated the process of converting the Aztecs as well as neighboring tribes. The Virgin's message spread beyond Mexico and had an influence on the evangelization of the whole of Latin America. On other continents, the priestly castes were Christianity's greatest enemies, who rightly feared that the new religion would limit their social influence. Hence tribal witches or shamans often urged the people to practice their old beliefs secretly and to oppose the missionaries. After the apparitions at Tepeyac Hill, there were no signs of such an attitude in Mexico.

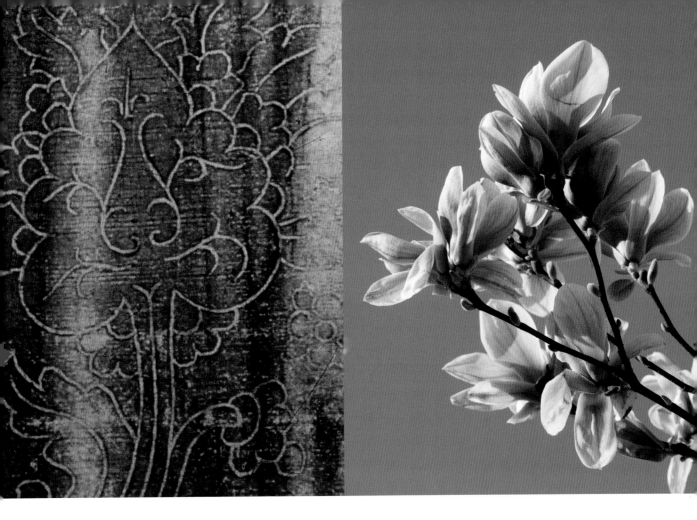

What is more, there were fervent devotees of Our Lady of Guadalupe amongst chiefs and priests – and the people followed them.

Pre-Columbian priests gave reasons for their conversions to Franciscan missionaries, who noted them in their letters (of 1524) to Pope Adrian VI and Emperor Charles V. Former Aztec religious leaders acknowledged that they had given up the faith of their ancestors on account of Our Lady of Guadalupe. She had convinced them that God had become incarnate and that one could feel His presence as well as converse with Him without fear. Hence the Indians believed that the Christians who had come from beyond the "Great Water" were envoys of the true God, Creator of the world and Giver of life. The former priests admitted that they were full of admiration for the missionaries and obedient to them. They not only had a fervent faith in Jesus but also were rooted in their indigenous culture, for they were able to express their religious feelings in forms that were characteristic of them. That was a true inculturation.

One of the few instances of someone practicing the old faith was the well-known case of a certain Don Carlos, an Aztec bureaucrat from Texcoco, who

THE MAGNOLIA, the heart flower, was the symbol of the human hearts the Aztecs offered to their gods.

THERE ARE ABOUT 250 species of magnolia, a flower that grows on trees or bushes.

57

AN IMAGE AS A CHRISTIAN ICON

THE SPANISH saw the image of Our Lady of Guadalupe as a Christian icon, where they found symbols that they knew well. What did they see? It is worth listing the elements they saw:

1) A MANDORLA, a vesica piscis shaped aureola, is a symbol of sanctity.

2) THE BLUE COLOR of the mantle symbolizes immortality and eternal happiness with God in heaven.

3) A SASH around the waist is a symbol of virginity, purity, and devotion to God.

4) A CLOUD surrounding Mary signifies the invisible and inexpressible God.

5) THE PINK COLOR of the tunic recalls the red of self-sacrificing love.

6) THE LEAVES on the tunic are a symbol of paradise.

7) THE MOON under Our Lady's feet is an allusion to the woman in the Apocalypse.

8) THE ERMINE LINING of Mary's tunic signifies her royalty and purity.

9) THE STARS on the mantle indicate her title of the Queen of Heaven.

AN IMAGE AS A CHRISTIAN ICON (CONT.)

10) A GOLD BROOCH has a cross, the most important Christian symbol.

11) THE ANGEL is Mary's servant.

12) HANDS folded in prayer show honor, praise, and worship to God.

13) MARY'S inwardly turned eyes symbolize contemplation and spiritual union with God.

14) MARY'S BENT knee signifies her humility before God.

15) MARY'S SMILE expresses joy in being in the presence of the Creator.

TO SUM UP, the image, to Europeans, was an understandable iconographic message, full of intelligible elements of Christian symbols. They saw it as a typical Marian image, characteristic of the sacred art of the Old Continent. To them it was most familiar, bereft of foreign influences or unintelligible signs. A similar image could easily be hung up in any church in Europe.

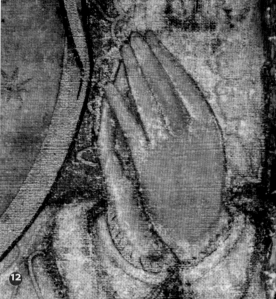

had been baptized but carried on his old cult in secret. In 1536, he was caught sacrificing people, splitting open their chests with a glass knife and removing their hearts. He was condemned to death. On December 26, 1531, another incident helped to win the Indians over to the new faith. Exactly two weeks after the image of the Virgin Mary had appeared on the tilma, it was taken in procession from the bishop's chapel to the foot of Tepeyac Hill, where the apparitions had occurred. Thousands of Indians participated, including representatives of the most prominent Aztec families. The natives were enjoying themselves, dancing and shooting arrows high in salute, until one of the arrows pierced a Chichimeca man and killed him. His body was brought before the image of Our Lady of Guadalupe on the altar of the newly built chapel. People began to pray for a miracle. The arrow was removed from the deceased, and to everyone's amazement he came back to life. There were thousands of witnesses, and the news quickly spread throughout the neighborhood.

A few years later, another event strengthened the cult of Our Lady of Guadalupe. In 1545, an epidemic broke out in the capital and the surrounding neighborhood. The natives were the main victims, as they were not resistant to the infectious diseases that had been brought from Europe. About twelve thousand died in just several months. As doctors were helpless, the Franciscans organized a children's procession to the image of Our Lady of Guadalupe to beg for help. Shortly after, the epidemic died out; this was universally attributed to the intervention of Our Lady.

Interestingly, the image of Our Lady was intelligible not only to the natives, but also to the

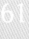
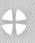

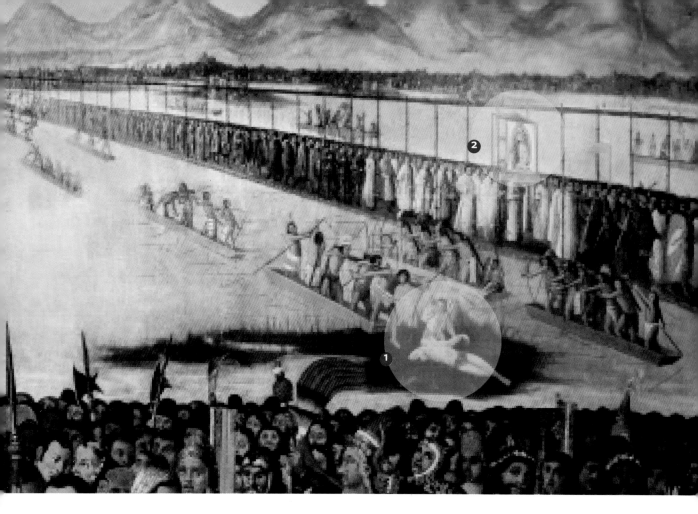

THE FIRST MIRACLE from the intercession of Our Lady of Guadalupe occurred on December 26, 1531. It concerned an Indian who had been fatally wounded by an arrow (1). He is depicted opposite a Marian procession on a causeway (2).

Spanish. Spanish Gothic art features can be detected in it, together with Italian and French influences. According to art historians, it most closely resembles the fifteenth-century *Virgen de la Merced*, now in the National Art Museum of Catalonia in Barcelona. There are many iconographic elements characteristic of Christian sacred art: a mandorla (a vesica piscis shaped aureola) surrounding the figure of Mary, a winged angel, and the moon under Mary's feet, which recalls St. John's Apocalypse. A particularly meaningful motif is the gold-encircled-cross brooch under the neck of Our Lady's tunic.

So the image is a synthesis of two cultures, Indian and Spanish, from which a third has emerged – the Mexican culture. It is no accident that there is a plaza in the center of Mexico City, Three Cultures Square, where there is a plaque with the inscription: "On August 13, 1521, Tlateloco, heroically defended by Cuauhtémoc, fell to Hernán Cortés. It was neither a triumph nor a defeat, but the painful birth of the Mestizo people, today's Mexico."

However, it would be more accurate to say that the actual birth of the Mestizo people was on December 12, 1531, when the image of Our Lady of

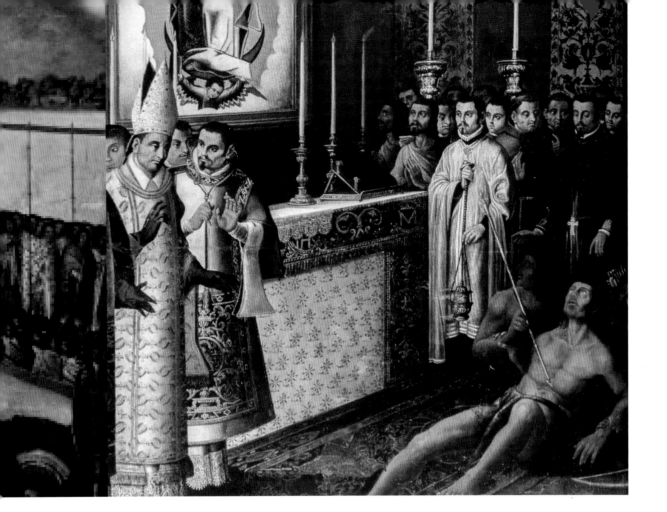

Guadalupe appeared. On the tilma, Mary is dark-skinned. From a distance she looks like an Indian, but like a white woman from close up. The peaceful merging of two worlds actually proceeded before the eyes of the Madonna. It was before her that both the Spanish and the Aztecs renounced their desire for revenge and resolved to overcome their mutual hatred, which had resulted from the Spanish conquest of Latin America.

When Mary appeared as a dark-skinned woman, the Mestizos were being treated with the greatest of contempt, both by the Europeans and the Indians. The Spanish saw them as fruits of war and debauchery, while the Aztecs saw them as the consequences of rape. Hence the unwanted children of mixed relationships were abandoned in large numbers. Bishop Juan de Zumárraga sadly noted that orphans, the children of Spaniards and Indian women, wandered around homeless, eating whatever they could find, even raw meat.

Our Lady's apparitions changed everything, as that which was a curse suddenly became a blessing, for Mary appeared as a Mestizo. So the present Mexico arose when she told Juan Diego that she was proud of being a compassionate

A CHICHIMECA man healed before the image of Our Lady of Guadalupe.

AN IMAGE AS AN AZTEC CODEX

To the Indians the image of Our Lady of Guadalupe was like an Aztec codex, in which various symbols and colors had specific meanings. It is worth mentioning the following elements:

1) MARY'S MASKLESS face signifies that she is human and not a goddess; her loose hair signfies that she is a virgin.

2) THE BLUE MANTLE symbolizes heaven, the abode of the supreme gods.

3) THE MANTLE'S COVERING the sky signifies that the Lady rules the stars, not vice versa.

4) MARY'S OBSCURING THE SUN signifies that she is more powerful than the sun itself, the greatest life-giving force on earth.

5) THE ARRANGEMENT OF THE STARS on Mary's mantle, clear to the Aztec priests, corresponds with their location on December 12, 1531, not as seen from the earth but from outer space.

6) THE PINK TUNIC, the color of the rising sun, is a sign of the renewal of life.

7) THE MOON, A FOOTSTOOL FOR MARY, signifies the dethronement of moon gods.

8) HANDS FOLDED in prayer honor someone more powerful than oneself.

9) THE BLUE MANTLE'S covering the flora on the dress shows heavenly care of the earth.

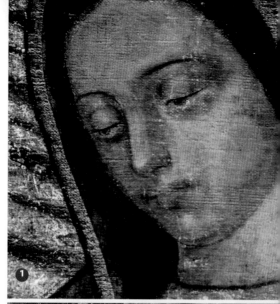

❶

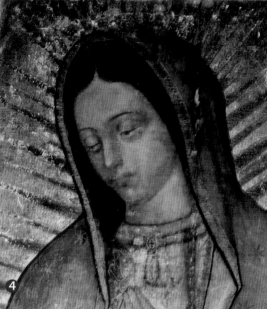

❹

❼

AN IMAGE AS AN AZTEC CODEX (CONT.)

10) **AN ANGEL** holding her clothing signifies Mary's humanity.

11) **A BENT KNEE** signifies a dance, a form of prayer, and of paying homage to the the gods.

12) **FLOWERS ROOTED** in the sky signifies that heaven is the source of life for people.

13) **A MAGNOLIA** symbolizes the human hearts that were offered to the gods.

14) **UNDER THE NECK**, a brooch (with cross) traditionally depicts, in the Aztec culture, an image of a god.

15) **AN ANGEL** waiting on Mary underlines her superiority over other beings.

16) **A BOW** was worn as a sign of pregnacy by Aztec women.

17-18) **A QUINCUNX FLOWER**, a symbol of perfection and transcendence, a symbol of the principle of order in the universe is situated on the womb of the pregnant Lady.

TO SUM UP, to the indigenous inhabitants of America, the image of Our Lady of Guadalupe was a clear message of intelligible symbols in the Aztec pictogram tradition. One could say that the image was a sort of codex to the Indians.

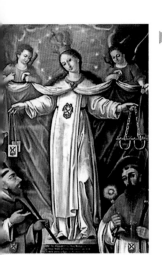

THE IMAGE of Our Lady of Mercy, National Museum of Catalan Art, Barcelona, has – in the opinion of culture experts – many elements in common with the image of Our Lady of Guadalupe.

Mother, both to him as well as to all the inhabitants of Mexico. She added that her motherhood extends to all those who love her, trust her, and call upon her name. That won the hearts of Indians.

The apparitions at Tepeyac became the most effective inculturation factor in the Church's history, that is, the translation of the Gospel into the language of a different culture. Fr. Joaquín Alliende-Luco, a contemporary Chilean thinker, wrote that inculturation was frequently a violent process. In the case of Mexico, however, it was completely different, as evangelization was rapid and peaceful. According to Fr. Alliende-Luco, the Franciscans' mission would not have ended successfully were they to have counted on themselves. The process that had begun in 1531 turned out to be a perfect example of inculturation, as Our Lady was its driving force.

Our Lady of Guadalupe was a turning point in the lives of Mexican Indians, who came to believe in Christianity thanks to the apparitions. She was also of great significance to the Spanish, particularly concerning their relationship with the natives. For when Europe was debating whether Indians were fully human, whether they could be saved at all, Our Lady chose an Indian as her envoy and proclaimed that she was the Mother of the Mexican people. That was a clear sign to the colonizers that they, together with the conquered tribes, were children of the same God.

That Marian message occasioned a colonization of Latin America – South and Central – that differed from that of North America, as evidenced by the way conquered populations were treated. Vittorio Messori, an Italian writer, noted that the Indians in North America are a small minority, while in the former Spanish and Portuguese America the majority of the population is Indian, Mestizo, and Mulatto. These facts speak of the two very different approaches to colonization.

North America was largely colonized by Anglo-Saxon Protestants, who saw the continent as the Promised Land and the Indians as Canaanites to be slaughtered. As a consequence there are now barely one and a half million registered "members" of Indian tribes (people with at least one-quarter of Indian blood) in the United States.

Jean Dumont, a French historian, states that had Spain and Portugal adopted Protestantism, Latin America might have seen an Indian genocide similar to the one that occurred in North America and Indian reservations might now exist in Latin America as they do in the United States.

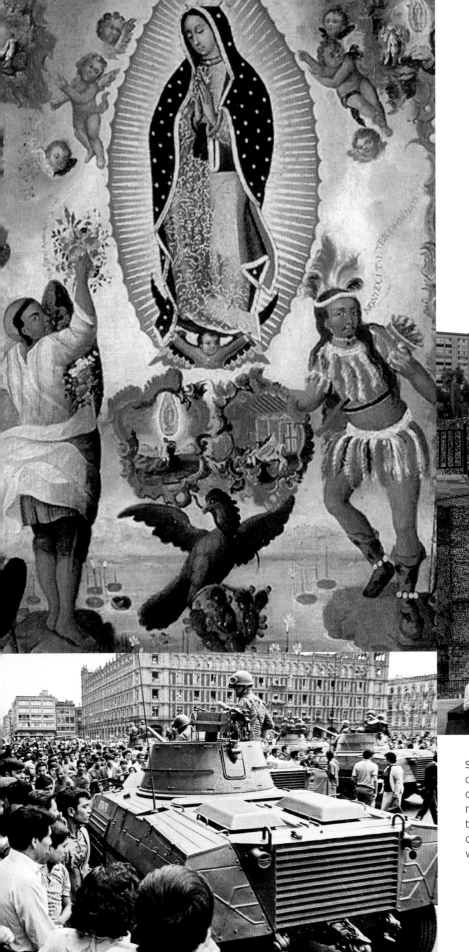

EUROPEANS AND Indians honoring Our Lady of Guadalupe.

SQUARE OF Three Cultures, Mexico City. Plaque with information on the birth of a new nation – Mexico.

STONE PLAQUE, Square of Three Cultures, commemorating the 1968 massacre of students by the Mexican Army. Several centuries earlier people were once sacrificed there.

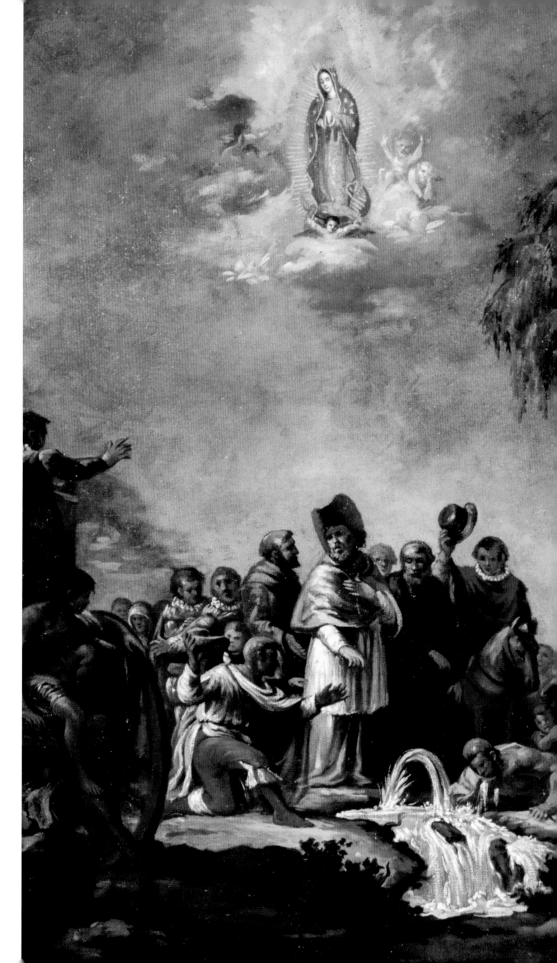

SPRING
at the site of
the apparitions
(Tepeyac Hill).

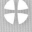

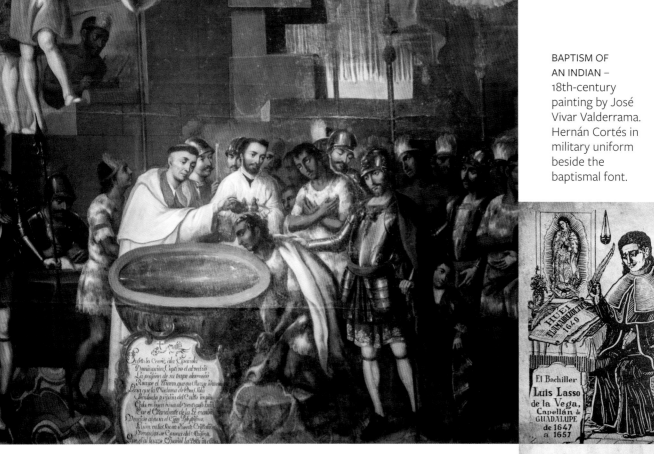

In Latin America, especially after the apparitions, Indians were not exterminated but evangelized, and marriages were contracted with them. Consequently, virtually 90 percent of the inhabitants of many South American countries, e.g., Brazil, Equador, Bolivia, and Peru, are Indians or Mestizos. There is a similar situation in Mexico, where a completely new society arose, one that created its own original culture from a synthesis of two cultures.

An example of the differences between the Iberian Catholics and the Anglo-Saxon Protestants is their attitudes towards the practice of scalping. When the Spanish conquered Mexico they strictly forbade scalping. They saw it as a sign of barbarism, totally unacceptable and utterly irreconcilable with Christianity. It was otherwise in North America, where scalping increased from the seventeenth century on, as white settlers offered large rewards for scalps of Indian men, women, and even children. Local authorities enacted such laws. In 1703, for example, the Massachusetts authorities paid twelve pounds for a scalp. So Indians were hunted.

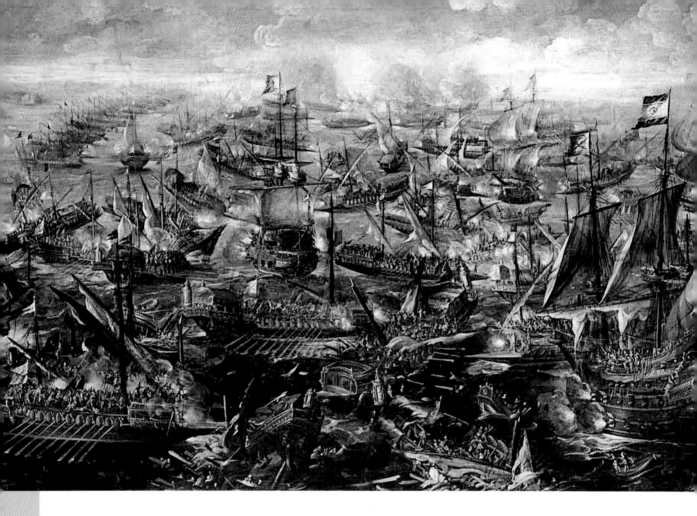

THE BATTLE OF LEPANTO was a frequent motif of battle scene art, particularly Venetian art at the turn of the 17th century.

ANTONIO DANTE'S fresco *Battle of Lepanto*.

THE BATTLE

THE CULT OF OUR LADY OF GUADALUPE began to spread to other continents as early as the 16th century. In 1570, the archbishop of Mexico, Alonso de Montúfar, commissioned a copy of the miraculous image, which he gave to the king of Spain, Philip II. The king in turn passed it on to Duke Giovanni Andrea Doria, one of the commanders of the Christian fleet that was to face a Turkish armada.

At that time the Ottoman Empire was at its zenith, and it intended to build the world's largest fleet to conquer countries in the Mediterranean Basin. The Muslims brashly spoke of capturing Rome and turning the Basilica of St. Peter into a stable.

On October 7, 1571, there was a naval battle at Lepanto in the Gulf of Corinth, in which over 200 ships were engaged. Pope Pius V called for the Rosary to

BATTLE OF LEPANTO – fresco in the vault of Colonna Palace, Rome.

DON JOHN OF AUSTRIA, commander of the Christian fleet, victor at Lepanto, kneeling before cardinals.

OF LEPANTO

be said for a Christian victory. The Holy League won the battle despite being outnumbered, and the pope established October 7 as the Feast of Our Lady of the Rosary to commemmorate the victory.

Admiral Giovanni Andrea Doria's crew attributed the victory to the intercession of Our Lady of Guadalupe, for at a critical moment, when the battle hung in the balance, the admiral went to his cabin and, on bended knee, begged for Mary's help before an image of her.

That image remained in the Doria family's possession until 1811, when it was given to the inhabitants of Aveto, Italy, where it is still to be found in the Church of St. Stephen. In 1815, Pope Pius VII elevated the church to a sanctuary. It has been one of the region's most popular pilgrimage centers for 200 years.

COPY OF the image of Our Lady of Guadalupe on Admiral Giovanni Andrea Doria's ship.

73

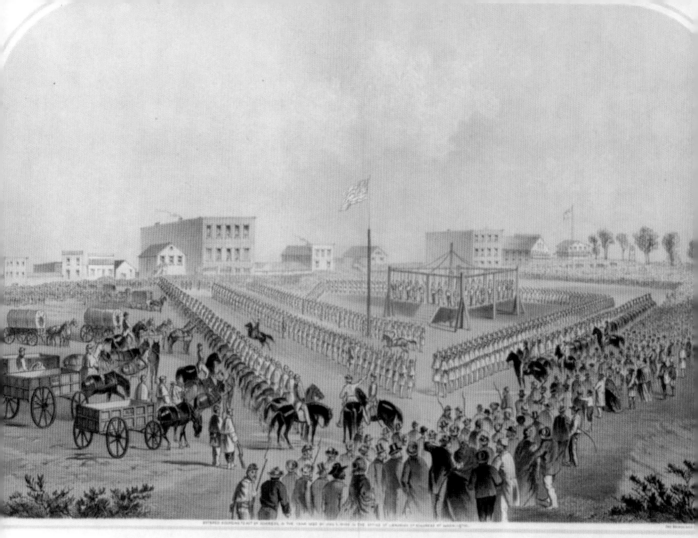

EXECUTION OF THE THIRTY-EIGHT SIOUX INDIANS

AT MANKATO, MINNESOTA, DECEMBER, 26, 1862.

EXECUTION OF
38 Sioux Indians
in Mankato,
Minnesota, 1862.

The colonization of Mexico might well have taken a similar path, because initially the conquistadors and the colonists openly ignored the orders of both Church and Crown to evangelize the natives. The turning point came after the apparitions at Tepeyac Hill. Historians agree that the first and most cruel period of the conquest, which will be further explored in subsequent chapters, lasted until the middle of the sixteenth century. It ended when the power of the conquistadors was curtailed by the authorities in Madrid, who extended control over conquered lands and introduced laws to protect the native populations. The year 1566 is symbolic in this process, for that is when the king of Spain foiled a plot by Cortés' son to overthrow the viceroy.

The Spanish, unlike the British, did not organize their overseas empire into colonies but provinces. Cortés' conquest was to be a New Spain, an

DEATH OF TECUMSEH, a Shawnee chief, at the Battle of Moraviantown in 1813.

NINETENTH-CENTURY INDIAN village in North America. The process of settling Indians in reservations began at that time.

extension of the mother country. No other place in the world has so many historic Baroque buildings. An original version of this architectural style, Churrigueresque, arose in Mexico. This would not have been possible were New Spain to have been seen simply as a place to be exploited. The country benefitted from the mining of gold and silver, and peace reigned when there were wars in Europe for almost the whole of the seventeenth century. Towards the end of that century, it is estimated that there were fifteen thousand horse-drawn carriages in the capital of Mexico, significantly more than in Madrid.

In North America, the English, and later the United States government, utterly careless of the rights of Indians, granted settlers land. The Spanish proceeded otherwise in South America; they established a feudal system, encomienda, where the Crown owned all the land and rented it to Spaniards.

PHOTOGRAPH OF INDIAN veterans of the 1812 war.

75

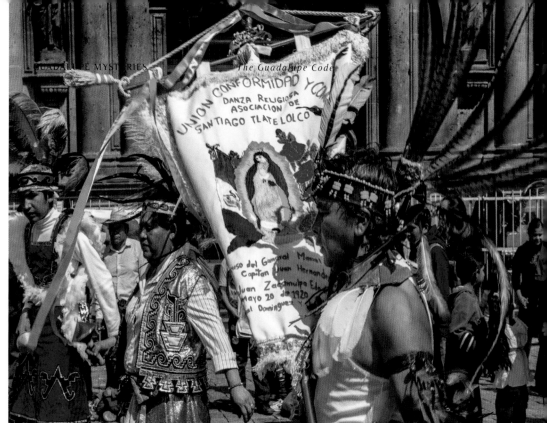

SOLEMN PROCESSION of Mexican Indians at the Basilica of Our Lady of Guadalupe.

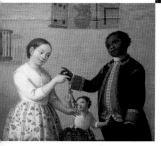

SPANISH-INDIAN COUPLE and their Mestizo child, a common sight in Mexico.

The natives were used as slave labor on these land grants, a practice many Church leaders, including Pope Paul III, tried to stop.

In 1596, the Council for Indian Affairs in Madrid, that is, the government institution that controlled Spain's overseas territories, asked the king to issue an order for an obligatory Hispanization of the whole of Latin America. Philip II wrote that he was against forcing Indians to give up their language; learning Spanish had to be of a voluntary nature.

Octavio Paz, a twentieth-century poet, wrote that Catholicism created a universal system, wherein all, both newcomers from Spain and their descendants, as well as the indigenous Indians, could find a place for themselves. Hence the Church was able to establish the whole Iberian religious system, with all its good and bad points, in Latin America.

Paz, however, appreciates the Church's great role in the history of his country. Were it not for the Church, he states, the fate of Indians would have been miserable. It was the Catholic religious who most sought to improve the lot of the local population and to organize their lives in a just way. That solicitude came from a sense of a brotherly community, which arose on the foundation of Baptism. Thus, Indians did not feel isolated in the universe after the fall of their religion. Their lives became ordered and meaningful. According

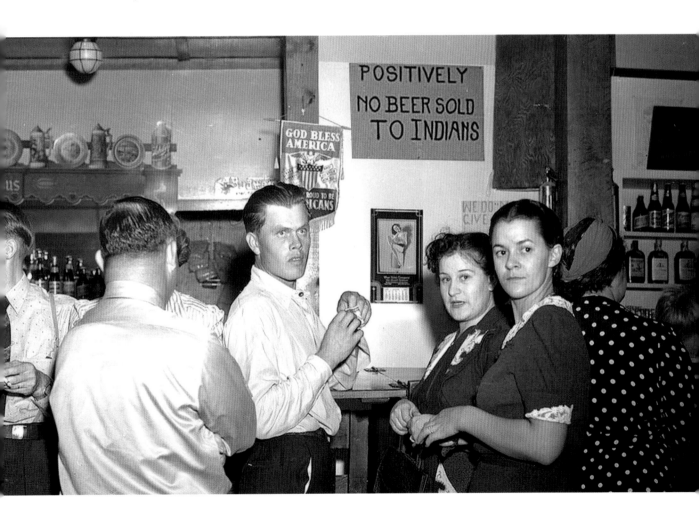

to the Mexican Noble Prize winner, Protestant colonists deprived the North American Indians of such a brotherly community.

Paz writes that the Mother of God is a mother to all orphans. This is particularly true of the Virgin of Guadalupe, who gives Mexicans a sense of security, arouses a sense of dignity, dries their eyes, brings peace, and calms emotion. She shows them her face and her heart, and thus allows them to discover their own identity – Mexican and children of God.

In time a difference of opinion arose as to the methods to be used to evangelize the natives. The first Mexican synod in 1555 initiated a new order in the religious sphere. The Church authorities acknowledged that after the initial period of spontaneous inculturation it was necessary to use proven European evangelization methods to a greater degree. That necessarily entailed the Hispanization of pastoral methods. The most evident

INDIAN RESERVATIONS, although they arose in the 19th century, still exist in the United States to this day.

RACIAL SEGREGATION was still in force in parts of the United States in the 20th century – for example, places where Indians were not served.

BAROQUE CATHEDRAL in Tepotzotlán.

ALTAR OF Our Lady of Guadalupe in Tepotzotlán Cathedral.

TILACO, a Franciscan mission (Landa de Matamoros region).

QUERETARO CATHEDRAL, a Baroque pearl.

sign of that was sacral art, which fulfilled an ancillary role in catechetics. Hence Juan Diego began to be depicted as a Castilian nobleman, with a typical Spanish beard.

One could say that two currents were present in the Church in New Spain throughout almost two hundred years: the first – to a greater degree of an Iberian kind – dominated the diocesan clerics; the second – valuing the Indian culture – prevailed in the Franciscan, Dominican, and Augustinian orders, but mainly in the Jesuit order. The Jesuits arrived in Mexico quite late, not until 1572. But they quickly established a network of thriving schools for the Indian youth. Their hub, in Tepotzotlán, was particularly renowned, the intellectual and spiritual formation center of the native elite.

In the seventeenth century, the Jesuits worked out an original form of evangelizing the natives in Latin America, establishing reductions in, for example, Paraguay, Bolivia, Equador, and Peru. These missions were modeled on the first Christian communities. They protected the Indians from slavery and from being exploited as serfs in the encomienda feudal system (this is related in *The Mission*, the award-winning film of 1986).

79

LEON CATHEDRAL,
Mexico.

In the middle of the eighteenth century, a whole generation of young Jesuits felt that New Spain was closer to them than Spain itself. They rejected European influences, valuing local traditions and cultures. They were of the opinion that the poor Indians lived the Christian ideals to a greater degree than the rich colonialists. Jesuits – e.g., Fr. Pedro José de Márquez, Fr. José Rafael Campoy, and Fr. Francisco Xavier Clavijero – were against a paternalistic attitude towards the Indians, seeing them as the equal of Europeans in everything.

At that time a conflict was escalating in Spain between the Jesuits and the ruling elite, which was under the influence of the Enlightenment. The latter gained the upper hand, and they persuaded the king to drive the Jesuits off property that belonged to the Spanish Crown. Hence in 1767 Charles III issued a decree ordering the immediate expulsion of the Jesuits. He wrote, as befitted a representative of Enlightenment absolutism, that he was the sole ruler of Spanish lands, whereas his subjects were born solely to be silent and obedient, and had no right to comment on matters of great national importance.

So the reductions in South America ceased to exist, never to revive, and the Jesuits were also suppressed in New Spain. On the night of June 24, 1767, soldiers entered all the Jesuit residences in New Spain and arrested 628 Jesuits. They were transported to Veracruz, a port, in such disgraceful and arduous conditions that 150 died. The rest were shipped to Europe and dumped on the shore of the Papal States. The reaction of the inhabitants of New Spain to those events was characteristic. The white Creole population was indifferent to the anti-Jesuit campaign, frequently succumbing to government propaganda against them. But the Indians, Blacks, and Mestizos rebelled because they saw the Jesuits as their benefactors. Demonstrations in defense of the Jesuits were organized in many cities. Here and there the demonstrations turned into armed riots, and there were even attempts at rescuing the prisoners. The authorities brutally put down the riots. Over one hundred were condemned to death, and over seven hundred imprisoned.

It was not long before the consequences of the expulsion of the Jesuits from Mexico became evident. As Jan Gać, a contemporary Polish historian writes:

> That which quickly became evident was the collapse of higher education. The school system completely collapsed. All the Jesuit colleges

FR. BACHILLERO Miguel Sánchez' 1648 publication on the image of Our Lady of Guadalupe.

80

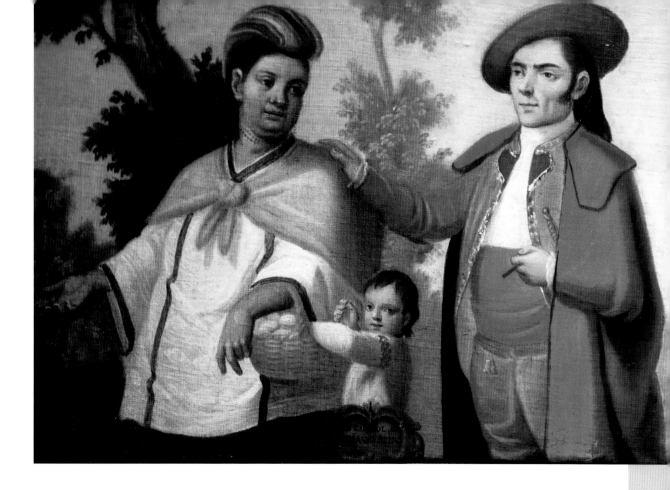

OCTAVIO PAZ ON NEW SPAIN

ONE OF THE MOST POSITIVE ASSESSMENTS of Mexico's colonial period was the work of a person who was at odds with the Church and the Catholic religion. Octavio Paz, a Nobel Prize winner in literature, was a man far from Christianity. However, in his best-known book, *The Labyrinth of Solitude*, he wrote that thanks to its universal character the Catholic religion became a religion for all, particularly for the poor, the handicapped, and the disinherited. Hence New Spanish society was able to create an order that was acceptable to the majority of its inhabitants, newcomers and natives alike. Though social and class inequality existed, there was no drastic tension among the various classes thanks to the common religion

Paz noted that no one felt lonely in Mexico, not even the poorest, for one lived immersed in a Christian world that ensured a community of faith with one's neighbor and familiarity with the deceased. Hence life and death took on a new meaning, full of hope, bereft of Aztec fatalism. Unlike pre-Columbian beliefs, the Christian order saw all as equal before God, and sought the communion of all the faithful.

In Paz's opinion, Spanish colonialism in Mexico degenerated because of the crisis of Catholicism in Europe. On the Old Continent Christendom became secularized, and religion was gradually eased out of public life. Faith in God ceased to inspire people to great things. New trends also reached America. Liberalism dawned, and Mexicans were plunged into solitude yet again.

MESTIZO CHILDREN were the fruit of Spanish-Indian marriages.

JESUIT in 18th-century clerical attire.

FORMER JESUIT mission buildings, a reduction, Santa Cruz, Bolivia.

82

✛

A 1598 Jesuit book issued in Naples.

were closed, and the students dispersed. There were no professors or teachers to take over the work of the Jesuits, so the youth was not educated for two generations. That educational void brought alarming consequences. There was no native intelligentsia in America in the first half of the nineteenth century, when independence movements where arising. The older generation of the intellectual elite, educated and raised by the Jesuits, was already dying out. The new generation was plunged in ignorance, and that included the native clergy.[3]

Throughout the whole of the Spanish reign all the inhabitants – the Creoles, Indians, and Mestizos – sensed that Mary was solicitous about their country. This was particularly evident at times of misfortune and of

cataclysms, like the smallpox epidemic of April 1736 in the Tacuba region, which spread to other areas. Chronicles show that forty thousand died in Mexico City alone. The inhabitants turned to the Madonna of Tepeyac for help. On April 27, 1737, Archbishop Juan Antonio de Vizarrón y Eguiarreta, who was also the viceroy of New Spain, officially proclaimed Our Lady of Guadalupe patron of Mexico City, and promised that he would also proclaim her patron of the whole country. That same day the epidemic began to subside. On December 4, 1746, Mary was proclaimed patron of the Viceroyalty of New Spain, which included, for example, Guatemala and the Philippines. How different was the patronage of Mary from that of the gods of the Aztecs three hundred years ago.

THE MISSION (film poster), directed by Roland Joffé, 1986.

KING OF SPAIN Charles III expelled the Jesuits from Mexico in 1767.

83

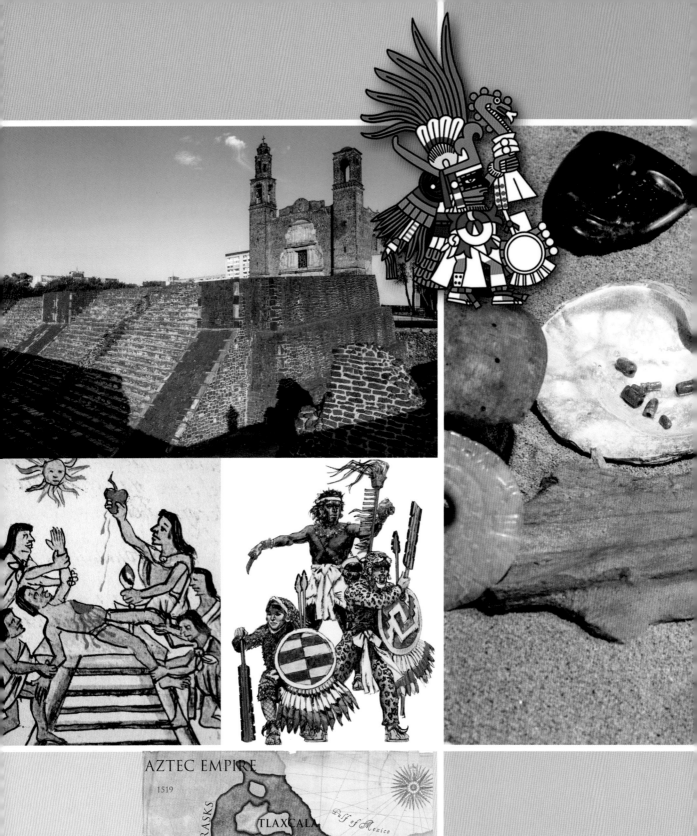

1519

TARASKS

TLAXCALA

Gulf of Mexico

TEOTITLAN route to Xoconochco

MIXTECOS

ZAPOTECS

AZTEC
STATE

TRIBUTARY
STATES

ALLIED
STATES

Pacific Ocean

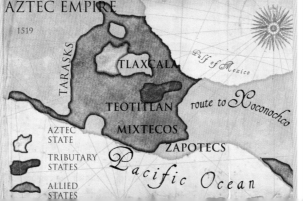

A Blood-Soaked Empire

A Blood-Soaked Empire

MAP OF
THE AZTEC
EMPIRE in its
heyday at the
beginning
of the 16th
century.

The most important temple in Tenochtitlán was consecrated in 1487. The celebrations were the most macabre in Aztec history, with human blood flowing for four days – from morning until night.

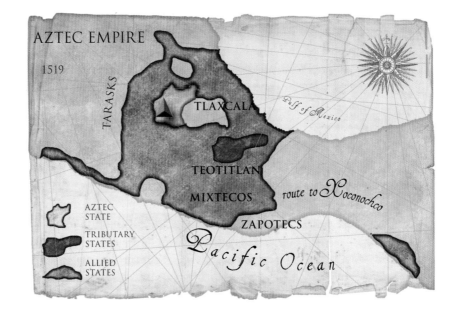

MAP OF THE AZTEC EMPIRE in its heyday at the beginning of the 16th century.

OBSIDIAN KNIVES used by priests to tear out human hearts.

FEEDING THE sun, i.e., human sacrifices.

OBSIDIAN KNIVES and a skull from an Aztec tomb.

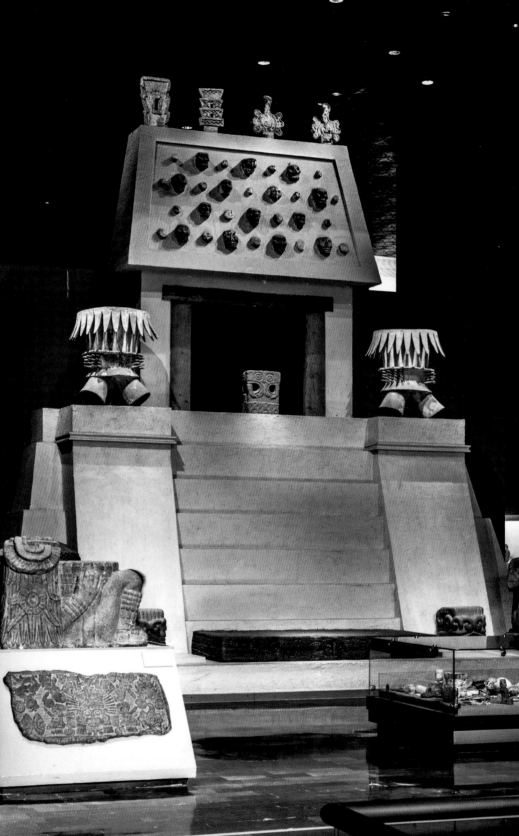

A MODEL of the Aztec Templo Mayor in the National Museum of Anthropology in Mexico City.

SPLIT SKULL of an Aztec victim.

Oc noce diablo oquijmoteutitiaque,
rqueque. vnitoca nappatceutli: quil
bre blanco.

From 1483 the Aztecs fought wars just to capture as many prisoners as possible to sacrifice to their gods. Historians are not in agreement as to how many were killed during the inauguration of the Templo Mayor: twenty-one thousand, sixty-four thousand, seventy-two thousand, or eighty-four thousand. But what is certain is the way they were murdered. The victim was taken to the top of the pyramid-like temple. Four priests, in dark attire and painted black, seized the victim by the arms and legs and laid him on a sacrificial stone. A fifth priest split open the living victim's chest with an obsidian knife and tore out the heart with his hands. Then he sprinkled the altar with blood, threw the heart into a large stone bowl, and pushed the body down the temple steps.

Francisco Javier Clavijero, a Mexican chronicler, wrote that Ahuitzotl, the Aztec ruler, invited all the kings and nobles of allied countries to the consecration of the temple. It was the largest gathering that Tenochtitlán had ever seen. News of the extraordinary event attracted people from far and wide. The proceedings lasted for four days, during which prisoners captured over the ▶

OLD CODICES testify to Aztec religious rites, for example, their human sacrifices.

MACABRE MASKS made of human skulls, usually found in Aztec tombs.

89

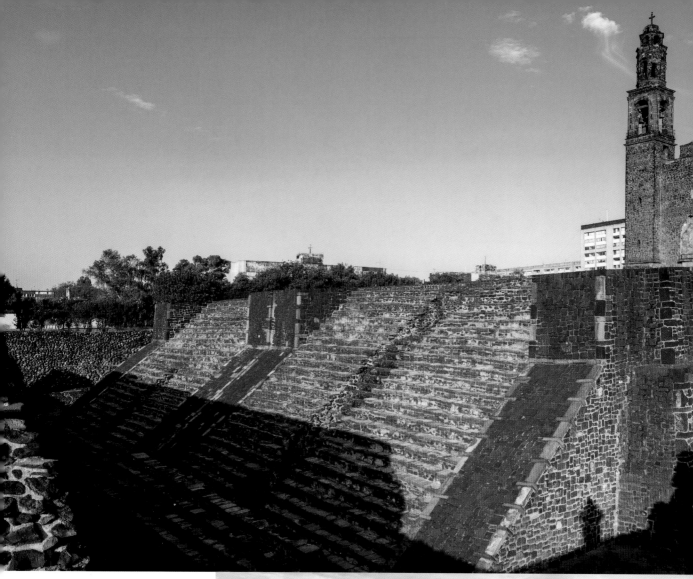

REMAINS OF THE MAIN Aztec temple in Tlatelolco. In the background, the 16th-century Church of St. James (Santiago), built of the stones of the demolished Indian temple (above).

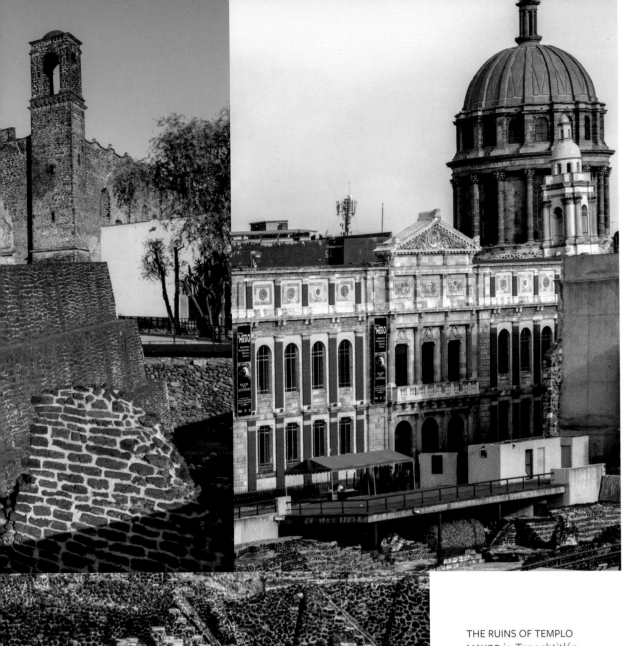

THE RUINS OF TEMPLO MAYOR in Tenochtitlán, the most important Aztec sacral building, where the largest ritual slaughter in Aztec history occurred in 1487. Today it is the site of America's largest and oldest cathedral, the seat of the archbishop of Mexico (above and far left).

91

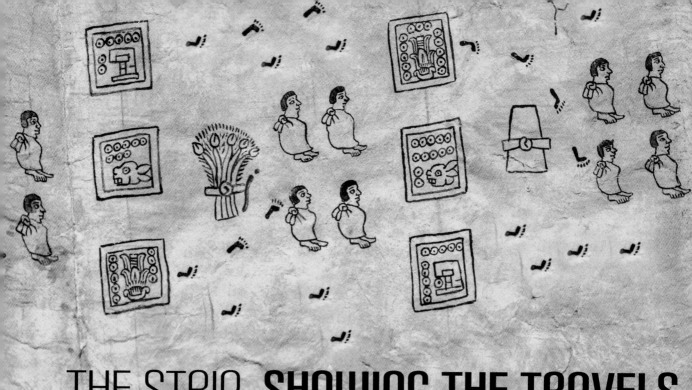

THE STRIP SHOWING THE TRAVELS

THE AZTEC MIGRATION to their promised land in the Valley of Mexico is described in an illustrated work *The Strip Showing the Travels*, also called the *Boturini Codex*. It probably arose between 1521 and 1540, as the third page shows a tree with European features. It is of one long sheet of fig bark, which is 18 feet long and accordion-folded into 22 panels.

The codex tells of the Aztec migration from Aztlán to Tenochtitlán under the leadership of the god Huitzilopochtli, who was symbolized by black footprints. Four "teomamoque" (god bearers, or priests) led the way. The first was Tezcacoatl (Serpent King), who carried a bundle on his back with a little figure of Huitzilopochtli. Two men followed him: Cuaucoatl (Snake Woman) and Apanecatl (Water Headdress), as well as a woman, Chimalma (Shield-Hand). All carried parcels that contained ritual objects.

The codex is named after an Italian aristocrat, Lorenzo Boturini Benaduci (1702–1755), the founder of Mexican ethnography, the first to collect pre-Columbian manuscripts. Benaduci arrived in Mexico in 1735 to collect documents about the image of Our Lady of Guadalupe. He traveled around the country recording testimonies on miracles at the intercession of Our Lady, but at the same time he started to collect old Indian documents. He collected over 300 in all. Some of them are now in museums in Mexico, Paris, London, and Berlin. The most famous is the *Boturini Codex*.

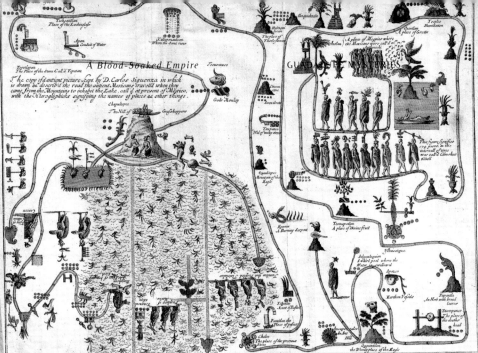

GIOVANNI FRANCESCO GEMELI'S 1704 map showing the mythological Aztec migration.

preceding four years were sacrificed on the top of the temple, which was in the form of a pyramid.

There is no doubt that the occasion was also a demonstration of the Aztec Empire's strength. The rulers of neighboring countries were to be terrified by the hecatomb, so as not ever to dare to oppose the will of the hegemonic leader, to undermine his unique, mystical role in world history.

At that time the Aztecs saw themselves as the chosen nation. Their history, in certain respects, recalls that of the people of Israel, for an Indian tribe, at the instructions of their god Huitzilopochtli, set out in search of a promised land. They set off from the legendary Aztlán (Place of Herons) and arrived in the Valley of Mexico.

According to ancient Aztec sources, Huitzilopochtli promised members of a tribe that he would make them great rulers and kings. They were to have countless vassals who would pay them high tributes. The god assured the Indians that he would keep his word, and that they would soon become convinced of what he had said. His vow was his mission, he said, the reason he had been sent to them.

According to scholars, the Aztecs probably originally inhabited what is now the Mexican–American borderland, though some think they originated in what is now New Mexico. However, we know that they passed through the present provinces of Jalisco, Guanajuato, and Michoacán.

HUITZILOPOCHTLI, the god who ordered the Aztecs to migrate to their promised land. Illustration from an Indian codex.

93

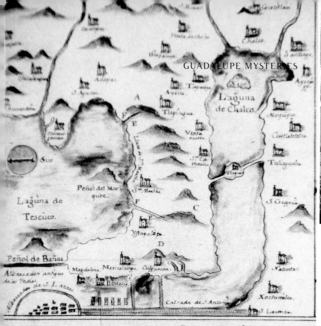

CROSS SECTION showing the construction of the floating islands: **1)** crops, **2)** canal, **3)** wicker fence, **4)** willows, **5)** silt, **6)** stilts.

FIVE LAKES map showing the lay of the land of Mexico City in the 16th century.

LAND **OF FIVE LAKES**

TODAY'S CAPITAL OF MEXICO, Mexico City, lies on terrain where several centuries ago there were five interconnected lakes: Zumpango, Xaltocan, Texcoco, Xochimilco, and Chalco, which covered 2,000 square miles. In the middle of the 15th century, the Aztecs built an impressive system of dams and causeways. They also created an archipelago of floating islands on which vegetables were cultivated.

The islands were called "chinampas" (floating gardens), and were built thus: rafts were made and covered with water plants, reeds, and layers of silt from the bottom of the lake, and then fruit and vegetables were planted. In order that the soil might stay fertile, fresh layers of silt were added every year. Hence the rafts became heavier, and they eventually settled on the lake bed, creating islands. In time they became connected and formed larger tracts of land.

Unfortunately, in 1382, 1439, and 1500, floods devastated Tenochtitlán and other cities on the shores of the lakes and on their islands. But the greatest flood in the region was in the 17th century (1629 – 1635), shortly after the Spanish conquest; there were about 30,000 victims. Hence the Spanish authorities decided to drain the lakes. It took four centuries and almost completely changed the hydrological map of the region.

Today a network of canals gives some notion of the former character of Lake Xochimilco, as there is still an area of floating islands with vegetable crops. This region, popularized by the historical film *María Candelaria*, is presently one of the biggest tourist attractions in Mexico City.

FLOATING GARDENS (chinampas) in today's Mexico City.

PICTOGRAM SYMBOLIZING three places: Tepeyac, Tenochtitlán, and Tláhuac.

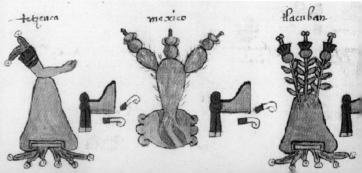

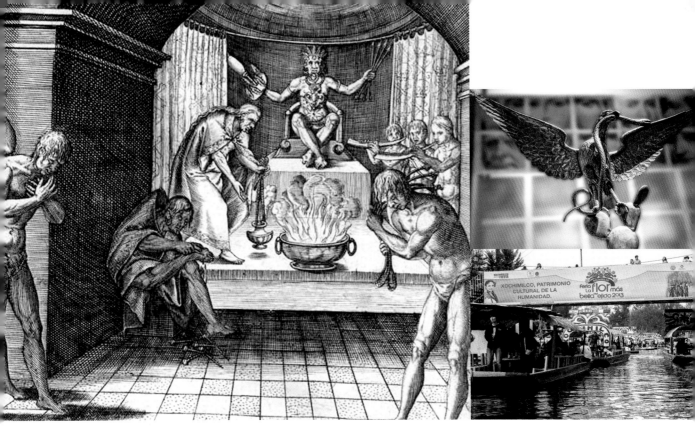

The migration south took a long time. According to historians it began in 1111 or 1116 and ended in 1325 or 1345. En route, the Aztecs settled in various places for a certain time, but more often than not they came into conflict with neighboring tribes and were forced to flee. Every fifty-two years they had long stops to light a new sacred fire. Fifty-two years, important in their religious life, was an Aztec century, when the solar calendar and the sacral calendar, based on tribal beliefs, returned to the same positions relative to each other.

The Aztecs' disputes with other peoples were usually due to their cruelty and ruthlessness. Their conflict with the Culhuacán tribe is an example. Its chief, Coxcoxtli, allowed the Aztecs to settle on its land. It was then that the first known sacrifices of people occurred. Francisco Javier Clavijero, a chronicler, relates that the Aztecs built an altar in honor of their tutelary god, Huitzilopochtli, and began a ritual dance, which included four Indians that had been captured in Xochimilco. They eventually laid the prisoners on a round stone, split open their chests with a knife, and tore out their hearts.

The Aztecs did not appreciate the Culhuacáns' hospitality. When Achitometl, Coxcoxtli's successor, became chief, the Aztecs insidiously lured his beloved daughter to them, and killed and skinned her. They then invited her father to come and worship their god. When Achitometl began to incense the supposed god, he saw that the god was an Aztec priest with his daughter's

SACRIFICES
to the god
Huitzilopochtli as
Europeans saw it
(1602 print).

XOCHIMILCO,
the floating
gardens district
in today's Mexico
City.

GOLDEN
EAGLE
perched
on a prickly
pear cactus
devouring
a snake –
Mexico's coat
of arms.

95

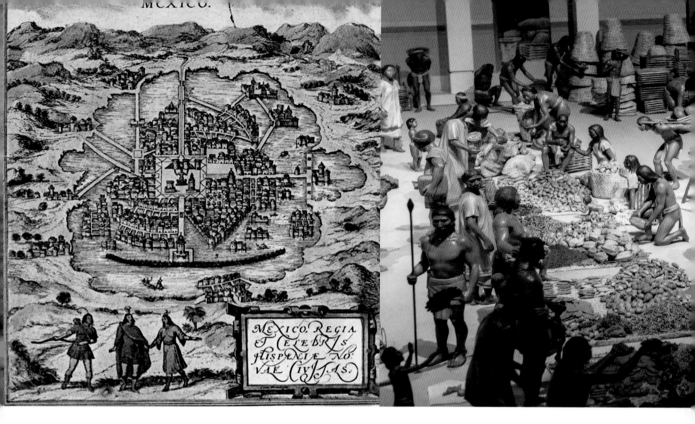

HERNÁN CORTÉS' map of Tenochtitlán – first published in Nuremberg, Germany (1524).

SCALE MODEL of Tenochtitlán's main market square in the National Museum of Anthropology in Mexico City.

skin pulled over his body. The chief fell into a rage, and a war began. The Aztecs had to flee further south.

Fernando Alvarado Tezozómoc, another chronicler, wrote that the Aztecs murdered the Culhuacán princess at the instigation of their god Huitzilopochtli. One should not, of course, take this literally, i.e., that the god addressed them directly. It was rather the priests who, in a state of altered consciousness, communicated the will of the spirit world to the tribe.

In time, the Aztecs, following Huitzilopochtli's instructions, settled on one of the small islands in Lake Texcoco, where they founded their first capital – Tenochtitlán. It was named in honor of their chief at that time, Tenoch. The island was not chosen at random. According to the oldest accounts they saw an eagle sitting on a prickly pear cactus, tearing a snake apart; that image is now Mexico's national emblem.

Over the years Tenochtitlán began to encompass other islands that were strewn all over Lake Texcoco, and which were connected to the mainland by numerous causeways. Its name was eventually changed to Mexico, in honor of Huitzilopochtli, who was also called Mexitli. The Indians established two more cities on the lakeshore: Texcoco and Tlacopán, which, together with Tenochtitlán, formed a political triple alliance.

Today they are the names of three districts in the Mexican capital. These districts are no longer the interconnected lakes of several centuries ago, as the Spaniards drained Lake Texcoco and the neighboring marshlands. Only Xochimilco's floating gardens recall the former character of the area.

96

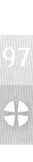

AXAYACATL, AZTEC king – Montezuma II's father.

AN INDIAN farmer at work.

CHACMOOL – a pre-Columbian stone altar showing a semi-recumbent figure. Archeologists think that the figure's stomach was used for offering human hearts.

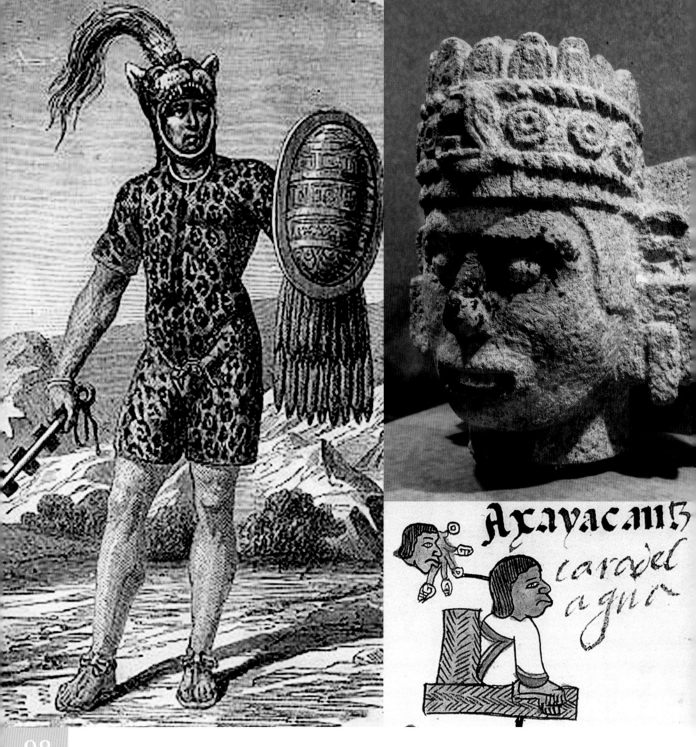

ITZCOATL, AN Aztec chief, wearing a jaguar skin.

STATUE OF Tlaloc, god of farmers and rain.

KING AXAYACATL in Aztec documents: the *Codex Telleriano-Remensis*.

At first, the three allied cities – Tenochtitlán, Texcoco and Tlacopan – were the vassals of the Tepanec tribe, the most powerful in the Valley of Mexico, with Azcapotzalco as its capital. However, in 1427 those allies decided to rid themselves of this dependence. They provoked a war, which they won a year later. Thus began the Aztec Empire, with Itzcoatl, a brave chief at its head, though Tlacaelel, his adviser, played a significantly more important role in the state.

Tlacaelel was the new power's chief legislator and ideologist. He advised three successive rulers: Itzcoatl, Montezuma I (his stepbrother), and Axayacatl. He himself had the title of "Cihuacoatl", high priest, second only to the king in the state hierarchy.

After winning the war in 1428, Tlacaelel took an unprecedented step. He ordered all historical codexes to be burned, those of the victorious Aztecs as well as those of the conquered Tepanecs. Codices were important in pre-Columbian Indian culture. They were pictographic records of a people's history, its religious beliefs, magic rituals, and astronomy observations; the most important facts pertaining to a given community, accumulated and passed down to future generations. But from that point on, history was to

AZTEC GOLD ornaments – National Museum of Anthropology, Mexico City.

STATUETTE of the god Tlaloc – a good harvest depended on him.

99

JAGUAR ALTAR
– a predator
the Aztecs held
in high regard;
only the eagle
was more
revered.

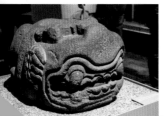

**STONE OF
MONTEZUMA I**
– sculpture with
a dominant solar
motif, showing
a sun disk.

100

**SCULPTURE
OF A JAGUAR**
– Aztec
warriors
prayed to these
predators to
give them their
strength in
battle.

be written anew – at Tlacaelel's bidding. Henceforth, the binding version of history did not correspond to the truth, but was at the service of the political interests of the empire.

The new vision of history attributed the prolongation of the world's existence to the Aztecs. They had been chosen for the role by the mightiest of gods – Huitzilopochtli, the sun god and god of war. He demanded human sacrifices in order for the sun to rise daily. Were the life-giving drink of human blood to run out, the world would cease to exist.

The period from 1450 to 1454 was a turning point in the history of the Aztec state; Mexico saw a prolonged drought, and Central America suffered a famine. According to the priests, the natural disaster was the consequence of insufficient human sacrifices, as the earth and the sun had not been adequately supplied with blood. So a war was provoked in order to obtain prisoners to be human sacrifices. In 1455, during an important ceremony, many prisoners were ritually murdered. Shortly after, rain began to fall, and

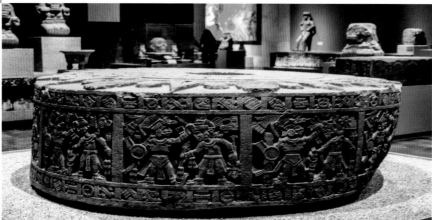

there was an abundant harvest for the first time in several years. This confirmed the Aztecs in their conviction that their fortunes depended on the number of people sacrificed on their stone altars. A new tradition arose – flower wars – solely for the purpose of capturing prisoners to be human sacrifices to the gods.

In the fifteenth century, the Aztecs took control of virtually all the land that is now Mexico and Guatemala. They conquered, for example, the Tobasco, Totonac, Mixtec, and Zapotec tribes. They oppressed them, exacted high taxes, and mercilessly suppressed every protest. The enslaved Indians were afraid of the Aztecs, as the slightest sign of rebellion ended in whole generations of young people being taken captive and offered as bloody sacrifices.

▶

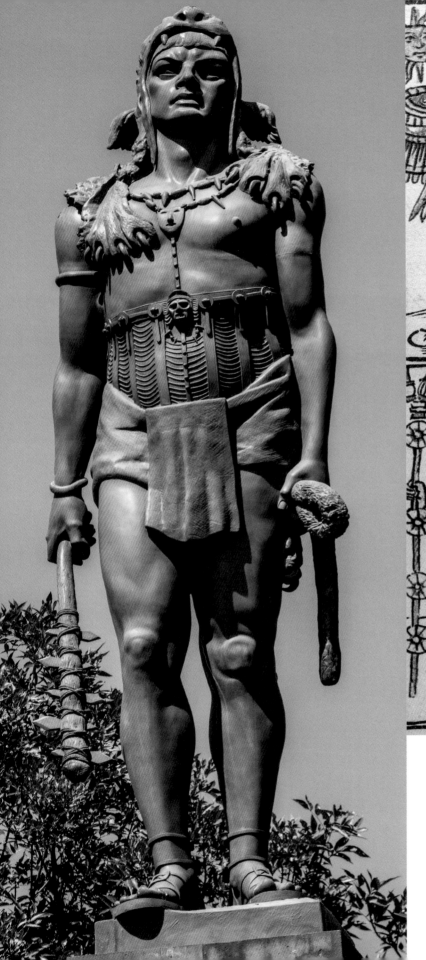

101

STATUE OF AN AZTEC
warrior – Chapultepec Park,
Mexico City.

INDIAN RITUAL ceremonies in
old chronicles.

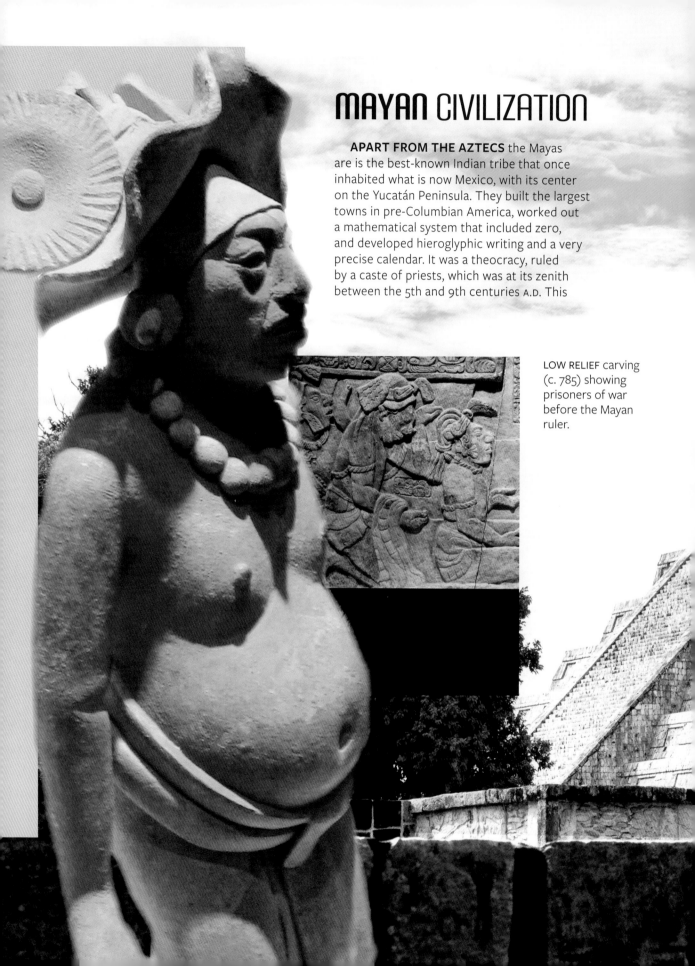

MAYAN CIVILIZATION

APART FROM THE AZTECS the Mayas are is the best-known Indian tribe that once inhabited what is now Mexico, with its center on the Yucatán Peninsula. They built the largest towns in pre-Columbian America, worked out a mathematical system that included zero, and developed hieroglyphic writing and a very precise calendar. It was a theocracy, ruled by a caste of priests, which was at its zenith between the 5th and 9th centuries A.D. This

LOW RELIEF carving (c. 785) showing prisoners of war before the Mayan ruler.

superpower began to decline from the 13th century, plunged in destructive civil wars.

The Mayas sacrificed people to their gods, but their cult did not require as many ritual murders as did the Aztec cult, though they were of a similar nature: victims had their hearts torn out, their bodies eaten, their skins donned by priests who then performed ritual dances. Sometimes the victims were censed with narcotic fumes, and then thrown down into sacred wells.

The Mayas were conquered in 1541 by the Spanish conquistador Francisco de Montejo, who managed to defeat them with just 400 men. The last stronghold, at Tayasal, located on an island in Lake Petén Itzá in Guatemala, did not fall until 1697.

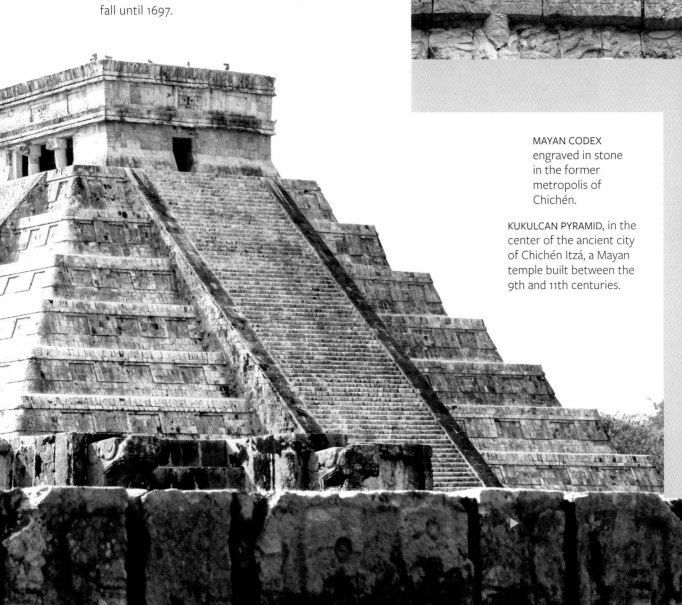

MAYAN CODEX engraved in stone in the former metropolis of Chichén.

KUKULCAN PYRAMID, in the center of the ancient city of Chichén Itzá, a Mayan temple built between the 9th and 11th centuries.

AZTEC WARRIORS
ready for battle.

CLAY STATUE
of a priest of
the god of
death from the
Templo Mayor,
Tenochtitlán.

▶ The Aztecs were cannibals. As everything in their lives had a sacral dimension,
consumption of human flesh took on a religious character. It also reflected social divi-
sions. The ruler had the right to consume the heart of the bravest prisoner; the priests,
the hearts and the heads of other victims; the warriors could consume the bodies that
had been pushed down the temple steps after ritual slaughters, bodies they took home
and served up at sumptuous feasts. Only the lowest class had no right to cannibalism.

As victims were continually needed for sacrifices, the warrior caste began to
play a greater and greater role in Aztec society. There arose a whole network of
"telpochcalli" (schools for warriors), whose patron was Huitzilopochtli. Novices
were inculcated with the idea that not only the fate of the state depended on their
courage and ruthlessness, but also that of the whole world.

The teaching in such schools was a kind of initiation, during which pupils were
subjected to successive, ever more brutal ordeals. The result of such an education was
to be the transformation of the "old man" into a "new creation". A warrior was to be

HEADSTONES WITH JAGUAR images – most probably those of warriors of the Jaguar Order.

WARRIOR'S HEAD – helmet of the Eagle Order.

transformed into a bloody beast on the field of battle. Two organizations in particular made up the Aztec military elite – the Jaguar Order and the Eagle Order. Their members, who wore jaguar skins or eagle feathers, were to recall those wild animals during battle. Such a transformation, such bestiality, required one to go through a special ritual under the direction of priests, during which psychedelic mushrooms were used to cause mind-altering effects. Ordeals were to evoke unearthly anger and animal-like rage. The "new man" (man-jaguar or man-eagle) believed that his superhuman strength was from the spirit world. Ignacio Bernal, a contemporary Spanish historian, wrote that, to the Aztecs, there were but two occupations that were worthy of a person of noble descent; the army or the priesthood. The emperor himself stood at the summit of the military and the religious pyramids. So it is not surprising that the Aztec state was built upon theocratic militarism. Bernal notes that in such a system a soldier was the arm, or even the head, of the community, while the priest was its soul. A soldier was obliged to wage war, but in exchange

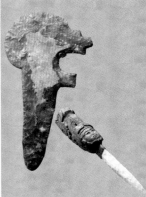

RITUAL KNIVES – used for human sacrifices.

105

COILED RATTLESNAKE, a symbol of the god of the earth and the forces of nature.

A SKULL- SHAPED vase symbolizing the god Mictlantecuhtli – ruler of Mictlan, that is, the last of the 9 levels of the underworld.

COMMON GRAVE of ritual victims killed at the Temple of the Feathered Serpent.

he counted on sharing in the spoils of war or possessing prisoners as slave labor. Warriors were extremely cruel, yet the Aztec culture promoted them as models.

The aristocratic warrior class was the mainstay of the empire, but it had to yield to the priestly caste. Priests were more important than warriors for they, as the earthly envoys of the gods, carried out the initiations of the soldiers and were their spiritual directors. It was an influential class, wealthy, and increasingly numerous – about five thousand priests, at various levels of initiation, lived in the temple in Tenochtitlán alone.

The majority of the people were poor. Peasants, often landless, craftsmen, and slaves lived in the proximity of a few wealthy men. The poverty was so great that some families sold their children for ritual slaughter in order to survive.

The Aztecs were polytheists. They believed in the existence of countless gods, of which Huitzilopochtli came to the fore – the sun god, the god of war, and simultaneously their guardian. According to Aztec mythology, he, immediately after being born, chopped off the heads of his brothers and the head of one sister. In 1519, a Spanish chronicler, Bernal Díaz del Castillo, found 136,000 human skulls in the largest temple dedicated to Huitzilopochtli (in Tenochtitlán). There were other gods that also demanded sacrifices. As many feast days were celebrated in their honor, human blood often flowed.

There were other cults, for example, the one pertaining to a god called Xipe Totec, the patron of human sacrifices. On his feast day, priests would skin live young people and then don their skins for twenty days, dancing and singing joyfully. An Aztec king would don the skin from the hands and the legs of a youth. This ritual symbolized the renewal of nature.

The celebration in honor of the god of farmers, Tlaloc, looked somewhat different. Drowned children were sacrificed to him, but before being drowned they were made to cry as much as possible, as it was believed that the more they dampened the

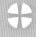

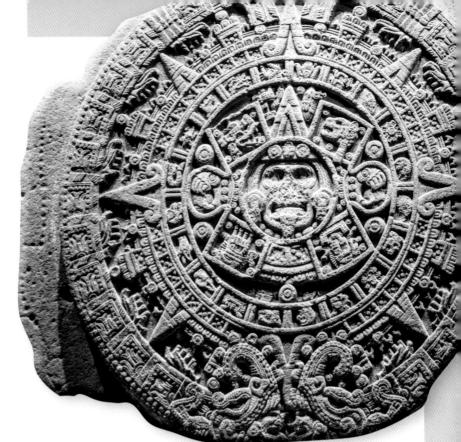

SUN STONE

THE NATIONAL ANTHROPOLOGY MUSEUM in Mexico City houses the Sun Stone, an enormous block of rock with a sculptured Aztec calendar on it. The block, in the shape of a cylinder, 11.75 ft. in diameter and 3.22 ft. thick, weighs 24 tons. This stone calendar was sculptured in Tenochtitlán during the reign of King Axayacatl and dedicated in 1479.

The dedication ceremony required many human sacrifices. Hence on the advice of Tlacaelel, the high priest and the king's chief adviser, it was decided to attack the Tarascan tribe in order to capture prisoners. The Tarascans inhabitated western Mexico, for example, today's states of Guanajuato, Querétaro, Guerrero, Colima, and Jalisco, and never succumbed to the Aztecs.

Axayacatl's expedition failed because the Tarascans defeated the invaders. As the dedication of the Sun Stone ceremony approached, the Aztecs decided to fight certain friendly tribes and came to an agreement with their own allies, that every warrior captured was to be sacrificed. The Aztecs took 700 prisoners, their allies 420, all of whom had their hearts torn out at the dedication ceremony before the stone calendar.

INDIAN CODICES and Spanish chronicles prove not only that the Aztecs offered human sacrifices, but that they were also cannibals.

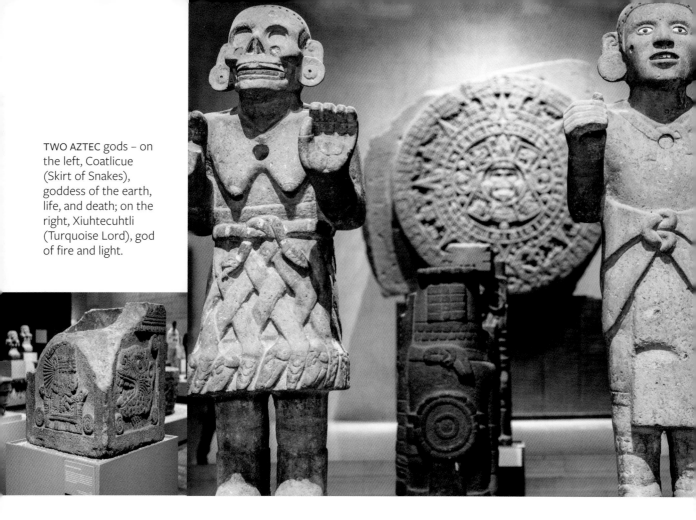

TWO AZTEC gods – on the left, Coatlicue (Skirt of Snakes), goddess of the earth, life, and death; on the right, Xiuhtecuhtli (Turquoise Lord), god of fire and light.

LOW RELIEF with Aztec figure on one side and jaguar on the other.

earth with their tears, the richer the harvest would be. Hence the children's finger nails were pulled out while they were alive – the louder the cries, the greater the joy of the people.

Xiuhtecuhtli was the god of fire. Large fires were lit on his feast day, into which naked, bound prisoners were thrown. But they were not allowed to die. They were pulled out with iron hooks, put on people's shoulders, and ritually danced around the fire. Just before the end of the ceremony they were butchered on an altar.

As a matter of fact, every Aztec god demanded appeasement in the form of human sacrifices. Depending on the feast day, the old, the young, women, children, and even infants were murdered. The killing methods varied too, not only tearing out hearts, skinning, or drowning, but also beheading and starvation.

The Aztecs worshipped their gods according to two different calendars – a solar one and a sacral one. Every fifty-two years, the first day of each of these calendars converged, beginning a new Aztec "century". At the turn of each century, the Aztecs believed, the world would end if they did not properly appease their gods. So the closer the solar calendar and the sacral calendar were to returning to the same positions

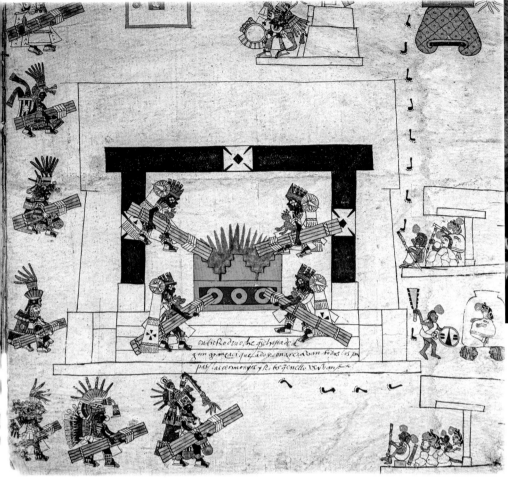

QUETZALCÓATL (Feathered Serpent) – one of the most important gods of Aztec mythology, the cocreator of the world.

CEREMONY OF LIGHTING a sacred fire at the end of a 52-year cycle and the beginning of a new one. The ceremony, during which people were sacrificed, was to appease the gods and to ensure the continued existence of the universe.

relative to each other, the more the Aztecs quaked with fear at the thought of a cosmic cataclysm.

In addition, the Aztecs also believed that at the beginning of some future century, a god would return from exile in the east. He would arrive from across the ocean, bringing retribution upon those who had forced him to flee and founding a new order.

The year 1519 was the start of a new Aztec century. It was also the year a band of Spanish adventurers landed on Aztec territory. Historians speculate whether the Aztec religion helped a few hundred conquistadors to conquer a superpower of ten million people in barely two years.

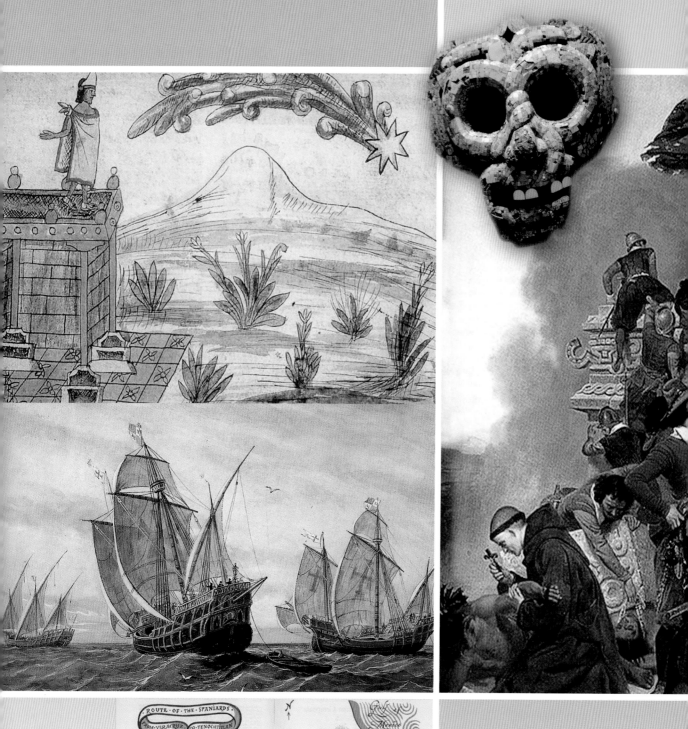

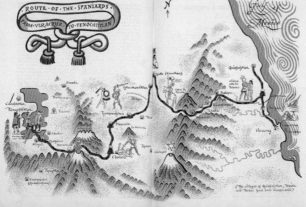

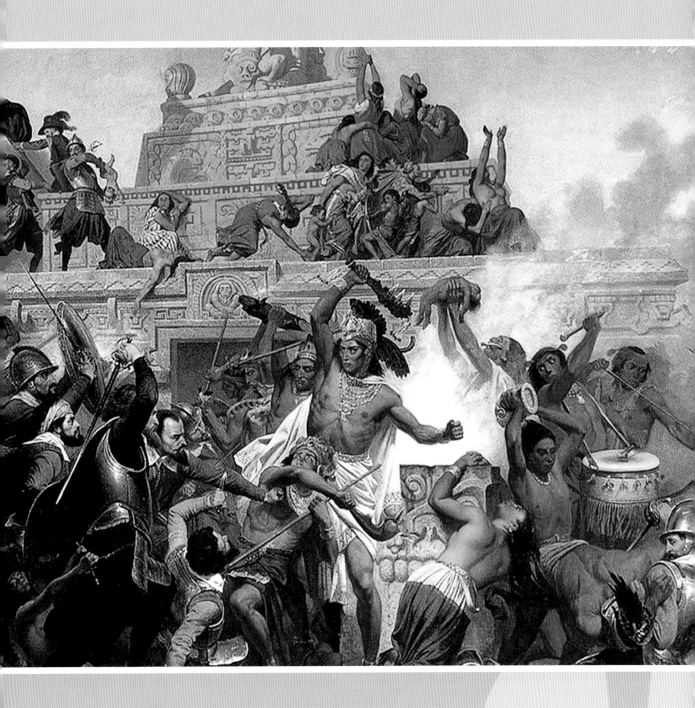

Twilight of the Gods

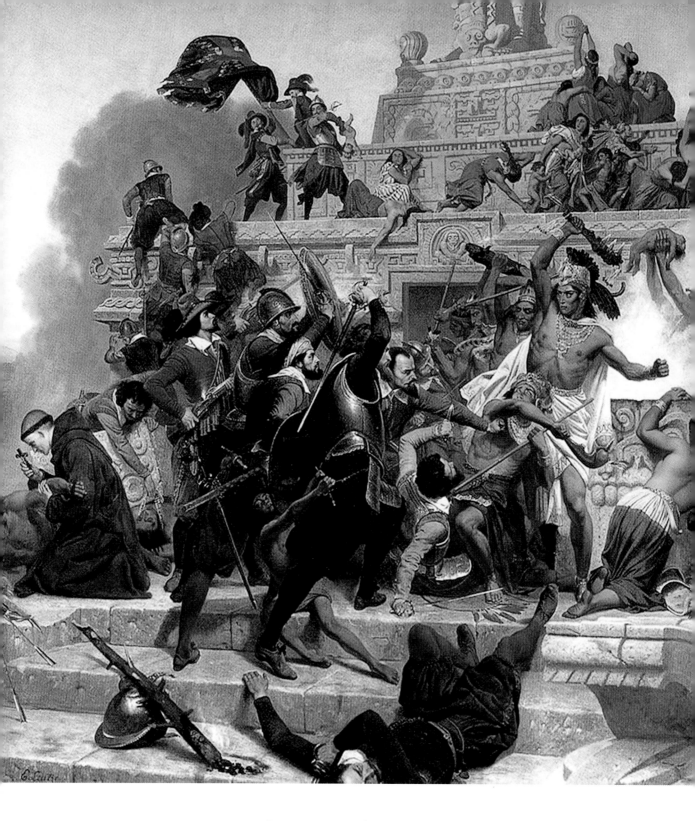

THE CONQUEST of Mexico was one of the most brilliant military campaigns in world history.

Twilight of the Gods

Two young men, a Spaniard and a Mexican, approached the huge statue of Huitzilopochtli on the top of the temple in Tenochtitlán: the commander of the conquistadors, Hernán Cortés, and the ruler of the city of Texcoco, Ixtlilxochitl. The former pulled the gold mask from the statue's face, the latter cut off the idol's head.

Tenochtitlán was captured on August 13, 1521. The Aztec state, seemingly invincible just three years earlier, ceased to exist. No Indian had ever entertained such a thought when, in February 1519, Hernán Cortés' expedition landed on the Yucatán Peninsula near the mouth of the Rio de Tabasco. The expedition consisted of eleven ships and about one hundred sailors, together with five hundred soldiers, eleven horses, fourteen canons, and two hundred Indian porters. Apart from that, the infantry had thirty-two crossbows and thirteen arquebuses (long-barreled guns), as well as bows, spears, and rapiers.

This small unit, which would have been quickly routed by any European

KING
IXTLILXOCHITL II,
Indian leader,
ruler of Texcoco.

113

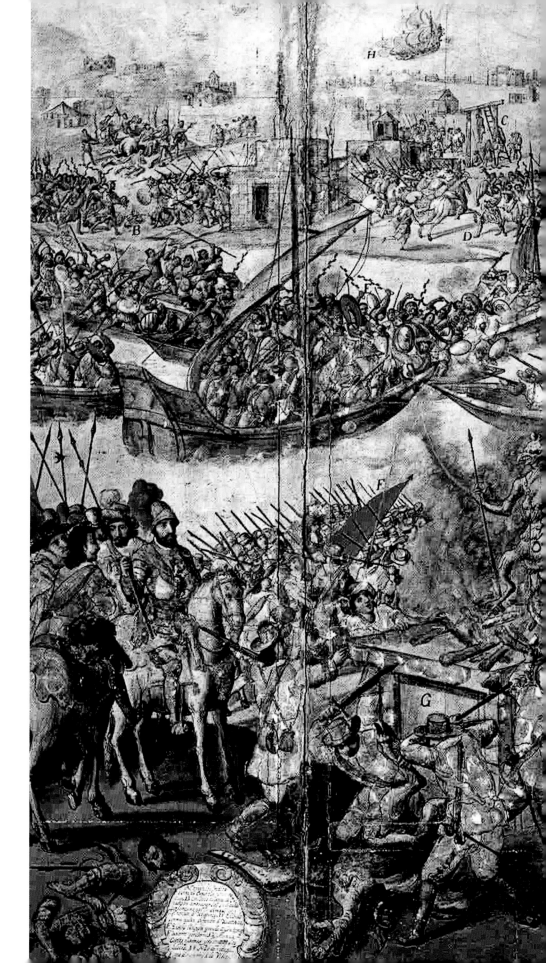

THE BATTLE
TENOCHTITLÁN
– May 26 to
August 13, 1521,
when Cortés
captured the
Aztec capital.

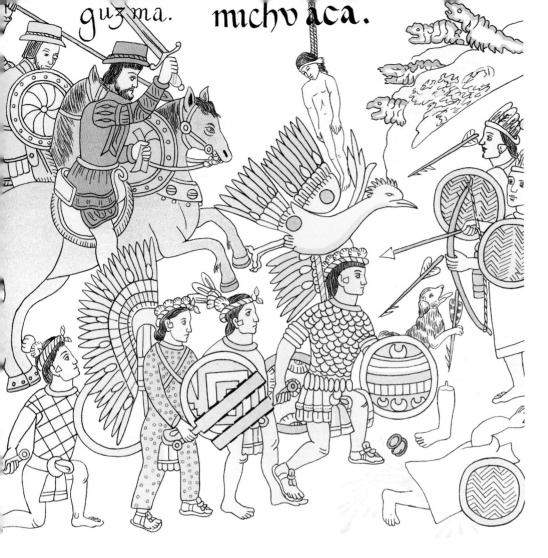

guʒma. michvaca.

BATTLE OF MICHOACÁN. Nuño Beltrán de Guzmán led the conquistadors.

army, made a historically incomparable conquest; it defeated the most powerful Indian empire of ten million in a very short time.

Historians are still in disagreement as to how it was possible, mentioning many factors that might have facilitated the Spanish conquest of the Aztec Empire. Though the Indians outnumbered the invaders, the Europeans were taller, stronger, and more durable. They also had a longer arm reach, which was important in hand-to-hand combat when using melee weapons.

The conquistadors also had better weapons. Indian weapons were characteristic of the Stone Age: spears, bows, slings, and short, wooden swords, studded with sharp pieces of obsidian. The Spaniards used firearms, canons, and arquebuses, which caused panic in the Indian ranks as they were unfamiliar with gunpowder and thought only gods could throw fire from a distance.

The indigenous inhabitants of America were also not familiar with horses and dogs. Hence white men on horses and trained fighting dogs made a great

115

impression on them, for the control of such animals also seemed to them to be more divine than human.

The conquistadors were also more determined, even desperate to succeed, as Cortés had given orders to pull the ships onto the shore in order to prevent his own men from retreating. Hence all they could do was to push forward.

The Spaniards were also superior in their battle tactics. The Aztecs did not fight wars to kill, but to capture people in order to offer them as sacrifices to their gods. Aztec battle tactics were geared to this end, whereas the conquistadors eliminated men from battle by inflicting heavy wounds or by killing them. This gave the Europeans the advantage on the battlefield.

The Spaniards also superbly took advantage of the animosity that prevailed amongst the Indian tribes. They quite quickly realized that the Aztecs were hated by their neighbors because of their aggression, tax extortion, and human sacrifices. So they quickly gained the favors of the peoples brutalized by the bloody rulers of Tenochtitlán. Hence the oppressed tribes went over to

HERNÁN CORTÉS,
a nobleman from
Estremadura,
conqueror of the New
World.

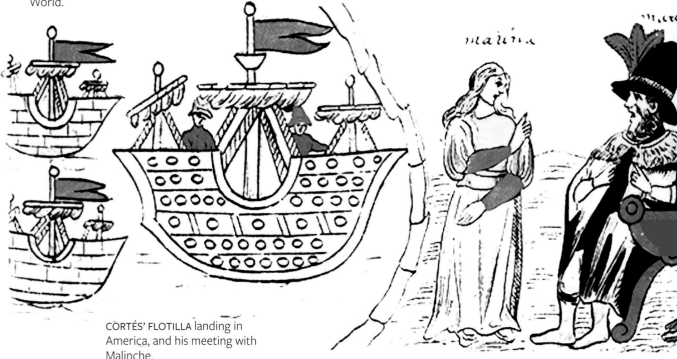

CORTÉS' FLOTILLA landing in
America, and his meeting with
Malinche.

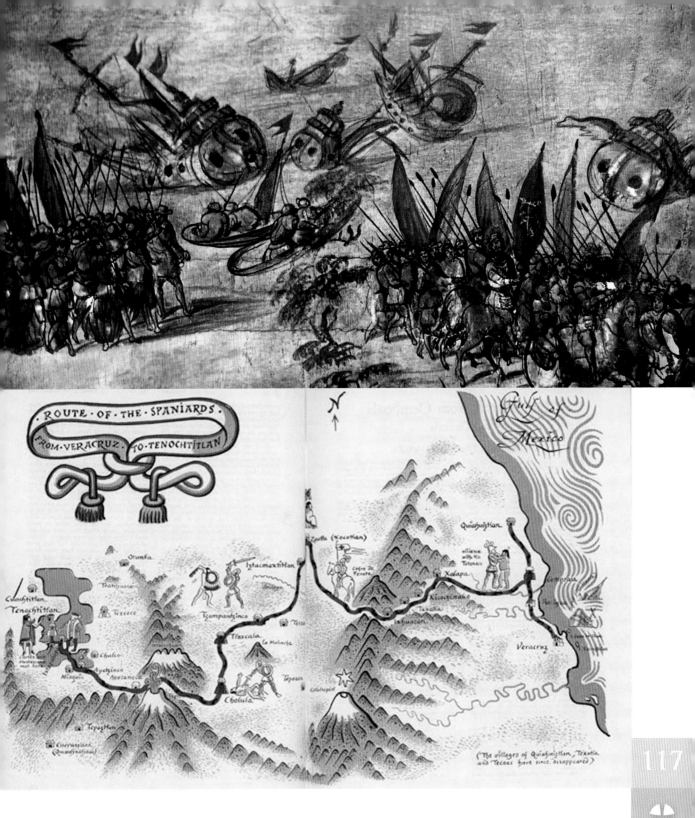

117

CORTÉS' IMMOBILIZATION of the Spanish ships on the Mexican coast prevented his men from retreating.

CORTÉS' COMBAT trail – Veracruz to Tenochtitlán.

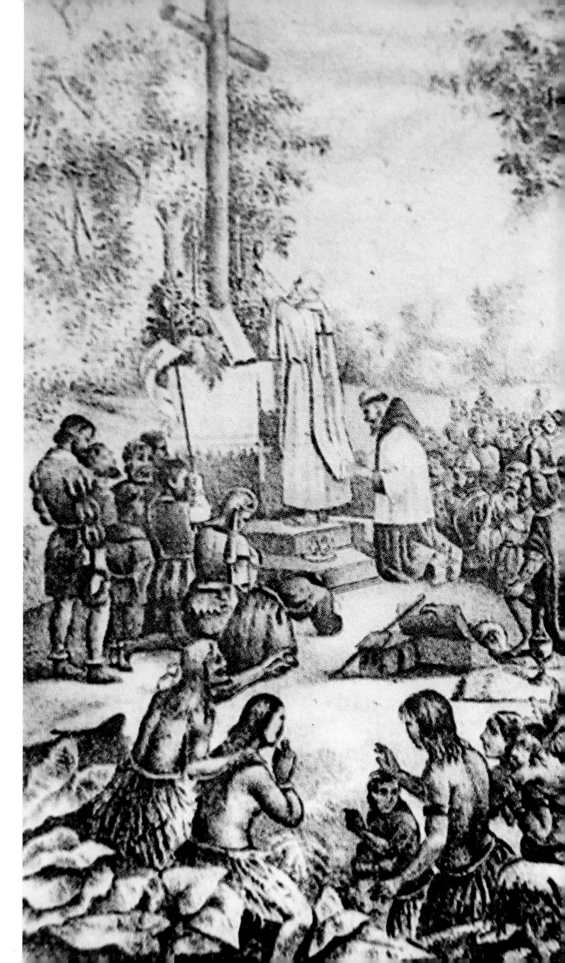

THE FIRST MASS in New Spain was celebrated by Franciscan priests in Potonchán.

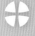

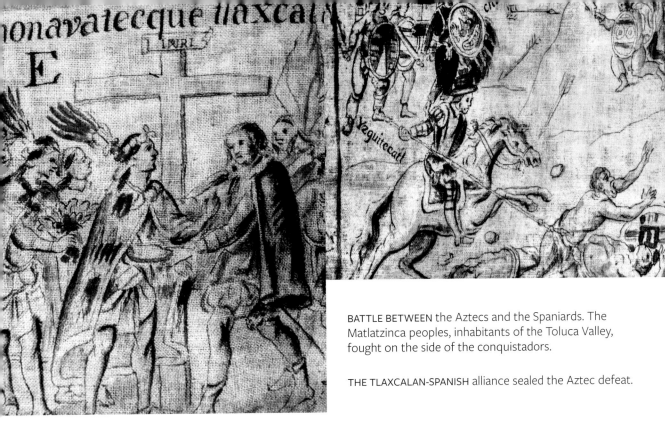

BATTLE BETWEEN the Aztecs and the Spaniards. The Matlatzinca peoples, inhabitants of the Toluca Valley, fought on the side of the conquistadors.

THE TLAXCALAN-SPANISH alliance sealed the Aztec defeat.

Cortés' side. It turned out that the Tlaxcalans were his most important allies, for it was in the Spaniards that they saw their sole hope of casting off their terrible yoke. The Spaniards would not have conquered the Aztec Empire without their help.

The differences between particular tribes were greater than is usually thought. A twentieth-century American expert on pre-Columbian cultures, historian Samuel Eliot Morison, noted that Indians from the same region, or the same language group, did not even have names in common. Only members of one's tribe were seen as one's people, whereas other tribes were described in offensive terms. Hence Morison claims that the idea of human equality was totally foreign to them.

Hernán Cortés' personal traits were not without significance as to the success of the expedition. Cortés, the son of an impoverished Spanish noble from Extremadura, was an adventurer attracted by voyages and danger. In 1504, barely nineteen years of age, he left Europe and landed in Hispaniola (now Haiti and Dominican Republic). Seven years later he participated in the conquest of Cuba by Diego de Velázquez. In 1519, he organized an expedition, his own private undertaking, which brought him great fame. Were it not for Cortés' character and abilities, Mexico would not have been conquered in such a short time.

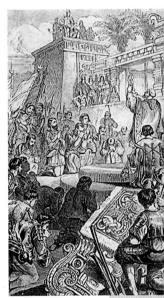

119

FIRST MASS celebrated by Franciscan priests in the captured capital of the Aztec Empire.

Guadalupe

SPAIN

MAIN ALTAR in Guadalupe – one of Spain's most important Marian shrines.

SIGN on the road from Extremadura to Guadalupe.

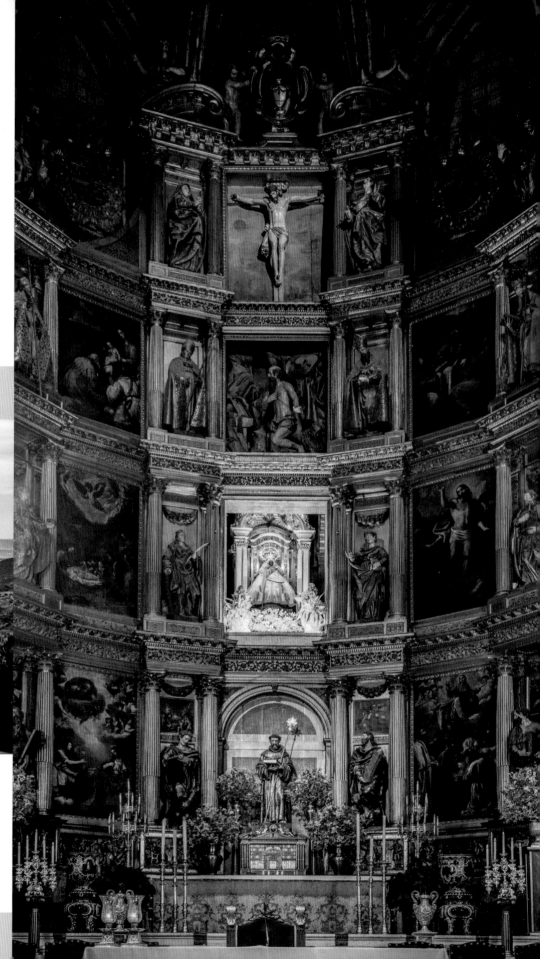

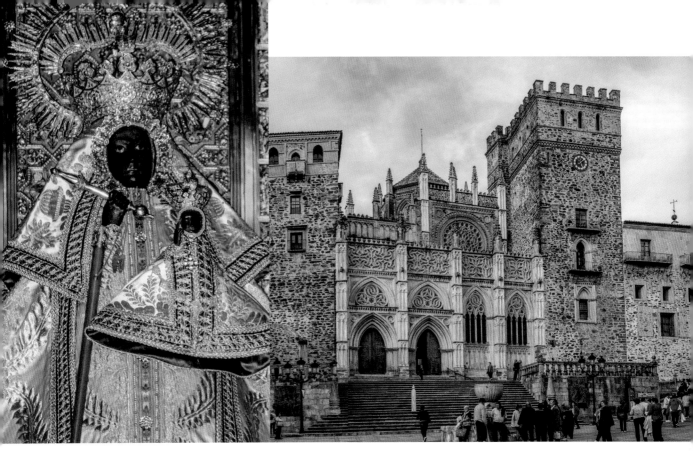

SHRINE IN **EXTREMADURA**

THE MONASTERY of Our Lady of Guadalupe is in the Spanish province of Extremadura. A wooden statuette of Mary, which has been venerated there for centuries, was – according to an old Christian oral tradition – sculpted by St. Luke the Evangelist. According to tradition, at the turn of the 6th century, Pope Gregory the Great gave the statuette to the bishop of Seville, St. Leander.

When the Iberian Penisula was invaded by Muslim Moors, the statuette was buried in a box for 6 centuries and not unearthed until the middle of the 13th century, when the Arabs were driven out of Extremadura. Later, a Hieronymite monastery and a Marian shrine, called Guadalupe, were built on the site. The name comes from a nearby river, which in Arabic means "River of Light". This place is now one of Spain's pilgrimage centers, which was once visited by King Ferdinand, Queen Isabella, Christopher Columbus, and Hernán Cortés.

The cedar statuette of Mary is just over 2 ft. high. It is usually adorned with gowns, so that one can see only Our Lady's hands and face, as well as Jesus on her knee.

STATUETTE OF Our Lady of Guadalupe, sometimes called the Black Madonna as the cedar wood of which it is made has darkened.

THE MONASTERY in Guadalupe – under the care of the Hieronymites from 1389 to 1835, and the Franciscans from 1908.

121

CORTÉS with his Indian concubine – Malinche.

▶ First, he was an outstanding military commander, gifted with an uncommon sense of strategy, recklessly brave and daring on the field of battle. Hence he won many battles that seemed all but lost.

Second, he was an exceptionally shrewd diplomat, capable of gaining the favor of Indian chiefs. Cortés was not a sadist who abused power, for he knew he would not achieve much through terror, although he was capable of being cruel and ruthless as a last resort. He preferred more refined methods to command respect. It is characteristic that the three biggest massacres perpetrated against the Indians during the Spanish conquest of America do not incriminate Cortés directly, but his allies. Two of the massacres – the first in Choluli, the second in Tenochtitlán – were perpetrated against the Aztecs by

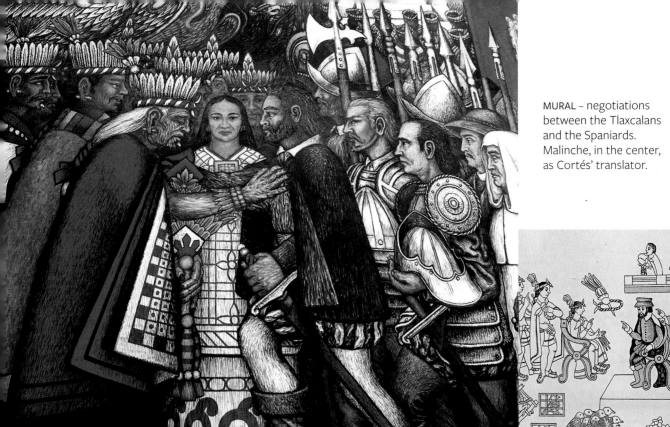

the Tlaxcalans, who broke rank with the Spanish command in order to take revenge on their old enemy. The third massacre, on May 20, 1520, at the Great Temple (Templo Mayor) in the Aztec capital, when Cortés was not in the city, was on the conscience of another conquistador, Pedro de Alvarado.

Third, Cortés had a lot of personal charm, thanks to which he made devoted friends. His close relationship with an Indian woman, Malinche, was of particular significance in the conquest of the Aztec Empire. This extraordinarily beautiful and intelligent woman was not only Cortés' lover, but also his faithful and devoted companion. She was his translator and chief adviser, who helped him to become familiar with the intricacies of Aztec society. Without her services – in the opinion of contemporary historians – the conquest of Mexico would not have been as rapid and as efficient as it was. According to conquistador Rodriguez de Ocaña, Cortés said that he owed his success first to God and then to Malinche.

It seems, however, that the deciding factor in the Spanish triumph lay in the spiritual, ideological, and psychological spheres. At the beginning of the sixteenth century, the conviction that the end of the world was nigh was spreading among the Aztecs. It referred to an ancient myth about

MASK of the god Quetzalcóatl – the Aztecs awaited his return from across the ocean.

MONTEZUMA II sees a prophetic sign in the bird's eye.

AZTEC KING observing a comet that appeared in the sky in broad daylight.

PART OF the temple of Quetzalcóatl in Teotihuacan.

the return of the legendary Quetzalcóatl (Feathered Serpent) to Mexico. This white, bearded god was to have come long ago on a winged steed from the land of the rising sun to establish a state for the Indians, confer law, and teach trades. But later he was driven away. Before setting off east on a raft, he prophesized that he would return at the beginning of a new century. Then he would restore his reign, and a time of great suffering would ensue.

According to the Aztec calendar, a new century began every fifty-two years. The Aztecs awaited the return of Quetzalcóatl in 1363, 1415, and 1467. The god, however, did not appear. The next century began in 1519, and the priests were convinced that the awaited demigod would arrive then because a series of mysterious events occurred. These were seen as harbingers of Quetzalcóatl's return and have passed into history as the eight signs that heralded the fall of Montezuma: the first was a comet in the middle of the day; the second, a column of fire in the night sky; the third, a fire in the temple of Xiuhtecuhtli; the fourth, lightening that struck the temple of Huitzilopochtli, though there was a clear sky at the time; the fifth, a great flood in Tenochtitlán; the sixth, a vision of multi-headed strangers in the Aztec capital; the seventh, the laments of women; the eighth, priests that had caught a strange bird, in the eyes of which Montezuma saw bearded men landing on a seashore.

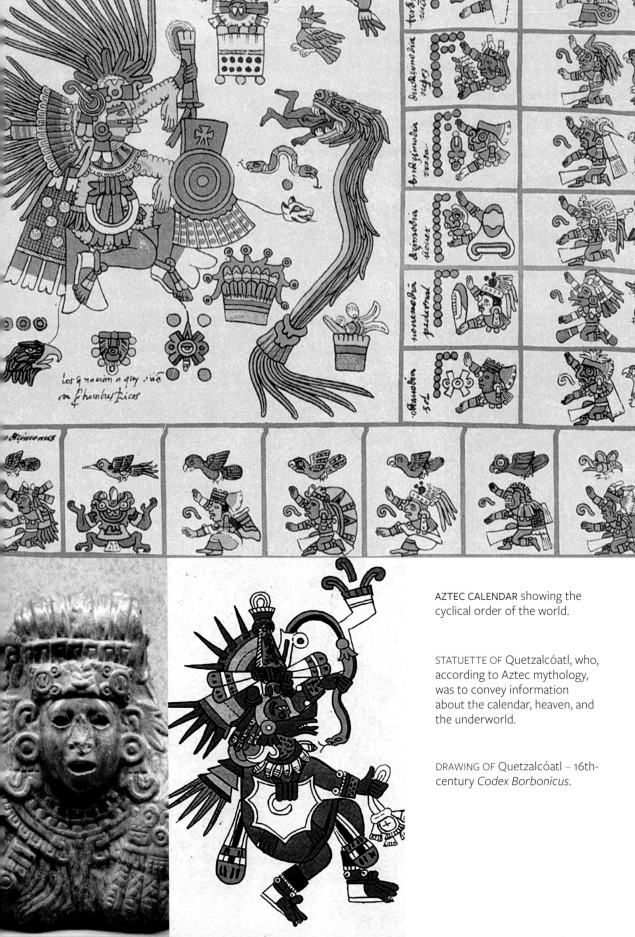

AZTEC CALENDAR showing the cyclical order of the world.

STATUETTE OF Quetzalcóatl, who, according to Aztec mythology, was to convey information about the calendar, heaven, and the underworld.

DRAWING OF Quetzalcóatl – 16th-century *Codex Borbonicus*.

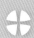

TENOCHTITLÁN

IN 1521 THE AZTEC capital numbered 80,000 inhabitants, and it was one of the largest capitals in the world. In Europe, only Paris, Naples, Venice, and Milan were populated by over 100,000, while Seville, with 45,000, was the most populous city in Spain.

Tenochtitlán, located on the picturesque islands and the shoreline of Lake Texcoco, made a great impression on newcomers from Europe. One of Cortés' soldiers, Bernal Díaz del Castillo, wrote that he and his companions were amazed by the capital of the empire. It seemed as if they had come across the fairyland depicted in *Amadis de Gaula*, a chivalric romance by an anonymous Iberian writer. They had the impression that they were sleepwalking as they admired stone buildings, with soaring towers, rising out of the water. Bernal Díaz del

PANORAMA OF Tenochtitlán – Diego Rivera's mural (National Palace, Mexico City).

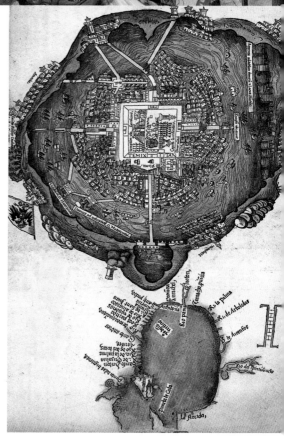

MAP OF Tenochtitlán – based on Hernan Cortés' studies.

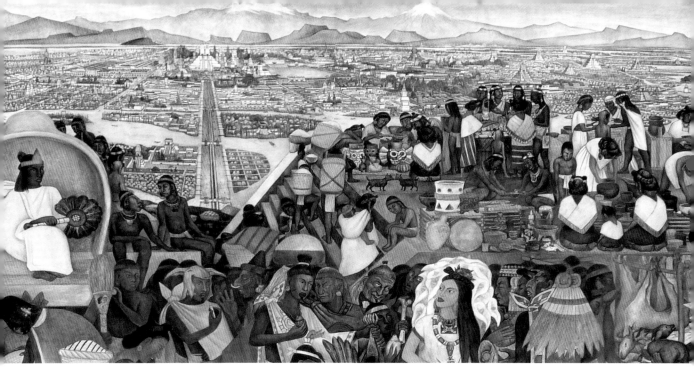

– CAPITAL OF THE EMPIRE

Castillo helplessly acknowledged that he did not know how to describe the view that stretched before him.

He also wrote that when his companions found themselves in the main square, they said that they had never come across a capital as beautiful as the Aztec's though they had been all over Europe, including even to Rome and Constantinople. They were enraptured by its harmonious layout and order.

Bernal Díaz del Castillo, during the whole of his stay in Tenochtitlán, experienced a veritable cognitive dissonance. On the one hand, he admired the refined Aztec culture, architecture, handicrafts, and passion for flower arranging, but on the other, he was horrified by the cruel Aztec religion, with its bloody sacrifices.

THE CHRISTIAN religion blossomed in Mexico on the ruins of a pagan cult.

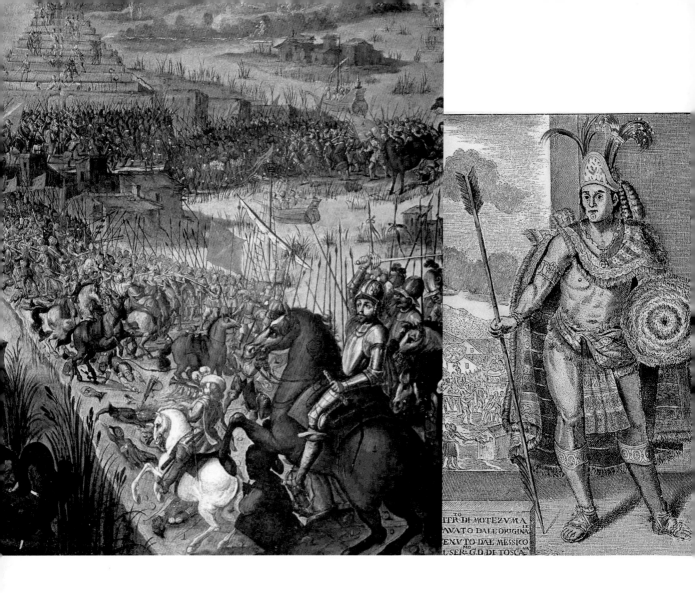

SIEGE OF
TENOCHTITLÁN,
the Aztec capital,
by Cortés' army.

MONTEZUMA II
– the last king of
the Aztecs.

It is not known if the Aztec king's vision was but a projection of his own fears. Since Quetzalcóatl had sailed east, the king expected him to return from the east. Hence he gave orders to observe the coast. The priests had even calculated when the god would arrive: April 22, 1519.

It was on that very day that Hernán Cortés stepped ashore. There were yet more similarities to the ancient myth. Quetzalcóatl was to have had – unlike the swarthy and beardless Indians – a fair complexion and a curly beard, and to have worn – as drawings in Aztec books show – black attire and a hat. This description fitted Cortés perfectly. The god was to have come from across the ocean on a white bird. So the Indians, who were not familiar with sailing ships, initially thought they were large white birds.

All these signs confirmed the Indians' fatalistic attitude: that one could not defy the destiny that was written in the stars. We can thus explain Montezuma

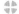
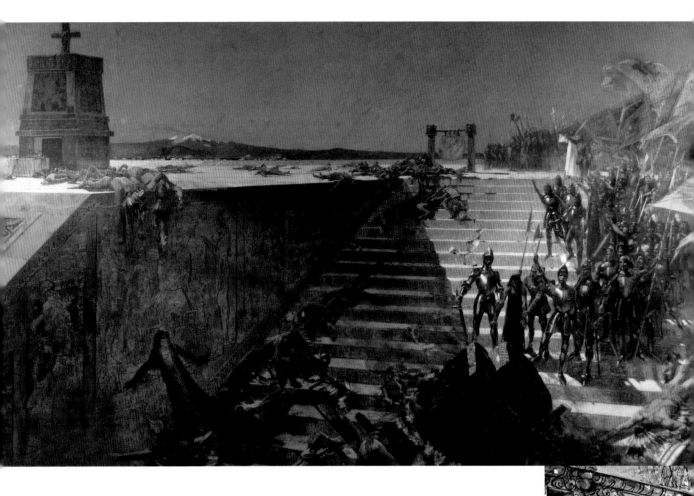

CAPTURE OF TENOCHTITLÁN by conquistadors led by Cortés.
MONTEZUMA II – a hostage on the balcony of his own palace.

II's passivity: he was completely paralyzed by the situation. Convinced of the inevitable end of his reign, he did not even attempt to resist.

The rapidity of Cortés' conquest of the Aztec state disquieted Octavo Paz, a Mexican poet, a winner of the Noble Prize in literature. He devoted a lot of attention to the matter in his book *The Labyrinth of Solitude*, in which he reflected on why Montezuma capitulated to the conquistadors so readily. He came to the conclusion that Montezuma had been incapacitated by the awareness that the gods had abandoned him. He not so much bemoaned the betrayal of his Indian allies as the betrayal of the gods themselves. Hence he behaved as one who had finally resigned himself, not only to the loss of his own life, but also to the annihilation of the world he knew. Suddenly the numerous prophe-

cies and portents that foretold the fall of the state, that actually coincided with the next Aztec time cycle, became clear to him. According to Paz, Montezuma understood that his fate had been sealed, while changes were irreversible as a certain cosmic era was ending and another was approaching. The old gods were departing, to be replaced by new gods. That fatalism had taken a hold of Montezuma and some of the state's elite, who were incapable of interpreting events otherwise. Hence they were passive and apathetic as they awaited that which inexorable fate would bring. That attitude of the elite, a sense of an inevitable end, also imbued the rest of the Aztec community and weakened their will to resist.

So the Aztecs were paralyzed by the conviction that their gods had departed, while the Spaniards were inspired by the awareness that God favored them, in giving them foreign nations to rule over. It is only by referring to the religious reality that one can explain why Cortés's conquest meant not only the fall of the Aztec Empire but also the destruction of the whole of its civilization. Seeing the Indian gods' altars covered in human blood, the Spaniards were convinced that they had to put an end to the cruel pagan cult. In order to understand those events, knowledge of the historical context of

A STATUETTE of Our Lady of Guadalupe in Extremadura, Spain – revered by Columbus and Cortés.

CHRISTOPHER COLUMBUS – a sailor who discovered America.

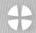

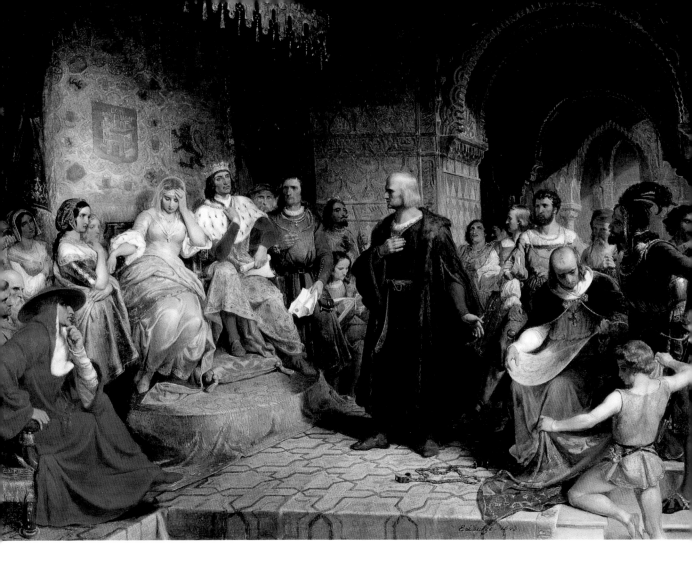

the time is necessary. One must remember that both material and religious motives inspired the great geographical discoveries at the turn of the fifteenth century and the later European overseas expansion. So, on the one hand, there was a desire for adventure and profit, while on the other, a spiritual zeal and a missionary dictate.

Christopher Columbus, who hoped to discover a sea route to India, persuaded the queen of Spain Isabella of Castile to finance his expedition. They easily found a common language, as both were Franciscan tertiaries and devotees of Our Lady. Both had also taken a liking to the Marian shrine in Guadalupe, in the Spanish province of Extremadura.

Columbus had a meeting with Queen Isabella at the Spanish court. He told her that while reading the Bible he had come across the following in the Book of Isaiah: "I will send survivors to the nations . . . to the islands afar off, that have not heard my fame or seen my glory; and they shall declare my glory

COLUMBUS during an audience with the rulers of Spain: Isabella I of Castile and Ferdinand II of Aragon.

131

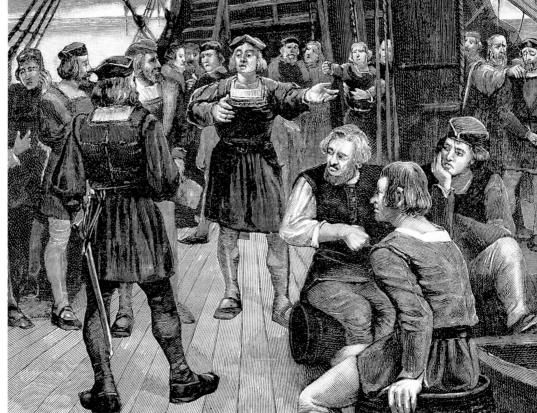

COLUMBUS SAILING out on his historical voyage from Palos de la Frontera (August 3, 1492).

COLUMBUS' MAP of the world.

among the nations" (66:19). He told her that he saw this verse as a personal challenge, one from the Holy Spirit. Hence, in turning to the queen for financial help, he was also inviting her to participate in God's plan of salvation. Those arguments not only convinced Isabella, but also the crews of the three ships that set out with Columbus on the expedition.

The contemporary Polish historian Nikodem Bończa-Tomaszewski writes: "The great Genoese believed that God had charged him with the mission of discovering new lands, and with their Christianization. It was that belief and not that of a beguiling vision of wealth, which helped him to persuade his companions that he was not leading them to certain death."[4] For in those days sailors preferred to keep close to land, as they feared the worst. Columbus' religious arguments dispelled their fears. This is attested to by his mystical work, *Book of Prophecies*, written about 1501, wherein he maintains that he had received a charisma, the "spiritus intellectus" (the gift of understanding the mysteries of sacred writings). Hence, he saw the summons in the Book of Isaiah as one that was addressed to him. As he himself wrote: "God has made me the messenger of a New Heaven and a New Earth, of which St. John spoke of in the Apocalypse (21:1), after he had spoken through Isaiah. He showed me where to find it."[5]

In 1503, Columbus wrote in a letter to the Spanish king and queen, Isabella

and Ferdinand, that in his youth he had heard the following from the Holy Spirit: "God shall extol your name throughout the world and give you the keys to the gates of the oceans, bound by huge chains."[6] Columbus even saw his own name, Christopher (Christ-bearer), in prophetic and missionary terms.

So, after having convinced Queen Isabella of his plans, Columbus sailed off on his historical voyage from the port of Palos de la Frontera, bidden farewell by a praying crowd. It was not by chance that his flag ship, *Santa Maria*, was so named, and that the commander of the expedition entrusted the whole crew to Mary before departing. Ferdinand and Isabella prayed for the success of the expedition at the shrine in Guadalupe, where they stayed for two weeks.

On October 12, 1492, one of the sailors spotted land. Columbus named the island that was discovered San Salvador (Holy Savior) in honor of Jesus Christ. The Bahamas, Cuba, and Hispaniola were also discovered on the voyage. As he had mistakenly thought that he had reached India, he named the local inhabitants "Indios" (Indians).

On the return voyage, Columbus ran into a storm, and his ships almost sank. During the raging storm he vowed to Our Lady that if he were to come out alive he would make a pilgrimage to Guadalupe, bare-footed and clad in a hair shirt. He kept his word.

COLUMBUS LANDING in America.

ANTIQUE BOOK, *The Travels of Marco Polo*, with handwritten notes by Christopher Columbus.

133

During his next three voyages (1493, 1498, and 1502) he explored and described the Lesser Antilles, Jamaica, and the coasts of South and North America. In 1496 his brother, Bartolomeo, founded Santo Domingo, the oldest Spanish city in the Western Hemisphere.

When enormous gold deposits were discovered on the American continent, Columbus encouraged Queen Isabella to finance an army of fifty thousand to participate in a crusade to regain the Lord's Sepulchre in Jerusalem. Thanks to that, he believed that a universal gathering of peoples at the foot of Mount Sinai would be possible, as foretold in the Apocalypse. This never happened. The European rulers, after successive defeats, disillusioned with the Crusades, lost interest in conquering the Holy Land. In the West, it was rather the Turks, who after capturing Constantinople in 1453, were then in the offensive.

Not all, however, had Columbus' religious motives. Many Spaniards, on hearing about the discovery of valuable metals across the ocean, were overwhelmed by a veritable gold fever. They hungered to do great deeds,

A PIECE OF AMERICA IN THE EUROPEAN UNION

DURING HIS SECOND EXPEDITION to America in 1493, Christopher Columbus discovered an island that he named Santa Maria de Guadalupe de Extaremadura, in honor of a beloved shrine of Our Lady in Spain. In 1635 it was captured by French pirates, who made it their base and renamed it Guadeloupe. Successive centuries saw it ruled by the British, the French, and even the Swedes.

From 1946, together with the neighboring islands, it has been a French overseas region. In 2003, there was a referendum on the island as to its future. About 73 percent of the voters were in favor of the political and administrative status quo, and only 27 percent for more autonomy. Guadeloupe, with its 400,000 inhabitants, is presently part of the European Union.

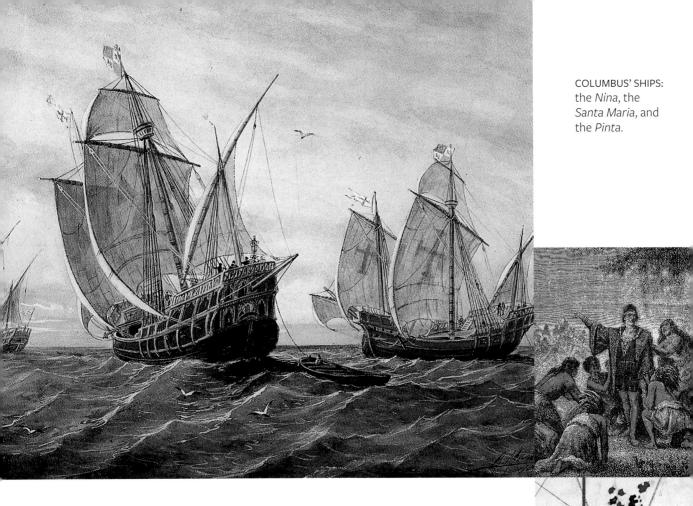

COLUMBUS' SHIPS: the *Nina*, the *Santa Maria*, and the *Pinta*.

COLUMBUS was the first to call the inhabitants of America Indians.

GUADELOUPE ISLAND in the Atlantic.

135

to be rich quickly. Cortés himself seemed to have been driven by a combination of both factors: material and spiritual. He named the first city that he founded on the American continent La Villa Rica de la Vera Cruz (Rich Village of the True Cross). This points to – as noticed by the Polish Mariologist Wincenty Łaszewski – "a mental interweaving of converting Indians with that of procuring their gold".[7]

The first period of the Spanish conquest was marked by great ruthlessness. After conquering the Aztec Empire, the invaders set up New Spain on Mexican soil. Subordinated to the authorities in Madrid, it was administrated in their name by the "Real Audiencia" (Royal Audience).

At the beginning of the sixteenth century, the Spanish Crown did not have the means to finance overseas expeditions or the conquest of American lands. These undertakings were, on the whole, privately financed. Hence the first period of the conquest was not subject to the control of the central authorities; the conquistadors themselves established their own order. As they were in the main troublemakers, desirous of adventure and wealth, they oppressed and exploited the natives. When they encountered resistance they at times

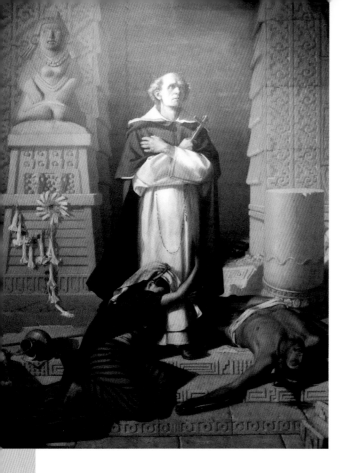

BARTOLOMÉ DE LAS CASAS – a Spanish Dominican and a great defender of Indian rights.

FATHERS OF MODERN INTERNATIONAL LAW

WHEN INFORMATION about the conquistadors' cruel treatment of Indians reached Europe, it evoked outrage and public discussion. Work began within circles of philosophers and theologians, which laid the foundations of contemporary international law. A group of religious, who turned out to be the most consistent defenders of the Indians in the 16th century, played a great part in that work; for example, Fr. Antonio de Montesinos, Fr. Francisco de Vitoria, Fr. Domingo de Soto, Fr. Luis de Molina, and Fr. Bartolomé de las Casas, who fought an intellectual duel concerning the issue in 1550 against an eminent philosopher, Juan Ginés de Sepúlveda. Las Casas spoke against the conquests and the use of force against Indians.

The Peruvian writer Mario Vargas Llosa, a Nobel Prize winner in literature, wrote that Bartomolé de las Casas was the best-known of the nonconformists who had rebelled against the harm that had been done to the Indians. At that time there was quite a large group of brave clerics who stood out in public life. They put faith and morals above the interests of state and nation. Their determination in the battle for the rights of Indians was even greater than that among the Indians themselves. As Vargas Llosa noted, in pre-Columbian cultures one was not seen as an individual but merely as a part of the collective, where one could not question a ruler's orders or the customs of one's community. Morality consisted in being obedient to a higher authority. It was completely otherwise in the Christian civilization. It offered people liberty, dignity, personal rights, and independence of thought, and it taught one to be critical, both of oneself and of authority.

Vargas Llosa also wrote that the Christian civilization was founded on the life and teaching of Jesus, Who said: "Render to Caesar the things that are Caesar's, and to God the things that are God's" (Mk 12:17). This had far-reaching consequences. It meant that one could not surrender one's freedom of thought or conscience to any ruler or state. Bartolomé de las Casas, along with other defenders of the Indians, was faithful to Christ in this respect.

DOGS TEARING an Indian's corpse apart.

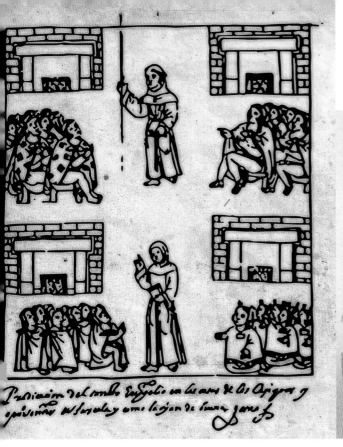

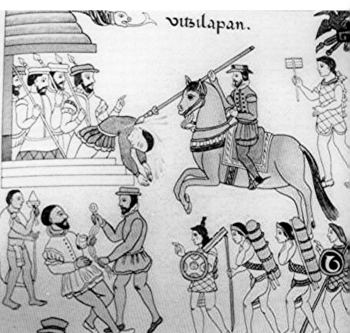

wiped out whole villages. Busy with multiplying their fortunes rather than being solicitous about the Crown's interests, they exploited and humiliated the Indians, treating them as beings of an inferior kind.

Such was the conduct of the members of the first Royal Audience, which had taken power in Mexico upon Cortés' departure to seek further conquests, this time in the direction of Honduras. In that assembly, the administrators of New Spain, were to be found such ruthless conquistadors as the president Nuño Beltrán de Guzmán, Alfonso de Parada, Francisco Maldonado, Juan Ortiz de Matienzo, Diego Delgadillo, and Gonzalo de Salazar. Their administration was characterized by murder, violence, slavery, looting, and injustice. Nuño de Guzmán himself was infamous for exchanging Indians for cattle. The Audience had enemies, and not just amongst the natives but also amongst the Spaniards. One of them was Hernán Cortés, whose wealth was confiscated by Nuño de Guzmán and his associates. Apart from that they accused him of treason before the king. However, it turned out that these conquistadors had significantly more redoubtable opponents – Catholic missionaries.

The central government's weakness during the pioneering period of the conquests meant that the laws passed by the Spanish Crown were not enforced in lands across the ocean. Far from Spain, the uncontrolled Iberian stewards thought they were

FRANCISCAN MISSIONARIES evangelizing Indians.

HERNÁN CORTÉS apprehended by conquistadors from the first Audiencia.

137

immune from punishment. The Catholic Church was the only power that attempted to oppose those ruthless administrators. Hence very quickly conflict arose between Nuño de Guzmán and the first bishop of Mexico, Juan de Zumárraga, upon whom Charles I, the king of Spain, had conferred the title "Protector of Indians" and had charged him with guarding their rights.

Juan Zumárraga, born in 1468 in Durango (not far from Bilbao), Spain, was of a noble family. He is the author of the oldest surviving work in the Basque language, a letter to his cousin Catalina Ruiz. When he felt he had a religious vocation he decided to become a Franciscan. He became known as a zealous missionary and preacher and fulfilled various functions in the Franciscan Order: definitor, guardian (superior), provincial minister. In 1527, as the superior of the monastery in Abrojo, he hosted the emperor, Charles V, who had decided to spend Holy Week there, observing the spiritual life of the Franciscans. Juan de Zumárraga's simplicity, humility, and piety impressed Charles V. Six months later the emperor recommended Zumárraga for the office of bishop of the far-off capital of Mexico. And so it was.

The new ordinary was not afraid to condemn publicly the conduct of the first Royal Audience, as did his subordinates. Hence an open conflict soon

JUAN DE ZUMÁRRAGA – the first bishop of Mexico, defender of Indian rights.

FR. LUIS Molina, Spanish Jesuit and theologian, zealously defended Indian rights.

NUÑO BELTRÁN de Guzmán, a cruel conquistador, well known for persecuting the indigenous inhabitants of America.

A SHORT ACCOUNT OF THE DESTRUCTION OF THE INDIES, by Bartolomé de las Casas, published in 1552, in Seville. It contains a description of the crimes perpetrated by the conquistadors in America.

138

FIRST DEFENDER OF THE INDIANS

FR. ANTONIO DE MONTESINOS was the first to condemn publicly the cruelty of the Spanish conquerors of America.

FR. BARTOLOMÉ DE LAS CASAS was nominated bishop for his services.

A DOMINICAN'S HOMILY, Fr. Antonio de Montesinos', was the first critique of Spanish colonial policy. In December 1511, he delivered his fiery homily in Hispaniola (now Haiti and Dominican Republic), in which he condemned the conquistadors' treatment of Indians. During his sermon Fr. Antonio de Montesinos condemned the Iberian invaders for keeping Indians under a cruel yoke of ruthless oppression and tyranny. He accused them of enslaving Indians, whom they forced to work beyond their strength. Hence they fell ill and died. The sermon made no impression on the conquistadors. The friar accused them of being blinded by their craving for gold, of their lack of solicitude for Indians, of exploiting them, and of not passing on the Faith to them. They thus, he warned, committed mortal sins, putting themselves in danger of eternal damnation.

The homily caused a scandal. The administrators of Hispaniola were outraged. Admiral Diego Columbus (also called Diego Colón), Christopher Columbus' son, demanded that the friar withdraw his accusations. A week later, during the following Sunday's homily, the Dominican not only repeated all the accusations but also warned that the conquistadors would not receive absolution if they did not change their conduct radically.

The matter reached the court in Madrid. Fr. Antonio de Montesinos found himself before King Ferdinand, who acknowledged that he was right. The king appointed a team of theologians and jurists to draw up laws that would regulate the rights of the natives in the New World. Thus arose the Laws of Burgos (1512) and the Laws of Valladolid (1513), the first legal acts to defend the Indian population.

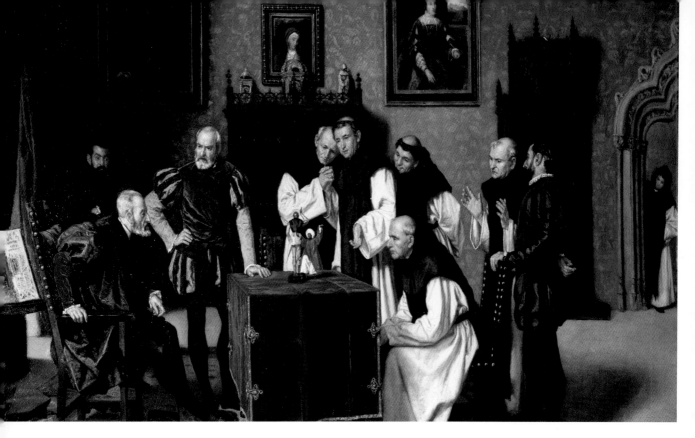

HIERONYMITE
MONKS during
an audience
with Emperor
Charles V in his
palace at Yuste
Monastery,
Extremadura,
Spain.

arose. The Spanish administrators began to treat the missionaries as enemies. As the Franciscans largely relied on alms, the conquistadors ceased to support them financially. They also endeavored to undermine their authority in the eyes of the Indians, spreading lies about them. They took advantage of any opportunity to annoy the missionaries, to make their lives miserable. However, they were continually afraid that the missionaries might inform the king and his court in Madrid of the their unrighteousness. So the first Audience sought to control all lines of communication between the Franciscans in America and the leaders in Europe. The Audience's underlings were charged with intercepting the missionaries' correspondence. Every letter had to be read by a censor and destroyed if its contents were unfavorable. Ships and baggage were thoroughly checked. The Audience also took anticipatory action, sending letters to the king accusing the bishop and the missionaries of offences they had not committed.

Bishop Zumárraga summoned the representatives of the Indian elders and declared that the king of Spain had appointed him protector of the Indians in America. Hence he instructed them to come to him with any complaints about the conduct of the administrators. In reply, the first Audience announced that if any Indian were to do so he would be hanged.

CHARLES V
– HOLY ROMAN EMPEROR

1469 SAW THE MOST IMPORTANT MARRIAGE in Spanish history, that of 18-year-old Ferdinand II of Aragon and 19-year-old Isabella I of Castile, which led to the unification of Spain.

Their heir, Joanna of Castile, known as Joanna the Mad, married Philip the Fair, son of Holy Roman Emperor Maximilian I. As Queen Joanna was mentally unbalanced, Cardinal Francisco Ximenes de Cisneros, regent of Spain, saw to it that her son was acclaimed king. Thus the young Hapsburg became king of Spain (Charles I) in 1516, and emperor (Charles V) three years later. He reigned for a very long time, to 1556.

He fought numerous wars and was the most powerful ruler on earth. It was said that the sun never set on his lands. On the Old Continent he ruled Spain, Austria, Holland, and some of the Italian and German states. It was during his reign that Cortés conquered the Aztec Empire, and Pizarro the Incas. The Philippines belonged to him, as did land in America, which stretched from California in the north, through Mexico and Peru, to Chile and Argentina in the south.

It is difficult to say what his nationality was. He is well known for saying that he spoke Spanish to God, Italian to women, French to men, and German to his horse. It is easier to establish his faith: a fervent Catholic who doggedly fought the Protestants in Germany. Yet, on the other hand, his soldiers sacked Rome in 1527.

He frequently changed his residence during his reign, spending most of his time in Spain – 17 years – where he decided to settle for the rest of his life. After his abdication in 1556, he lived in the Hieronymite monastery in Yuste, Extremadura, where he died 2 years later.

EMPEROR CHARLES V was the most powerful ruler in the world in the first half of the 16th century.

A MAP of Charles V's dominions – over which the sun never set.

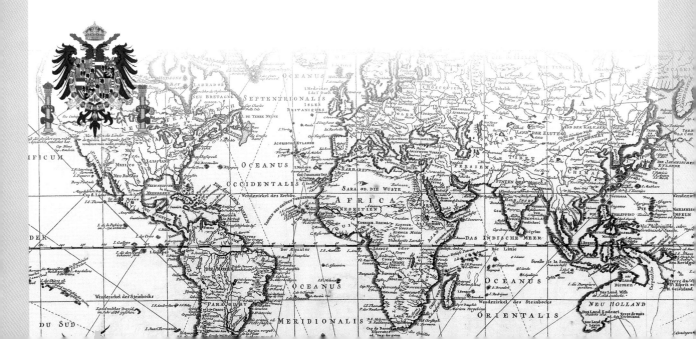

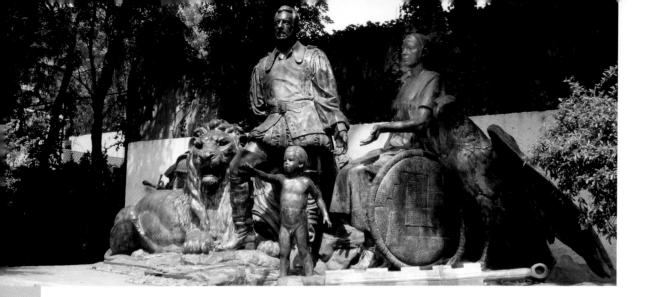

MONUMENT of Cortés, Malinche, and their son, Martin, erected in 1982 in Coyoacán. It was initially in the center of the city, but after protests it was moved to a little-visited park.

IN MEMORY OF CORTÉS

MIRCEA ELIADE, during his stay in Mexico in 1965, was amazed that there were no streets or monuments in Mexico dedicated to Hernán Cortés, whereas countless places commemmorated Cuauhtémoc, the last Aztec chief to fight against the conquistadors. Eliade wrote that Mexicans did indeed speak Spanish, but their loyalties were with their Aztec ancestors, who were defeated by the conquistadors.

This famous historian of religion compared the history of Mexico with that of Romania, his own country, as Romanians also claim to have had their beginnings in a conquest, the Roman conquest of Dacia in A.D. 106. Yet, unlike the Mexicans, the Romanians honor both the victors and the defeated – they erected monuments to Decebalus, the last king of Dacia, and to Trajan, the Roman emperor.

The Church of Jesús Nazareno in Mexico City is the only place in Mexico that commemmorates Cortés – his remains are interred there. It was some time before his remains ended up in the church. The conqueror of the Aztecs died in 1547, near Seville, Spain. In his will, he requested to be buried at the monastery in Coyoacán, in Mexico City. This was disregarded, and the funeral was at the Church of San Isidoro del Campo, in the village of Santiponce, Spain. However, he was exhumed in 1566 and taken to Mexico, where his place of rest was repeatedly changed. In 1794, his remains eventually ended up in the Church of Jesús Nazareno. As they were not safe there, they had to be hidden in 1823 and in 1836; they were hidden so well that they were not found until 1946.

CORTÉS' PORTRAIT on a 1,000 peseta Spanish banknote.

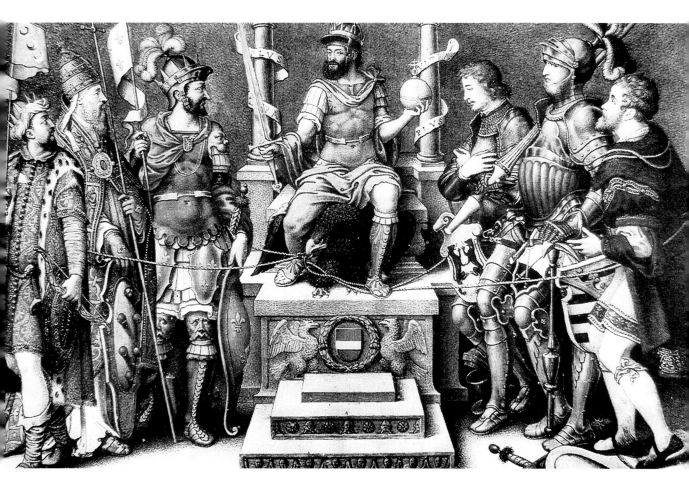

The conflict escalated, and Juan de Zumárraga felt ever more helpless. Joaquín García Icazbalceta, a nineteenth-century Mexican historian, wrote that the hierarch's sole weapon was his spiritual strength, which was repeatedly derided by ruthless conquistadors. Whereas they seemed to be completely immune from punishment, as evidenced by an incident at a convent in Texcoco, when, on the orders of Diego Delgadillo, a member of the first Audience, two Indian novitiates were kidnapped. Two other Indians met a similar fate when they complained to the bishop about the Audience; they sought refuge in the Franciscan monastery in Huexotzinco, but were eventually caught and killed.

Shortly after, the situation was exacerbated when the bishop gave instructions to one of the Franciscans, Br. Antonio Ortiz, to condemn publicly the ignoble deeds of the members of the Audience; this was to be done during a Mass at which they were to be present. When the Franciscan began to criticize them, Nuño de Guzmán loudly told him to stop. When the monk contin-

A 16TH-CENTURY PRINT – Emperor Charles V and his enemies attempting to bind his legs with twine.

143

ued his homily, Diego Delgadillo gave a sign, and Gonzalo de Salazar's men forced their way into the pulpit and silenced him. The bishop endeavored to inform Charles V about everything, but the Audience spies intercepted his letters. Juan de Zumárraga had to send his correspondence to Madrid concealed inside various objects; his first report reached the monarch in a barrel of wax. In it, the bishop called Nuño de Guzmána "a greedy devil from hell".

When grievances finally reached Madrid, Guzmán was dismissed and accused of maltreating the natives. Yet the tension between the Church and the conquistadors continued, reaching its zenith at the beginning of 1530. On March 4, an armed Audience unit forced its way into the Franciscan monastery and dragged Br. Cristóbal de Angulo out of his cell, along with Garcia Llerena, Cortés' servant. Both were tortured the next day. Bishop Zumárraga organized a procession that demanded their release. The procession was attacked, and Diego Delgadillo even struck the bishop with a spear. The bishop threatened to excommunicate the conquistadors if the two prisoners were harmed. But this made no impression on them. On March 7, Br. Cristóbal de Angulo was hung and quartered, while Garcia Llerena was given one hundred lashes and had one of his feet cut off.

FRANCISCANS baptizing Indians.

Bishop Zumárraga had no choice but to excommunicate the members of the Audience, suspend the sacraments in the capital of New Spain, and order religious to leave the city. Thus as Fr. Eduardo Chávez noted, the capital of Mexico

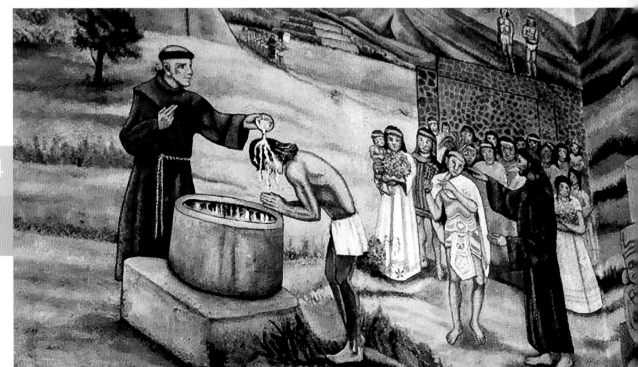

was without the Eucharist, without God. That brought about a great spiritual crisis amongst the Indians, who felt as if they had been orphaned again: first, their Aztec gods had died, now, their Christian God had abandoned them.

The conflict between the Church and the first Audience was not just a local matter. One could say that it arose from differences of opinion amongst Europeans as to the status of the Indians. Some scholars of that time, at Oxford University, for instance, maintained that Indians were not fully human and hence natural law did not apply to them. But Pope Paul III was not happy with that stance, and he ordered studies in this field, which we would now call comparative anthropology.

A Spanish Dominican, Fr. Francisco de Vitoria, one of the most eminent European thinkers of the time, took up the matter, and became famous for a series of lectures on Indians at the University of Salamanca in 1532. He argued that the indigenous peoples of America had the same rights as other people, and that no higher civilization or religion could justify a violation of those rights. He also categorically rejected the view that Indians were bereft

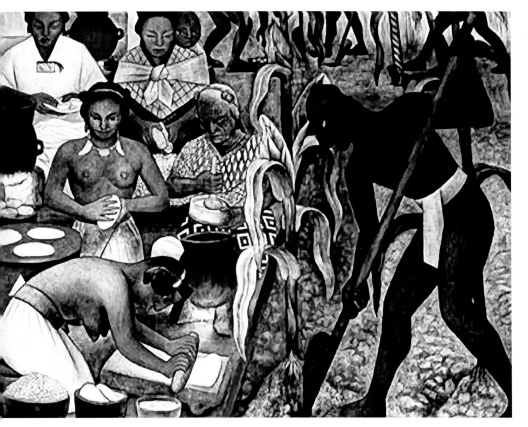

FARMING WAS an Indian's main occupation in New Spain.

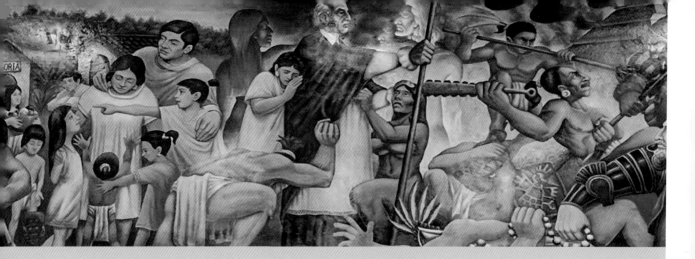

REVIVAL OF **PRIMITIVE CHRISTIANITY?**

WHEN NEWS of Nuño de Guzmán's bloody excesses reached Spain, the court in Madrid dismissed the cruel conquistador and sent the 60-year-old Vasco de Quiroga to America as the king's inspector. This eminent lawyer, of Galician gentry, had a great desire to go overseas as he had heard of the persecution of the Indians and wanted to help them.

He turned out to be a great benefactor and defender of the Indians in New Spain. In 1532 he initiated mission settlements for them, which were enclosed and guarded to protect the natives from the exploitation by the conquistadors. In addition to houses, they had churches, schools, and various workshops. Care was taken to teach the Indians, including women, to read and write, and to aquaint them with European culture. The settlements were to be self-sustaining, though care was taken to restrict the working day to 6 hours. The first of such settlements was Santa Fe near Mexico City.

A Polish historian, Jan Gać, writes of the hopes that Vasco de Quiroga had regarding the settlements: "He maintained that model settlements could well be centers for spreading Christianity and principles of civilized life. With a deeper understanding of the Indians, he came to the conviction that God had permitted the inhabitants of newly discovered lands to live such a dreadful form of paganism for so many centuries. The Creator now, after their conversion, wanted them to become the germ for a new society, like the Church community of apostolic times, a community that would be an example for fallen Europeans. For the Indians had retained many positive features, typical of primitive peoples, features untouched by civilization, like simplicity, openness, veracity, mildness, docility, obedience; who lacked avarice and an abnormal pursuit of the goods of this world, all of which greatly distinguished them from the Spanish. Hence those naturally good inclinations were to be developed, the bad habits eradicated, and the Indians kept far from the scandalous influence of the white population."[8]

In 1538, at the age of 68, Vasco de Quiroga was ordained and appointed bishop of Michoacán. He completely dedicated himself to the Indians – he built hospitals, orphanages, shelters, and schools for them at his own expense. He wrote a catechism for the natives, *Manuel de Adultos*, and always defended them against the abuses of the Spanish. He died in 1565, at the age of 95, highly respected by the local people. Many streets and institutions in the state of Michoacán are named after him.

MURAL – the bishop of Michoacán Vasco de Quiroga, great defender of Indians, surrounded by his people.

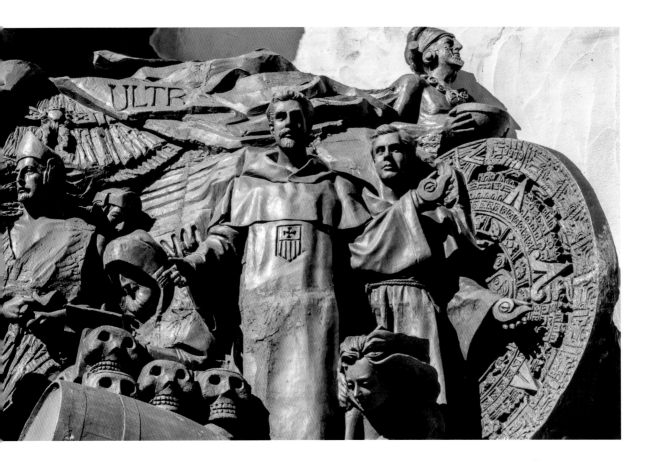

of reason or not fully developed mentally. He wrote: "In essence they are not irrational; they just use reason in their own way." It is no accident then that Fr. Francisco de Vitoria is now seen as the "father of modern international law". Pope Paul III fully agreed with his arguments and on May 29, 1537, sent an apostolic letter, *Pastorale Officium*, to the archbishop of Toledo, in which he clearly stated: "Indians, even if outside the bosom of the Church, are not to be deprived, of their freedom or the ownership of their goods, for they are men and, therefore, capable of faith and salvation."[9] The pope also forbade slavery (regardless of whether the Indians were Christians), as they were "veri homines" (true people).

Shortly after, on June 2, 1537, Pope Paul III promulgated a weightier document, the bull *Sublimus Deus*, in which he wrote: "Indians are true people, not only capable of understanding the Catholic Faith, but also, as we know, fervently desirous of accepting it." He added that "Indians and any other people that might be discovered by Christians could not be, under any circumstances,

PART OF THE MONUMENT
A Tribute to Charles V in Yuste, Spain. In the center, the Dominican Fr. Bartolomé de las Casas, and on his right, the Franciscan, Br. Toribio de Benavente.

147

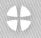

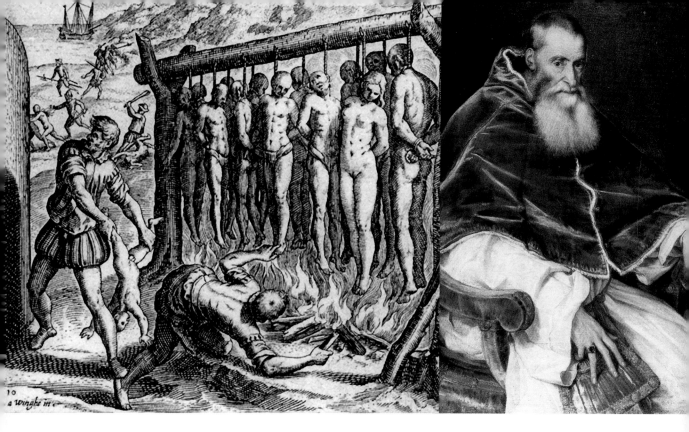

deprived of their freedom or their property, even if they were not to be of the Faith. And they could, and should, legally, enjoy their freedom uninhibited, and take pleasure in their possessions. In no way can they be enslaved, but if that were to happen it would be illegal." The pope also specified that "the aforementioned Indians and other people ought to be converted to the Faith by preaching the word of God, and by example, that of a good and holy life."[10]

In his bull, Pope Paul III also referred to statements that undermined the humanity of Indians. He did not hesitate to describe such statements as demonic, for he wrote: "The enemy of the human race, who opposes everything that is good in order to lead one to one's doom, seeing this, and jealous, has found unheard of ways to hinder the preaching of God's Word of Salvation. Hence he has inspired his lackeys, who – in order to curry favor with him – do not hesitate to proclaim far and wide that Indians from the South and West, as well as other people, of whose existence we have recently learnt, ought to be treated as deaf and dumb animals that have been created to serve us, maintaining that that they are not capable of receiving the Catholic faith."[11]

In 1524, when the first missionaries, the Franciscans, appeared in Mexico, the Holy See had still not published an official declaration on the status of Indians, but it was obvious that the spiritual sons of St. Francis of Assisi regarded the natives as human beings.

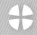

Hernán Cortés insisted on missionaries being sent to America. In one of his letters to the king, he asked for friars, who were known for their self-denial and religious zeal, and not diocesan clerics, whom he reproached for being inclined to luxury and formalism.

The Indians saw the conquistadors not only as a physical force, but also as a spiritual one, regarding Cortés himself almost as a demigod. Hence they were shocked by what they saw on June 13, 1524. That day the first twelve Franciscans – who had walked from the port of Veracruz to Tenochtitlán – met Hernán Cortés in Texcoco. The conquistador dismounted from his horse, knelt before them, and deferentially kissed Fr. Martin de Valencia's habit. To the Indians, such a gesture was an evident sign that there was an authority before which even the most powerful Spanish leaders would bend the knee.

FR. FRANCISCO DE VITORIA, a Spanish Dominican and defender of Indian rights, is regarded as the father of modern international law.

149

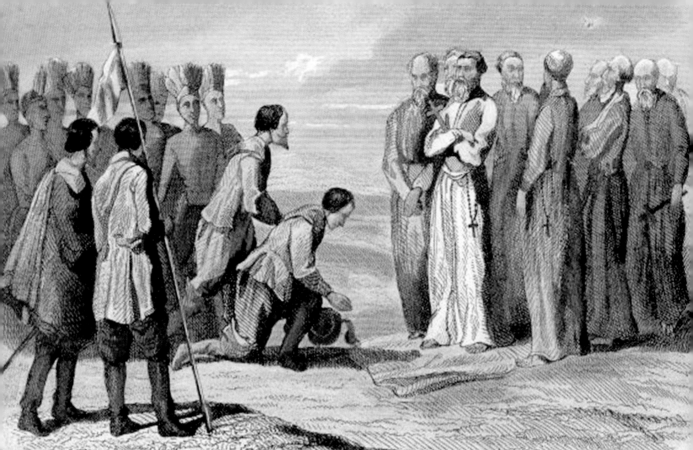

CORTÉS WELCOMING the first 12 Franciscans to Mexico in 1524. It was Cortés who insisted that the king of Spain send them to America.

The natives witnessed a yet more startling event a little later. Cortés arrived late for Mass. In those days that was seen as an affront to the Eucharist, punishable by a public flogging. No exception was made for Cortés, who was whipped by Franciscans in front of a large crowd.

Several years later the Indians experienced another mental dissonance. The news that Diego Delgadillo had attacked Bishop Juan de Zumárraga with a spear had spread like wildfire. So the Indians learnt that the conquistadors not only knelt before clerics, but even raised their hands against them, not showing them respect, but utter contempt. A later conflict ended in the triumph of the colonizers and the expulsion of the missionaries.

Octavio Paz wrote that the gods had betrayed the Aztecs, leaving them to the mercy of the conquistadors. Many Indians felt that they had been betrayed again, but this time by their Christian God. Further, they could not comprehend how, on the one hand, the conquerors could believe in God, Who was Love, but on the other, be ruthless and cruel, traits that contradicted their religion.

150

BIOGRAPHY of Martin de Valencia – the first Franciscan superior on the American continent.

Many people had similar doubts centuries later. Mircea Eliade, a Romanian historian, wrote in his diary (February 3, 1965) that he was ashamed of being a European and a Christian every time he read about the conquest of the Aztecs.

Bishop Juan de Zumárraga was perfectly aware of the tragic nature of the situation. In a letter to King Charles, he wrote that if God did not intervene, then Mexico would well-nigh be destroyed.

Intervention soon came – the visitation of Our Lady of Guadalupe. As we have seen, within only ten years of the Spanish conquest of Mexico, Our Lady appeared to Juan Diego, bringing comfort, hope, and Christian faith to millions of oppressed Indians. From that time onward, Our Lady of Guadalupe has been an icon of the Mexican people's aspirations for freedom and independence.

CHARLES V under the care of the Hieronymites on his death bed in his palace at Yuste Monastery in Spain.

VIEW FROM CHARLES V death bed. His bedroom adjoined the church, hence the seriously ill emperor could hear Mass through the slightly open door.

151

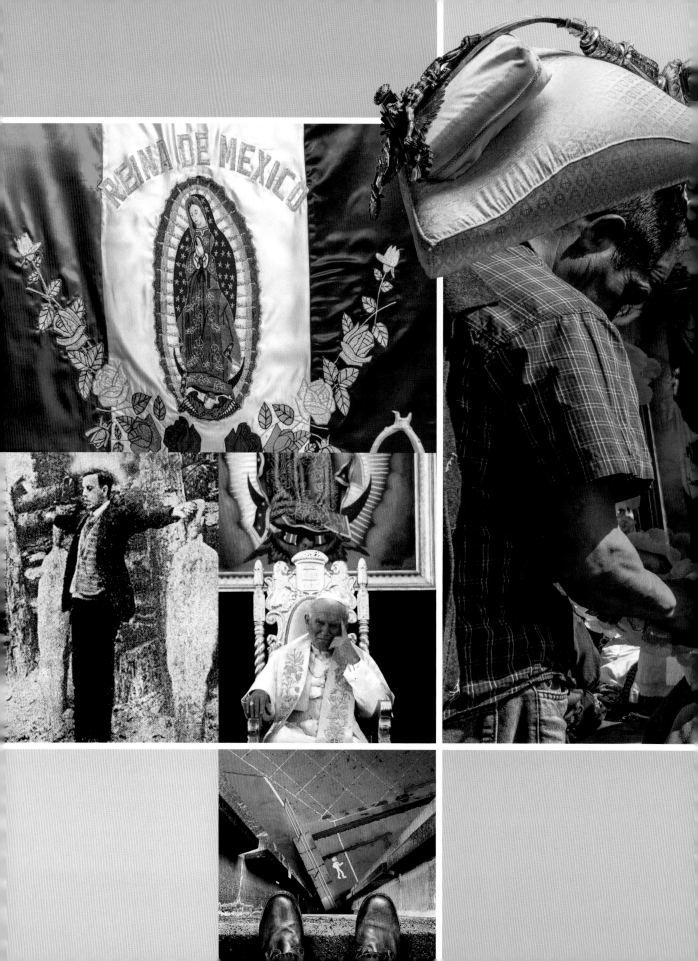

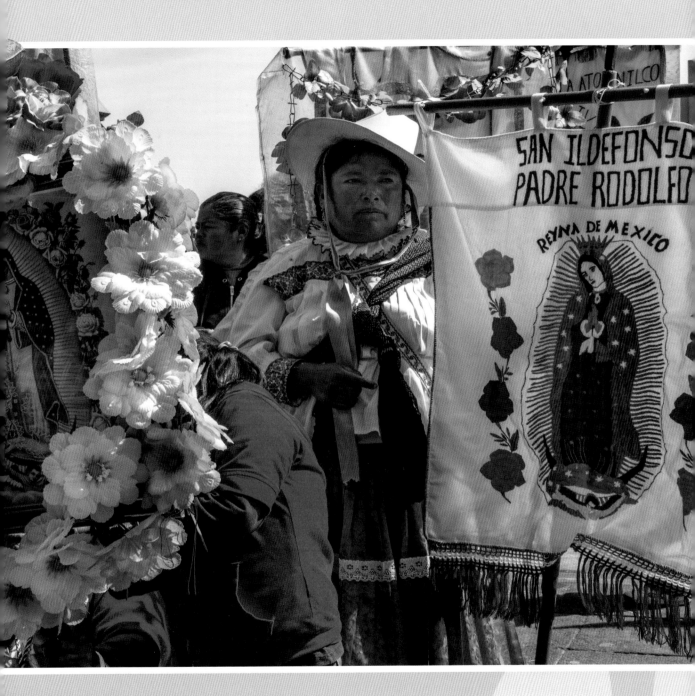

Patron of Mexico

Patron of Mexico

The history of Mexico is a turbulent one, of bloody, armed conflicts. When arms were taken up, the first cry was often: "Viva la Virgen de Guadalupe!" And an image of her fluttered on flags.

QUEEN OF MEXICO, Our Lady of Guadalupe, on a Mexican flag.

The Spanish reign in Mexico lasted for exactly three hundred years: from 1521 to 1821, when independence was proclaimed. The Mexican War of Independence proceeded under the standard of Our Lady of Guadalupe, while the Catholic clergy played an important role. It was not by chance that a Catholic religious, Fr. Juan Antonio Montenegro, deputy head of St. John the Baptist Secondary School in Guadalajara, led the first independence organization in 1793.

Liberation ideas were particularly evident in Creole circles, that is, among the white descendants of colonizers and immigrants. Many of them saw Mexico, not distant Spain, as their true fatherland, where their ancestors had lived for centuries. They had had enough of their country being exploited by Spain, and they resented sharing the wealth they had earned with the increasingly alien authorities in Madrid. The "peninsulares", officials from the Iberian Peninsula, frequently incompetent careerists, particularly aroused their anger.

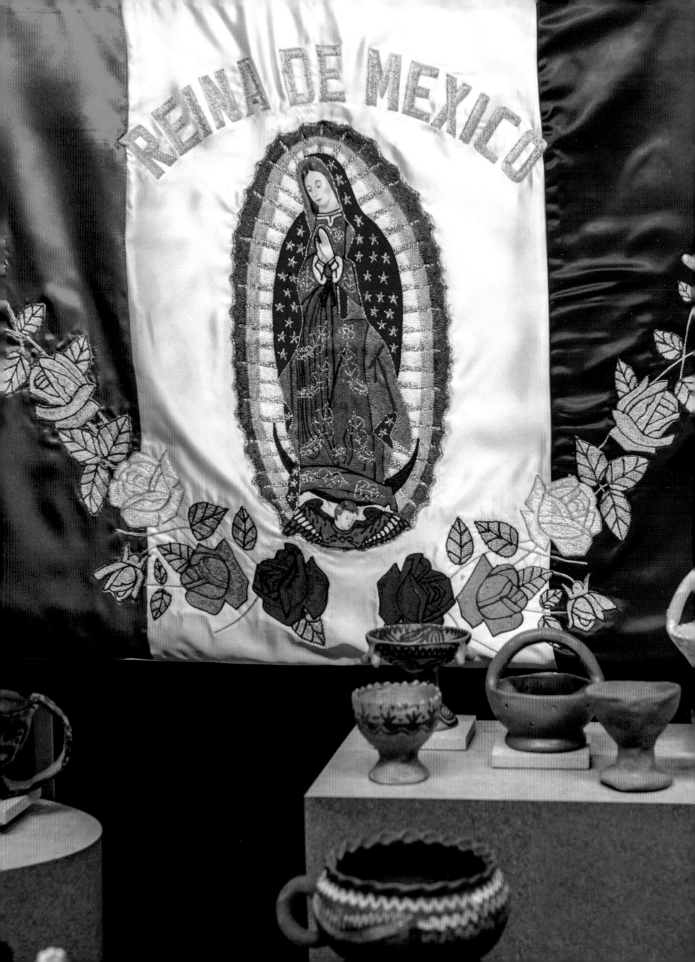

PARISH CHURCH in Dolores (now Dolores Hidalgo), where Fr. Miguel Hidalgo gave his famous homily (September 14, 1810).

REBEL BANNER with Our Lady of Guadalupe – 1810.

An opportunity to gain independence came in 1808, when Napoleon's soldiers seized Madrid and set Joseph Bonaparte on the Spanish throne. The Mexican independence movement decided to take advantage of the weakness of the Bourbon dynasty. The pro-independence ferment also seized a large part of the Catholic clergy, whose ideas on liberty were inspired by Christianity. Fr. Melchor de Talamantes is regarded as the precursor of the country's sovereignty, the author of writings that called for an end to Spanish control.

The first independence uprising in Mexico broke out in 1810. It was led by a Catholic parish priest, Fr. Miguel Hidalgo y Costilla, from the little town of Dolores. On September 14, during Mass, he gave a fiery homily, in which he called for the overthrow of the government. The homily, known as the *Grito de Dolores*, was a turning point in the modern history of Mexico. Two days later the uprising had

FR. MIGUEL HIDALGO with the rebel banner.

ANOTHER REBEL flag – National History Museum of Mexico, Chapultepec Castle.

157

BOOK about Fr. Hidalgo, a Mexican national hero, 1886.

FR. JOSÉ MARIÁ MORELOS, a Catholic priest and a leader of the independence uprising.

EXECUTION OF MORELOS, December 22, 1815.

FR. JOSÉ MARIA MORELOS, a great devotee of Our Lady of Guadalupe.

its own banner for Costilla went out of the Church of Jesús Nazareno, in the village of Atotonilco, and raised a banner that depicted Our Lady of Guadalupe. The rebels' battle cry was "Long live our Virgin of Guadalupe! Long live Mexico! Long live liberty!" One of the rebels' main demands was the return of the Jesuits to Mexico, expelled by virtue of the royal decree of 1767.

At that time the Church in New Spain was divided. On the one hand, priests led some of the insurgents' units, for example, Fr. José María Mercado from Ahualulco seized the town of Tepic and the port of San Blas; and the friars Luis Herrera and Juan de Villerías took control of the state of San Luis Potosí. On the other hand, the Catholic hierarchy had condemned the revolt. On September 20, 1810, in Valladolid, the bishop of Michoacán excommunicated insurgents for two reasons: first, for revolting against the legitimate royal rule; and second, for the sacrilege of using the image of Our Lady of Guadalupe on the insurrection standard.

Despite initial successes, the uprising was put down, and Fr. Miguel Hidalgo was apprehended and shot. But that did not discourage the advocates of independence, who set up a network of underground associations. It was not by chance that one of the most important illegal organizations was called Guadalupe; for to the underground activists, the Virgin was a symbol of national unity for Indians, Mestizos, and Creoles.

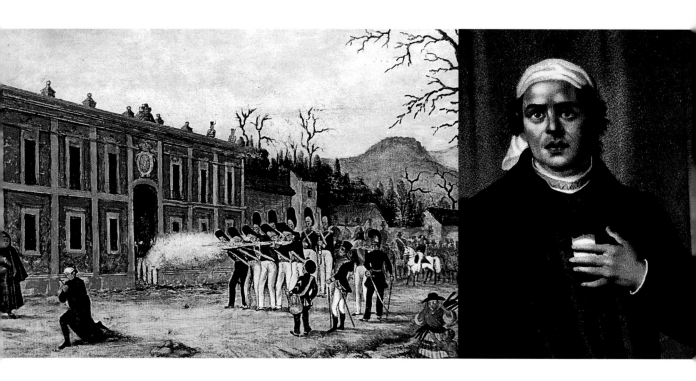

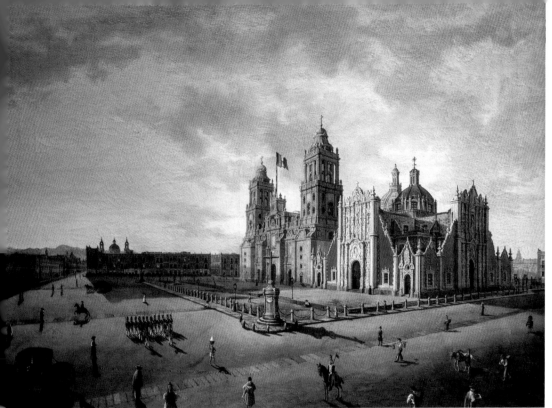

The leader of the next independence uprising, which lasted from 1811 to 1815, was also a Catholic priest, Fr. José María Morelos, who, like Fr. Miguel Hidalgo, was also a great devotee of Our Lady of Guadalupe. He had many victories at the front and was greatly respected amongst the insurgents, who sang that they would give a real (a Spanish colonial coin) for a corporal, a silver coin for a sergeant, but their whole heart for their general, Fr. Morelos. He was called the "Lightning of the South" on account of his military successes. In 1814, in Apatzingán, he summoned a national congress, which approved Mexico's first constitution. It proclaimed independence from Spain, the people sovereign, and Catholicism the national religion. However, it did not come into effect as the uprising failed, and Fr. Morelos was shot. Witnesses recalled that before his execution, when passing by the Basilica of Our Lady of Guadalupe, he wanted to kneel, but his chains prevented him from doing so. After many years, the city of Valladolid had its name changed to Morelia in his honor.

One of Fr. Morelos' bravest soldiers was José Miguel Ramón Adaucto Fernández y Félix, who during the War of Independence, decided to change his name to Guadalupe Victoria. Under this name he became the first president of Mexico (1824 – 1820).

However, before that came about, the Mexican population finally rid itself of Madrid's control. On August 24, 1821, Creole units, commanded by Agustín de Iturbide, defeated a Spanish army, forced the viceroy to abdicate, and proclaimed ▶

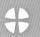

OLD BASILICA

INITIALLY THE IMAGE of Our Lady of Guadalupe was on public display in the chapel that the Indians had built at the foot of Tepeyac Hill in December 1531. As it was very small, a larger church was built beside it in 1622. The image was moved elsewhere for a time, for example, to the catherdral during the great epidemics in 1629 and 1634 in order that people might pray before it. In 1647, it was housed behind glass for the first time, 116 years after it was first put on public display.

With an increase of pilgrims, a new Baroque church was built, consecrated on April 27, 1709, on the pattern of the temple in Jerusalem, regarded to this day as one of the most beautiful sacral buildings on the American continent. In 1904, Pope Pius X elevated it to the rank of a basilica.

Because of earthquakes and the geological instability of the terrain, the church began to tilt, and its walls to crack. Hence a new church, designed by Pedro Ramírez Vázquez, was built in record time (22 months). The state did not contribute to the investment and the Mexican Church had no funds to help. Jesús González Labastida undertook to raise the funds. The basilica was consecrated on October 12, 1976, and can accomodate about 50,000 people.

Today, the Basilica of Our Lady of Guadalupe is the world's most visited Marian shrine. It is estimated that about 20 million pilgrims visit it annually. Basilica records testify to many having being healed of incurable diseases there over several centuries.

FROM 1709 TO 1976, the image was housed in a church that is considered to be a Mexican Baroque pearl.

TO THIS DAY multitudes of pilgrims visit the old Basilica of Our Lady of Guadalupe, even though it does not now house the image.

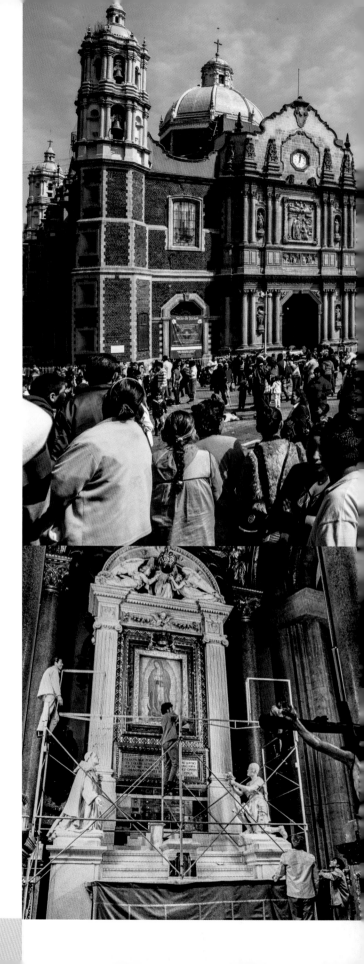

STATUE OF ST. JOHN PAUL II between the old and the new basilicas. Mexicans virtually saw the Polish pope as a fellow countryman.

A GROUP OF MEXICAN GIRLS during a pilgrimage to the Shrine of Our Lady of Guadalupe.

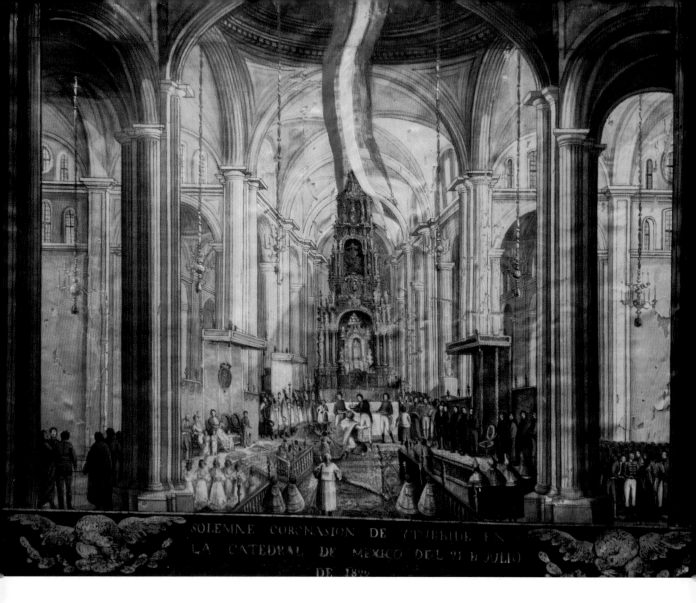

SOLEMNE CORONASION DE ITURBIDE EN LA CATEDRAL DE MEXICO DEL 21 DE JULIO DE 1822

CORONATION OF AUGUSTÍN DE ITURBIDE as emperor of Mexico in 1822.

Mexico's independence. The victorious leader, who proclaimed himself emperor a year later, established the National Order of Our Lady of Guadalupe as the highest state decoration.

In 1829, Vicente Guerrero became the second president of Mexico. After defeating Isidro Barradas' army, which had attempted to regain Mexico for Madrid, Guerrero went to the Basilica of Our Lady of Guadalupe on a thanksgiving pilgrimage and laid the seized Spanish standards before the image of Our Lady.

In 1828, the newly formed Mexican General Congress established December 12 – the Feast of Our Lady of Guadalupe – as a national holiday. This was confirmed by Benito Juárez's liberal government in 1859. Though Juárez himself was anti-clerical and had introduced many anti-Church laws – for example, the suppression and looting of religious orders – he had a great respect for Our Lady of Guadalupe. Her image

AUGUSTÍN DE ITURBIDE'S APPEAL with traces of his blood.

AUGUSTÍN DE ITURBIDE'S tomb, Metropolitan Cathedral in Mexico City.

BENITO JUÁREZ was the son of Indian peasants from the Zapotec tribe.

BENITO JUÁREZ, president of Mexico from 1857 to 1872, architect of constitutional state reform.

TWO MEXICAN Revolution leaders: Pancho Villa and Emiliano Zapata.

appeared on standards whenever there was social unrest, demonstrations, or armed clashes. There were many opportunities for this as, after the proclamation of independence from Spain, Mexico was like a keg of gunpowder. There were frequent civil wars and coups, while from 1821 to 1850 the government changed fifty times. On losing the Mexican-American War in 1848, Mexico suffered great territorial losses. To the United States she then lost half of her territory, an area that encompasses Arizona, California, Colorado, New Mexico, Texas, and Utah.

The period after 1910 also turned out to be a restless time. A revolution broke out against Porfirio Diáz' oligarchic government, whereupon the dictator had to flee the country the following year. That did not end the armed struggle, which lasted for another ten years. Historians estimate that two million people lost their lives in that civil war.

Some of the partisan units – for example, the one commanded by the peasant hero Emiliano Zapata – fought under standards depicting Our Lady of Guadalupe. But the revolutionary elite, mainly from Masonic circles, and openly anti-clerical, took power. Under Masonic influence, the revolt took on an ever more anti-Catholic nature. This was evident in the Constitution of 1917.

Not only was the Constitution openly anti-Christian, it also violated freedom of conscience and religion. It deprived the Church of her legal personality and nation-

EMILIANO ZAPATA'S soldiers with a banner of Our Lady of Guadalupe.

164

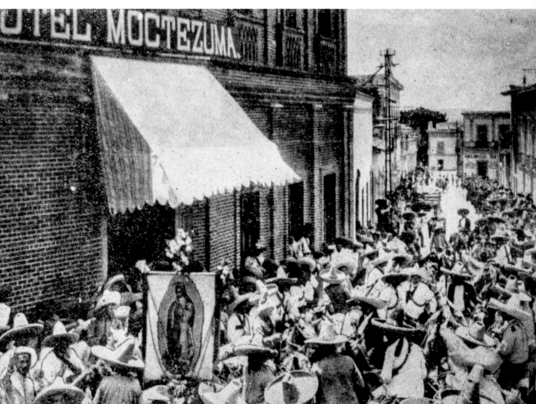

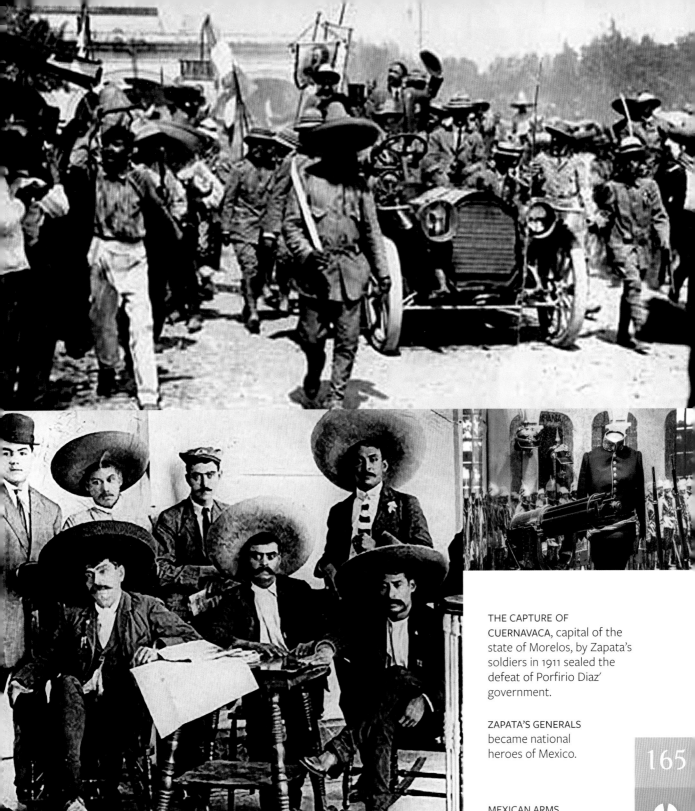

THE CAPTURE OF
CUERNAVACA, capital of the
state of Morelos, by Zapata's
soldiers in 1911 sealed the
defeat of Porfirio Diaz'
government.

ZAPATA'S GENERALS
became national
heroes of Mexico.

MEXICAN ARMS
and uniforms from the
time of Porfirio Diáz'
rule.

165

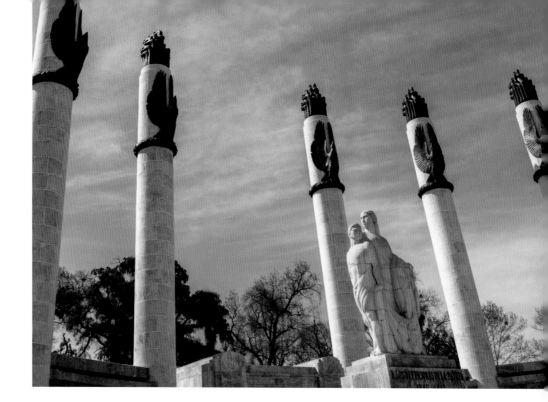

MONUMENTAL ALTAR a la Patria in the center of Mexico City. It is of 6 marble columns surrounding a mausoleum, which contains the remains of 6 cadets who were killed during the U.S. invasion of Mexico in 1847. In the center is a marble statue of a woman symbolizing Mexico.

alized her property, including her churches. It prohibited religious institutions from owning or acquiring any property whatsoever. The government was to decide whether sacred buildings could be used for religious purposes. The Constitution also prohibited the Church from engaging in educational activities, suppressed religious orders, and delegalized religious organizations, for example, Christian trade unions. Particular limitations pertained to priests, henceforth officially referred to as those "practicing the profession of a cult official". They were deprived of the right to vote and also of the right of inheritance. They were to be registered in government offices, while local authorities were to decide on the number of religious in a given state. Only native Mexicans could be priests, and all foreign priests had to leave the country.

Such was the situation when certain events shocked every Catholic in Mexico. On November 14, 1921, a certain Luciano Pérez entered the Basilica of Our Lady of Guadalupe, approached the altar, and laid a bouquet of flowers under the image of Our Lady of Guadalupe. Dynamite was concealed amongst the flowers and exploded as he left the basilica. The explosion was so great that it crumbled the marble chancel stairs, destroyed the metal candlesticks, and bent the huge crucifix on the altar. But it did not damage the image; it did not even leave a scratch on the glass that protected the image, though windows had been shattered in nearby houses.

Pérez was immediately apprehended by secret agents, who – as it turned out – happened to be in the basilica in large numbers, and thus protected him from the

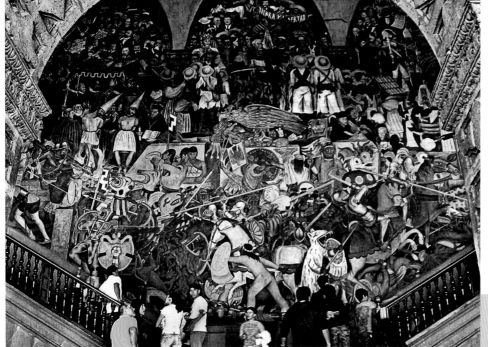

DIEGO RIVERA'S large murals fulfilled a "liber pauperum" role for the illiterate citizens of Mexico.

A CONVERTED COMMUNIST

DIEGO RIVERA (1886–1957) was undoubtedly the most famous Mexican painter of the 20th century. In the 1920s he created a national arts program under the patronage of the then minister of education, José Vasconcelosa, a program that drew on pre-Columbian traditions. The program mainly expressed itself in the form of murals—monumental wall paintings that adorned many buildings.

According to the assumptions of Mexican revolutionaries, art ought to be of an ideological nature, and serve the socialist vision of the world. The murals were to assume the role of a "liber pauperum", aimed at the illiterate, to indoctrinate by images and not by the written word.

Diego Rivera became an excellent example of such art. He created a great artistic synthesis of Mexican history, whose villains were the Catholic clergy; the liberals and left wing revolutionaries the heroes. His last work was an enormous fresco, *Dream of a Sunday Afternoon* in Alameda Central Park, painted in 1947 at the luxury Hotel del Prado. At the bottom left corner of the fresco he wrote: "Dios ne existe" (God does not exist).

Rivera was not only a declared communist, but even a Stalinist. On one of his murals, at the Palace of Fine Arts in Mexico City, he presented Stalin and Mao Zedong as saviors of humanity, looming over the whole globe. In 1956, he even supported the Soviet invasion of Hungary.

Rivera died of cancer a year later. Before he died he appeared in the Hotel del Prado and personally painted over the words "Dios ne existe" on his fresco. Two days later he called a press conference and announced: "I am a Catholic." The following day he published a formal announcement in the press, in which he owned his devotion to Our Lady of Guadalupe. He added that she was on Zapata's standard and was still a symbol of Mexico. He also stated that he wanted to make amends to his countrymen, of whom 96 percent were Catholics. Not long afterwards he died.

DIEGO RIVERA and his wife Frida Kahlo, 1932.

PHOTOGRAPH OF the altar where the bomb was placed in 1921.

CRUCIFIX BENT by a bomb under the image of Our Lady of Guadalupe on November 14, 1921.

168

outraged crowd. Pérez, however, was soon released, without suffering any consequences. The prosecutor, Eduardo Neri, simply stated that the attempt had brought the Church nothing but benefit, thanks to which she could present herself as a victim of persecution. And he added that the miraculous survival of the image would serve the clergy in organizing further pilgrimages and in collecting donations.

As a result of the unstable situation in the country, continually rocked by social disturbances, the anti-Catholic regulations of the 1917 Constitution were not enforced. This changed in 1924, when Plutarco Elías Calles became president. He was an anti-clerical socialist, a member of the Helios Lodge, and was seen as a "personal enemy of God", an anti-Christ. His main aim was the destruction of the Catholic Church in Mexico. Calles kept a careful eye on events in the Soviet Union: how the Communist Party brought about a split in the Russian Orthodox Church, subordinated her, and set up a collaborationist "living Orthodox Church". He decided to do the same thing in Mexico, nam-

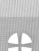

ing the seventy-three-year-old Fr. José Joaquína Pérez patriarch of the state church. But one and a half years of government attempts in that direction resulted in failure – of the four thousand Mexican priests, only fifteen joined the state-sanctioned church.

In June 1926, the president changed his tactics and had a law passed that enforced the anti-Catholic restrictions of the 1917 Constitution. Catholic schools, monasteries, and convents were closed, and non-Mexican priests deported. Further restrictions were introduced: the clergy were ordered not to wear cassocks outside church walls, and criticism of the government was punishable by up to five years in prison. "Calles Law" obliged priests to be registered – otherwise they were arrested.

The anti-Catholic policy evoked mass protests. Peaceful resistence was organized in defense of religious freedom. In a short time, of the sixteen million people in Mexico, two million signed a petition demanding the repeal of anti-

RECONSTRUCTION OF THE DAMAGE to the altar after an explosion: a bent brass crucifix and the intact image of Our Lady of Guadalupe.

169

UNDERGROUND POSTCARD from the Mexican Catholic resistance – Christ beaten by President Calles and others who were persecuting the Church.

A CIVIL DISOBEDIENCE campaign organized by Mexican Catholics as a protest against the government's anti-Church policy.

170

Catholic laws. But the Mexican Congress was steadfast. Hence in the summer of 1926, the Mexican episcopate took the unprecedented step of suspending all public worship, in other words, there was a strike by the clergy. Priests stopped saying public Masses, administering Baptism, and participating in funerals. In a pastoral letter, the Mexican bishops claimed that the 1917 Constitution, government policy, and government sympathy with Masonry—all testified to the fact that the government sought to destroy Catholicism in Mexico. The bishops asserted that the Church could exist without property, religious orders, or churches, but not

CRISTEROS, MEXICAN partisans, defending religious freedom.

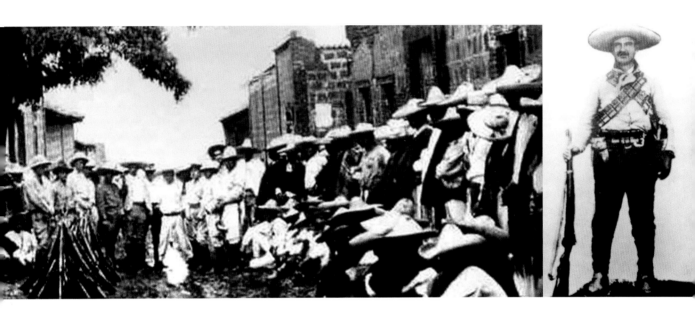

without freedom. They thereby took no heed of Pope Pius XI, who suggested in his apostolic letter *Paterna Sane* that they ought to be circumspect, pray, and not provoke the authorities.

So the Mexican episcopate did what Bishop Juan de Zumárraga had done four hundred years earlier, when he suspended Christian worship in the capital in 1530; then it was in protest against the policies of the conquistadors, now it was against the practices of revolutionary radicals. On July 31, 1926, the abbot of the basilica decided to hide the image of Our Lady of Guadalupe, fearing that it would be destroyed by the anti-clerical authorities. At night, in the presence of several witnesses, the image was wrapped in cloth, sealed, and taken away in a furniture van. It remained concealed for almost three years – until June 1929. A copy by Rafaela Aguirre was hung up in the basilica. Only a small group of people knew about the change.

VICTORIANO RAMIREZ (Catorse), one of the Mexican leaders of the Cristero Rebellion.

171

EXECUTION OF A JESUIT, Bl. Miguel Pro, shot on November 23, 1927.

ST. PEDRO MALDONADO LUCERO, a Mexican martyr, canonized with 24 companions by Pope John Paul II in 2001.

MEXICAN MARTYRS

WHEN BISHOP KAROL WOJTYŁA was engaged in pastoral work with the youth of Kraków, one of the students asked him to recommend a good, contemporary book. The student specified that he was interested in fiction of high artistic value that conveyed a Christian message. Without the slightest hesitation, Karol Wojtyła recommended Graham Greene's *The Power and the Glory*, about a hunted Catholic priest in 1930s Mexico.

Karol Wojtyła did not forget about the Mexican martyrs, and when he became pope it was he who did most to spread information about them. During his pontificate, he beatified 27 victims of religious persecution in Mexico. As he emphasized, they themselves did not take up arms against the anti-clerical authorities, yet they were murdered out of hate for the Faith.

On September 25, 1988, Pope John Paul II beatified Fr. Miguel Agustín Pro, a 36-year-old Jesuit who was shot on November 23, 1927. He was the first martyr in history whose execution was photographed.

On November 22, the pope beatified 25 Mexican martyrs (22 priests and 3 lay people) who were murdered between 1915 and 1927 by anti-clerical radicals. They most frequently died shouting "Viva Cristo Rey!" and "Viva la Virgen de Guadalupe!" Eight years later, on May 21, 2000, they were all canonized by Pope John Paul II.

On October 12, 1997, the pope beatified another martyr, the Augustinian priest Fr. Elias del Socorro Nieves, who was shot in 1928 for fulfilling his ministry, which was forbidden by the authorities.

On November 20, 2005, Pope Benedict XVI beatified 13 victims of the anti-Christian dictatorship in Mexico. They were killed between 1927 and 1931, one of whom was 14-year-old José Sánchez del Río, who was the main hero of the 2012 film *For Greater Glory*.

PROCESSION WITH a statue of Blessed José Sánchez del Río, a 14-year-old Cristero martyr.

In 1928, a Mexican painter, Gerardo Murillo Cornado, better known as Dr. Atl, in sympathy with the anti-clerical authorities, examined the image. He saw it as a purely decorative work, of a standard art technique, and the work of a person of a mediocre artistic imagination. His opinion was made public by the anti-Church state elite, who thought that they had further proof of the clergy's chicanery.

At that time Calles triumphed. The Church withdrew from the public sphere. It seemed that the backbone of Mexican Catholicism was definitively broken. Yet a reaction came from a quarter that the president least expected.

The president, like all revolutionaries, believed that everything was determined by an aware and disciplined elite that the masses followed. He thought that if he were to pacify Church leaders, the clergy, he would thereby control all believers. He saw the Catholic community as a passive and amorphous mass, one that was not capable of independent action without the leadership of the priests. The events of 1910 had convinced him of that. For when Mexico was in flames, Catholics never openly took sides in any of the conflicts. But Calles had underestimated the religious zeal of his countrymen. To him it was a question of influence in the public spheres of life; to them, a matter of life and death, salvation or eternal damnation. People could bear many things, but they would not put up with being refused Baptism for their children, with being refused

CRISTEROS UNIT. The majority of Mexican partisans lost their lives.

CRISTEROS OFFICERS with their families, and a standard of Our Lady of Guadalupe.

Holy Communion, and with the dying not being able to confess their sins. Hence they spontaneously took up arms.

The president thought that wives would calm their husbands, for over half of those who went to church were women. But it turned out to be quite the opposite, for the following situation was not an infrequent occurrence: soldiers would turn up at some church to close it; the faithful would lock themselves inside and pray; so the soldiers would force them out with rifle butts, whereupon the women would shout out to their husbands, fathers, fiancés: "Cowards! How can you allow your women to be beaten?" The men could not stay passive – they resorted to force.

In many places there were spontaneous skirmishes between federal soldiers and desperate Catholics. There were many explosive points, and in some states they turned into local uprisings. One of the government commanders then sneeringly said that the campaign awaiting him would be easier than going hunting. But the Catholic guerrillas, who were active in many parts of the country, turned out to be a force that was beyond government control.

The uprising lasted three years, and it was not defeated militarily. The rebels led a partisan war, avoiding decisive battles, harassing federal units by sudden attacks. At its height it consisted of about fifty thousand armed men. Called the "Cristeros", in honor of Christ, as they were motivated by purely religious reasons, they most frequently died crying out: "Viva Cristo Rey!" (Long live Christ the King!). Hence the uprising was called the "Cristiada", which according to the French historian

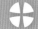

Jean Meyer, was, like the *Iliad*, a heroic epic but a tragic one. The image of Our Lady of Guadalupe fluttered on the rebels' standards, as it often had in Mexican history.

Enrique Gorestieta, a Mexican Army officer, was one of the heroes of the uprising. He managed to transform ill-disciplined partisans into capable and efficient armed units. Interestingly, he was a Mason and an atheist, who did not hide his contempt for religious practices. When his soldiers were at prayer in some church, he would lounge on a back bench, ostentatiously smoking a cigar. He accepted the proposition to be commander-in-chief of the Cristeros as he could not accept the government's violation of religious freedom. He was of the opinion that the state's war against the Church was destroying national unity and causing unnecessary divisions.

In time, however, Gorostieta, inspired by the zeal of his subordinates, converted to Catholicism. In a letter to a friend, he wrote that he was uplifted by the attitude of the insurgents, while that for which they were fighting was a holy matter, hence they would not lose. He did not live to see the end of the uprising as he was shot dead on June 2, 1929, by a federal agent who had infiltrated the partisans.

A SCENE from the film *For Greater Glory*, directed by Dean Wright (2012).

The Cristero Rebellion ended in 1929, a consequence of mediations led by American ambassador Dwight Whitney Morrow. The U.S. government wanted an end to fighting, as American oil companies had favorable contracts in Mexico. An agreement was facilitated when Emilio Portes Gil, who was not as fanatically anti-Catholic as Calles, became president in 1928. Thanks to Morrow's efforts, the government and the Church reached a compromise: the Church recognized the Constitution of 1917, while the government undertook not to enforce its most anti-Catholic restrictions; it primarily abandoned the idea of priest registration. The government promised to return some of the confiscated churches and offered amnesty to the Cristeros. Hence the episcopate called off the strike. Public Masses were again celebrated in Mexico, and the real image of Our Lady of Guadalupe was returned to the basilica.

The majority of the insurgents, obedient to the bishops, laid down their arms. But many felt resentment. They thought that the compromise was unsatisfactory, that the Church had been cheated by the government. Time proved them right, as the government did not adhere to the agreement. Instead of an amnesty, prison and execution awaited the Cristeros. About five hundred defenseless leaders were murdered, and also many priests. It is estimated that the post-uprising purges claimed more victims than the Cristiada itself.

The authorities continued their anti-Catholic policy. A government decree of 1931 referred to the Church as a "commercial organization, enriched thanks to the exploitation of the people". Clergy and churches were limited – one priest and one church to fifty thousand inhabitants. In a country of sixteen million, only three hundred thirty-three priests were permitted to engage in pastoral work legally. In some states

CATHOLIC INSURGENTS hanged by government soldiers in the state of Jalisco.

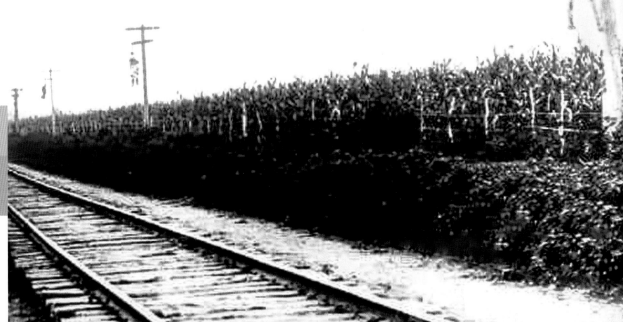

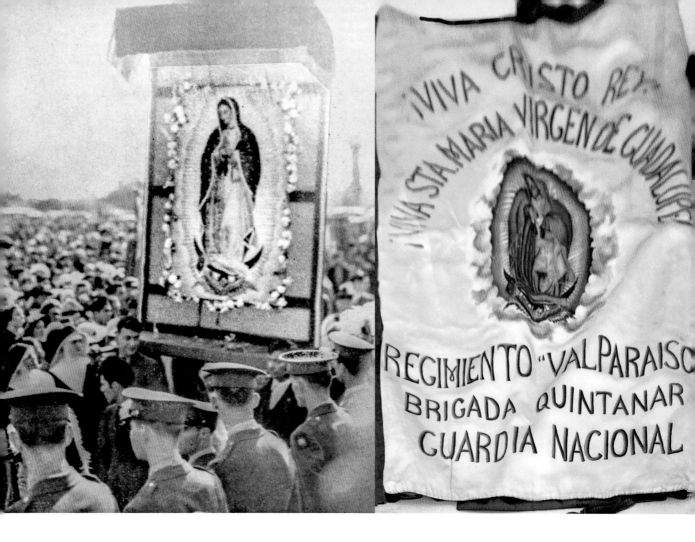

they had to fulfill additional requirements, for example, they had to be fifty years of age or over and married.

The most drastic scenes were to be seen in the state of Tabasco, whose governor Tomás Garrido Canabal was vehemently anti-clerical. He named his three sons Satan, Lucifer, and Lenin, and he gave sacrilegious names to his farm animals: he named a bull "God", a donkey "Christ", and a cow "Virgin of Guadalupe". He set up a terrorist group, the Camisas Rojas (Red Shirts), which murdered priests, profaned churches, and publicly derided religion. Delighted by that, the Bolivian revolutionary Roberto Hinojosa called the state of Tabasco the "Bethlehem of a Socialist Dawn in America".

It is not surprising then that Catholics took up arms yet again. A second Cristiada began in 1932. This uprising was smaller – eight thousand partisans – but it was more ruthless and bloodier. The fighting did not end until 1938, mainly due to Lázaro Cárdenas, who had become president of Mexico in 1934. Two years after taking office, he ordered the arrest of Calles and his closest

AN IMAGE of Our Lady of Guadalupe always accompanied public, religious events organized by Mexican Catholics.

BANNER OF a Mexican National Guard unit with an image of Our Lady of Guadalupe.

177

associates, including Canabal, and their deportation to the United States. The new president, though an anti-clerical atheist, realized that in the long run civil war just led to the devastation of the country. Hence he made peace with the Church.

Despite the agreement of 1938, the relations between the state and the Church were far from normal for years, as the Institutional Revolutionary Party (PRI), founded by Plutarco Elías Calles, the supreme commander of the revolution, ruled without a break from 1929 to 2000. The seventy-one-year, one-party rule was only possible thanks to the rigging of elections and the party dependency of the administration, the mass media, and the intelligence agencies.

Mexican poet Octavio Paz once described the PRI as a "man-eating philanthropist": on the one hand, it aspired to establish a Latin version of a welfare state, while on the other, it attempted to do so by authoritarian means, often resorting to force.

On October 2, 1968 – several days before the Olympic Games in Mexico City – there was a massacre in the capital. The police opened fire on a peaceful demonstration of students, which had gathered in Three Cultures Square. Several hundred were killed. Octavio Paz, who was then the Mexican ambassador in Delhi, resigned in protest. He also wrote a well-known text, in which he compared the Institutional Revolutionary Party to Aztec rulers, and the shooting of defenseless students to the bloody rituals of pre-Columbian times. The comparisons were the more forceful due to the fact that the massacre was in the Tlatelolco district, right next to the temple where people were once sacrificed.

There was a paradoxical situation in Mexico for the greater part of the twentieth century: on the one hand, 90 percent of the country was Catholic, on the other, the authorities were openly anti-Catholic. But a change gradually came about. After a period of repression and bloody persecutions, a détente ensued, followed by a truce between the Church and the state. Pope John Paul II played an important role in the changes, as he chose Mexico for his first overseas pilgrimage (January and February 1979).

When the pope landed in Mexico, the episcopate had to pay a fine for him as he had worn a cassock in public, which was officially prohibited. As Mexico had no diplomatic relations with the Holy See, the pope could not be received as the head of the Vatican State, and so he had to have a visa just like that any other traveler.

However, the enthusiasm of ordinary people on greeting the pope surprised everybody, especially the authorities. It is estimated that twenty million people participated in meetings

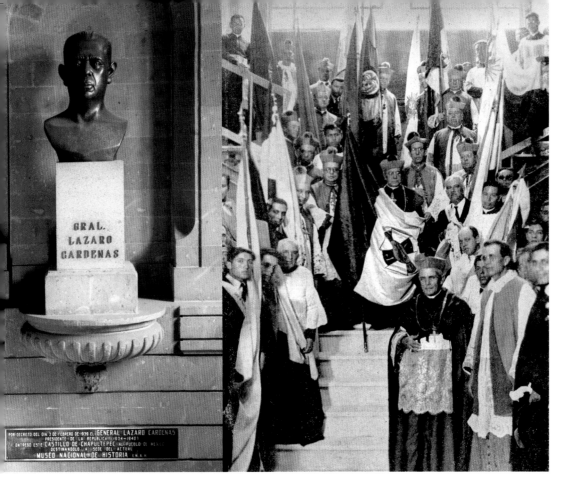

BUST OF Lazaro Cardenas, president of Mexico; he made peace with the Church and so ended the Cristero Rebellion.

SOLEMN PROCESSION on the 400-year anniversary of the image of Our Lady of Guadalupe in 1931.

with the pope. The term "Mexico semper fidelis", then used by the pope, went into public circulation, as in one of his homilies he said:

It is said of my native country: "Polonia semper fidelis." I want to be able to say also: Mexico "semper fidelis", always faithful! In fact, the religious history of this nation is a history of faithfulness; faithfulness to the seeds of faith sown by the first missionaries; faithfulness to a simple but deep-rooted religious outlook, sincere to the point of sacrifice; faithfulness to Marian devotion; exemplary faithfulness to the Pope.... At this solemn hour I would like to call upon you to strengthen this faithfulness, to make it stauncher. I would like to call you to express it in an intelligent and strong faithfulness to the Church today. And what will be the dimensions of this faithfulness if not the same as those of Mary's faithfulness?[12]

On January 27, the pope visited the Basilica of Our Lady of Guadalupe. Witnesses recalled that he seemed to be pensive, even worried. Praying before the image of Our Lady, he entrusted to her the speech he was to deliver the next day during the general assembly of the Latin American Episcopal Council (Spanish: Consejo Episcopal Latinoamericano), better known as CELAM, in Puebla.

179

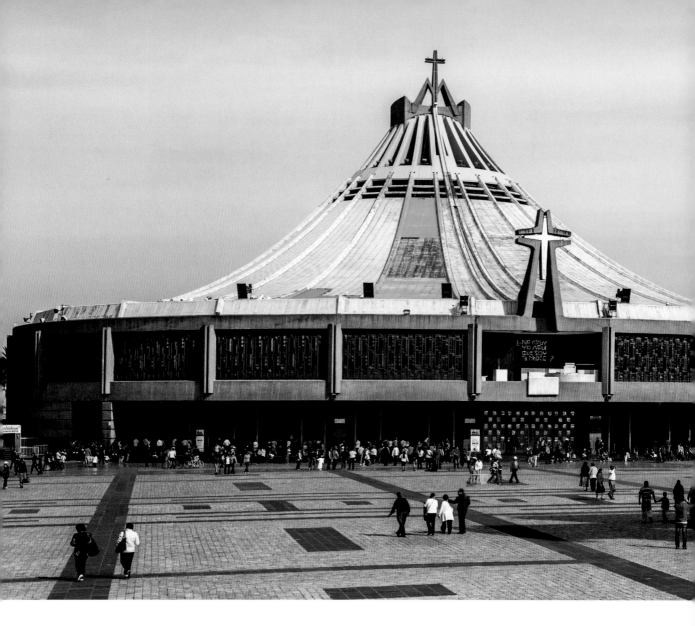

ΠEW **BASILICA**

THE NEW BASILICA WAS BUILT in record time (22 months) according to a design by the architect Pedro Ramírez Vázquez . The state did not contribute to the investment, while the Mexican Church had no funds to help. Jesús González Labastida undertook to raise the funds. The basilica was consecrated on October 12, 1976, and it can accommodate about 50,000 people. The square for pilgrims was funded by Carlos Slim Helú, the world's richest man, a Mexican entrepreneur of Libyan descent. Today the Basilica of Our Lady of Guadalupe is the world's most visited Marian shrine. It is estimated that about 20 million pilgrims visit it annually. Basilica records testify that over a period of several centuries many pilgrims to the image of Our Lady of Guadalupe have been healed of incurable diseases.

THE NEW BASILICA of Our Lady of Guadalupe was built in less than 2 years.

JESÚS GONZÁLES LABASTIDA organized the funding of the basilica.

180

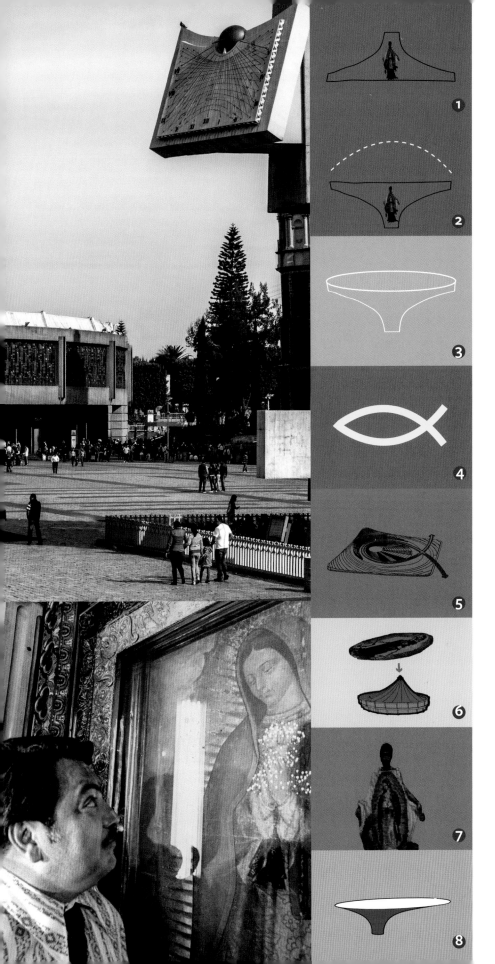

THE NEW BASILICA of Our Lady of Guadalupe has inspired the builders of other Catholic churches, for example, architects working on the Church of St. Juan Diego in Mexico City. In the following pictures we see the following:

1) The present basilica, Mexico City's flagship and the destination of millions of pilgrims

2) Inverted basilica – model for the new church

3) The Church of St. Juan Diego, its shape adapted to the limited space

4) "Ichthys" (fish), a secret sign of the first Christians

5) The fish sign in the church's spatial plan and the direction for visiting the interior of the church

6) The basilica's roof representing Mary's mantle protecting the faithful

7) St. Juan Diego with the Image on his tilma

8) The roof of the Church of St. Juan Diego representing his tilma.

181

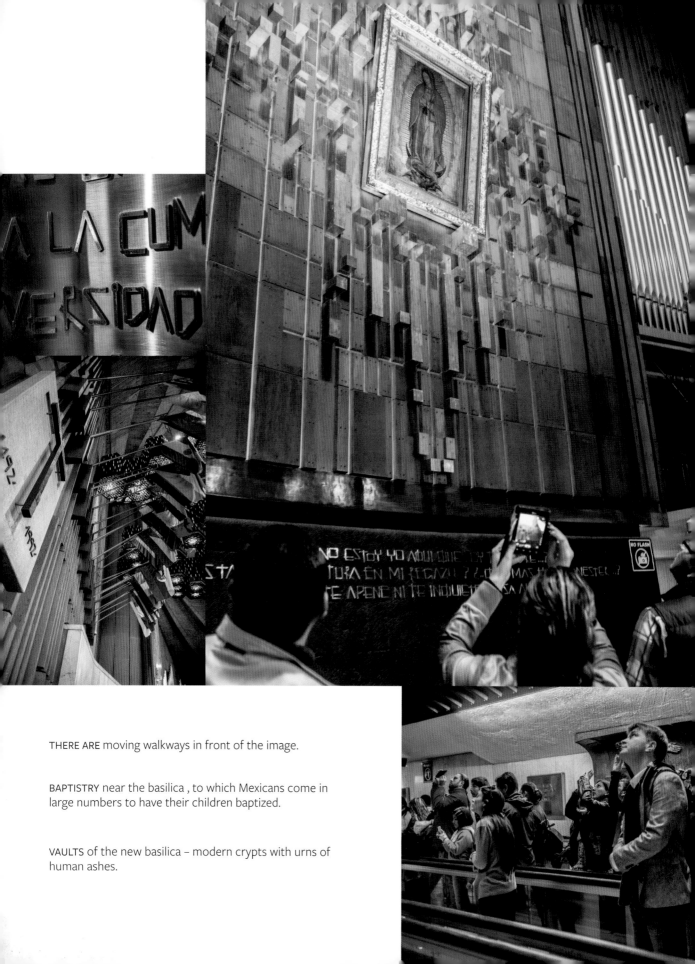

THERE ARE moving walkways in front of the image.

BAPTISTRY near the basilica , to which Mexicans come in large numbers to have their children baptized.

VAULTS of the new basilica – modern crypts with urns of human ashes.

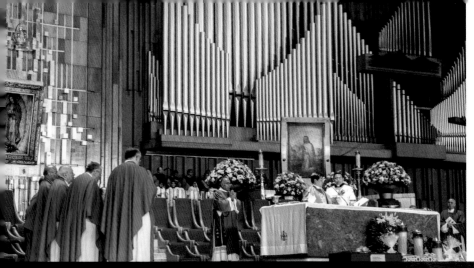

THE BASILICA OF OUR LADY OF GUADALUPE is the central point of the most visited shrine in the world – 20 million annually.

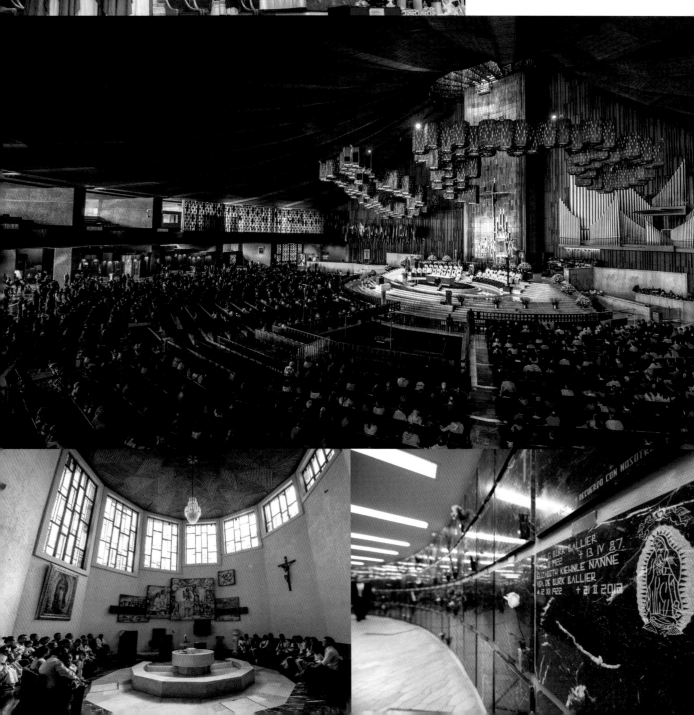

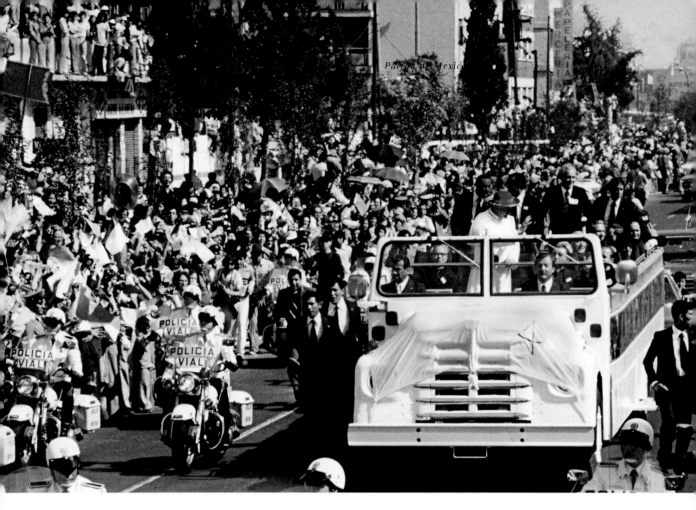

Patron de Mexico

POPE JOHN Paul II's first pilgrimage to Mexico in 1979, the first of the pope's 104 journeys overseas.

▶ It was one of the most important speeches of his pontificate, critical of liberation theology – a mixture of Christianity and Marxism – then very popular amongst many of the Latin clergy, which advocated the necessity of armed struggle for a more just world.

The pope then said: "This idea of Christ as a political figure, a revolutionary, as the subversive man from Nazareth, does not tally with the Church's catechesis. . . . He does not accept the position of those who mixed the things of God with merely political attitudes (cf. Mt 22:21; Mk 12:17; Jn 18:36). He unequivocally rejects recourse to violence." Quoting John Paul I, the pope said, "It is wrong to state that political, economic and social liberation coincides with salvation in Jesus Christ." True liberation, he said, is liberation from all forms of oppression, especially the oppression of sin.[13]

The pope's speech did not signify that he was indifferent to social injustice. The day after his speech in Puebla, January 29, he met Indian representatives in Culiacán. At that time a poor Indian stood before him and said that cows had a better lot than Indians, who had no one to speak to about their suffering, which they had to keep quiet about. He then said that he and his compatriots were at the service of the pope. Pope John Paul II replied to the crowd: "The Pope wishes to be your voice, the voice of those

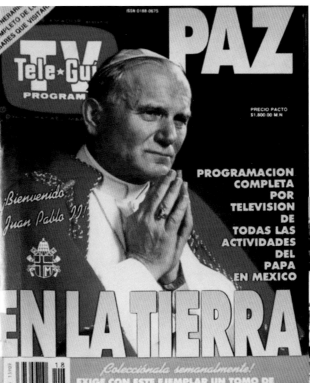

A MEXICAN pilgrim with an image of Our Lady of Guadalupe.

IN 1979 JOHN PAUL II became a media hero not only in Mexico, but also in the whole of Latin America.

who cannot speak or who are silenced." He then addressed the politicians: "Human conscience, the conscience of peoples, the cry of the destitute, and above all the voice of God, the voice of the Church, repeat to you with me: It is not just, it is not human, it is not Christian to continue with certain situations that are clearly unjust."[14]

On January 31, as the pope was departing from Mexico City for Rome, he looked down at twinkling lights in the city. It turned out that millions of the capital's inhabitants had reflected the sun's rays, via mirrors, in the pope's direction.

In 1990, the pope visited Mexico for a second time. On May 6, he beatified Juan Diego Cuauhtlatoatzin in the Basilica of Our Lady of Guadalupe. During the beatification Mass, the pope said of him: "Juan Diego represents all the indigenous peoples who accepted the Gospel of Jesus, thanks to the maternal aid of Mary.... The Virgin chose him from among the most humble as the one to receive that loving and gracious manifestation of hers which is the Guadalupe apparition."[15]

MEXICANS SET images of Pope John Paul II in peseta coins as mementos of his pilgrimages.

185

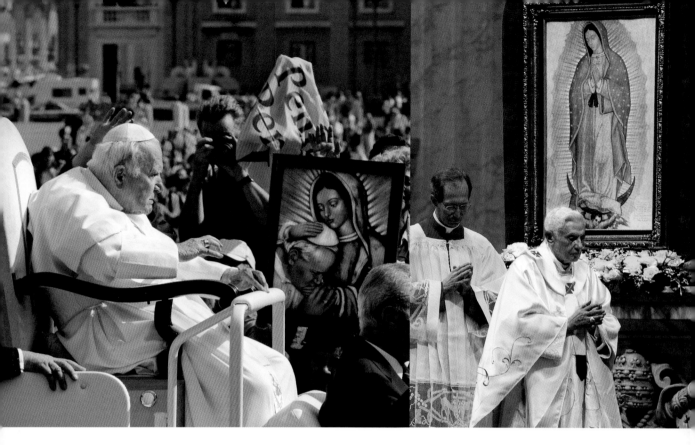

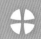

Though the anti-Church Mexican Constitution was still in force, and the Institutional Revolutionary Party was still in power, the authorities received the pope with much more kindness than in 1979. The pope took advantage of his visit to change the attitude of the ruling elite towards Catholics. He said: "The Church does not wish to be treated as an alien entity, nor like an enemy to be overcome, but an ally in all that is good, noble and beautiful."[16]

The pope's mediation yielded fruit. His third pilgrimage to Mexico, in August 1993, proceeded in a completely different atmosphere. He was received with all due ceremony befitting a head of state. A year earlier, the Church's legal personality had been restored, priests were allowed to vote, and diplomatic relations between Mexico and the Holy See had been re-established. Pope John Paul II visited the Basilica of Our Lady of Guadalupe once again, and referred to the five-hundred-year jubilee of the discovery of America, celebrated in 1992. In this context he emphasized the importance of a dialogue of cultures and evangelization through inculturation.

The pope went to Mexico for the fourth time in January 1999. He then called Our Lady of Guadalupe "Star of the New Evangelization", and proclaimed her patron of Latin America.

Eighteen months later, the country saw its biggest political changes since 1929. For the first time in seventy-one years, the new president, Vicente Fox, a declared Catholic, was not of the Institutional Revolutionary Party. After his electoral victory he made his way to the Basilica of Our Lady of Guadalupe, where he fell on his knees before her image.

POPE FRANCIS
in St. Peter's (the Vatican) during Mass on December 12, 2014, the Feast of Our Lady of Guadalupe. In his homily the pope recalled that devotion to Our Lady of Guadalupe extends over the whole of America, "from Alaska to Patagonia". Its message says that henceforth "no one is a servant, that all are children of the same God – brothers." Pope Francis pointed out that Mary not only visited American nations, but also wanted to stay with them in the miraculous image on the tilma. "Through her intercession, the Christian Faith began to grow into the most precious treasure of the soul of the American peoples, whose pearl of great value is Jesus Christ."[17]

187

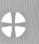

JOHN PAUL II during his second pilgrimage to Mexico in 1990.

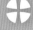

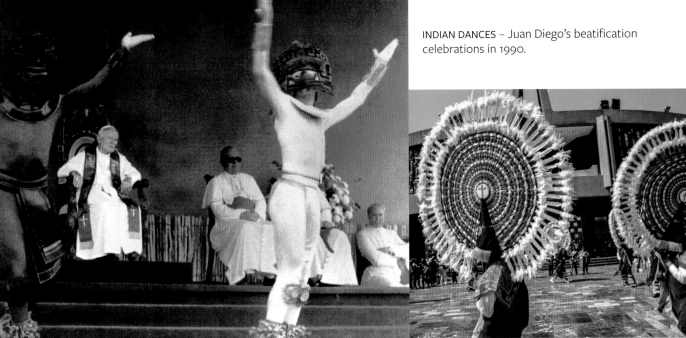

INDIAN DANCES – Juan Diego's beatification celebrations in 1990.

INDIANS IN festive attire at the Basilica of Our Lady of Guadalupe.

POSTER – St. Juan Diego's canonization in 2002.

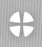

Pope John Paul II's fifth and last pilgrimage to Mexico was in July and August 2002, during the Fox administration. For the first time in Mexican history, its president knelt before a pope and kissed the Piscatory Ring. At one point the president declared that Mexico was developing under the care of the Virgin Mary of Guadalupe. The guest from Rome was received, as usual, with great joy by millions of ordinary people who chanted: "Juan Pablo, hermano, ya eres mexicano!" (John Paul, brother, you are a Mexican now!)

Further changes in the relations between the state and the Church were inevitable. Over the following years other restrictions that limited the activities of Catholics in the public sphere were abolished, the last of which was annulled in 2011, when religious ceremonies were allowed outside the grounds of churches without the consent of the authorities.

The main event of Pope John Paul II's last apostolic visit to Mexico was the canonization of St. Juan Diego Cuauhtlatoatzin at the Basilica of Our Lady of Guadalupe on July 31, 2002. During the homily, the pope said:

In accepting the Christian message without forgoing his indigenous identity, Juan Diego discovered the profound truth of the new humanity, in which all are called to be children of God. Thus he facilitated the fruitful meeting of two worlds and became the catalyst for the new Mexican identity, closely united to Our Lady of Guadalupe, whose Mestizo face expresses her spiritual motherhood which embraces all Mexicans. This is why the witness of his life must continue to be the inspiration for the building up of the Mexican nation, encouraging brother-

ST. JOHN PAUL II'S 5th pilgrimage to Mexico in 2002, when he canonized Juan Diego in the Basilica of Our Lady of Guadalupe.

hood among all its children and ever helping to reconcile Mexico with its origins, values and traditions.

The noble task of building a better Mexico, with greater justice and solidarity, demands the cooperation of all. In particular, it is necessary today to support the indigenous peoples in their legitimate aspirations, respecting and defending the authentic values of each ethnic group. Mexico needs its indigenous peoples and these peoples need Mexico![18]

Juan Diego's canonization was possible because the Congregation for the Causes of Saints acknowledged a miracle from his intercession. The miracle concerned a certain Juan José Barragán, a nineteen-year-old student from Mexico City, who on May 3, 1990, in a state of deep depression, attempted suicide by jumping from an apartment balcony. His mother managed to grasp his legs at the last moment, but she did not have the strength to hang on to her son. He fell head first from a height of thirty-three feet. She managed to shout out: "Juan Diego! My son! My son!" Witnesses saw the boy fall head first onto the concrete footpath.

Passersby were convinced that the boy was dead, so they covered his body with a sheet and placed a candle beside it. But after a few minutes, to the amazement of all, Juan José discarded the sheet and stood up without help. His face was deformed, and blood poured from his mouth, nose, and eyes. He recognized his mother and said to her: "Mother, what a hard fall!" An ambulance arrived and took the boy to Durango Hospital. Dr. Juan Homero

VICENTE FOX the first practicing Catholic president of Mexico in decades.

VIEW from the apartment balcony from which Juan José Barragán jumped (computer visualization).

191

A MEDICALLY INEXPLICABLE CURE

DOCTORS SAID that there was no chance that José Herón Badillo would live. The boy was 5 years of age and suffered from advanced leukemia. He had had his spinal cord pierced several times, passed urine with blood, ate virtually nothing, was going bald, and barely weighed 30 pounds. When his mother learned that Pope John Paul II was to visit Mexico, she realized that it was her son's only chance. She decided to take him to Zacatecas Airport, close to her home in Rio Grande, as the pope's plane was to land there. Her husband, who was not a believer and a well-known left-wing local politician, thought that it was crazy, but yielded to his wife's persuasion.

On May 12, 1990, the couple and their son found themselves at Zacatecas Airport, together with a dense crowd of Mexicans. The family stood at a certain distance from the place where the pope was to pass, while the boy's mother prayed that the pope would mingle with the crowd. And Pope John II did indeed turn in their direction. Little José, who held a white dove, released it at a signal from the pope, who came closer to the couple and kissed the boy's balding head.

The boy later told his parents that at that very moment he felt as though a current of strength flowed through his body. While returning home by car he asked for food, something he had not done for some time. After several months there were no traces whatsoever of the leukemia. His father became a fervent Catholic.

Some years later, José Herón Badillo, then a healthy 19-year-old, had an audience with Pope John Paul II. He showed the pope a photograph of their meeting at Zacatecas Airport. The pope simply said: "God does great and wonderful things."

JOSÉ HERÓN BADILLO as a young man, a witness to the holiness of Pope John Paul II.

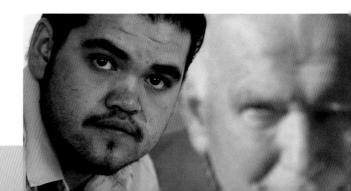

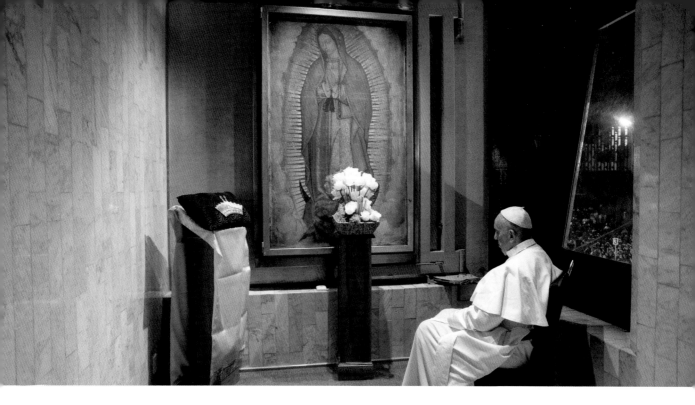

Hernández Illescas attended to the boy. The doctor wanted to give him a pain-killing injection, but the boy protested, waving his hands and kicking his feet frantically. The doctors were amazed that the boy was still alive, as he had fractured his skull and lost a lot of blood and cerebrospinal fluid. According to them it was just a question of time before he died. On May 5, they told his mother that her son was in a critical condition, that they were helpless, and that death would come at any moment. Specialists at other medical centers, who had been given photos and results of examinations, were convinced that they had the data of a deceased boy before them. His mother, however, did not give up and stubbornly prayed the whole time to Juan Diego, who was to be beatified the next day by Pope John Paul II.

On May 6 – at the very moment the pope was beatifying Juan Diego at the Basilica of Our Lady of Guadalupe – Juan José Barragán suddenly came round in the nearby Durango Hospital, not showing any signs of illness. The medical personnel were shocked. Examinations showed that the fractured skull had knitted spontaneously. On May 12, the boy left the hospital, healthy and without help. Eleven years later, in December 2001, the Congregation for the Causes of Saints confirmed that his cure was a miracle, that it had occurred at the intercession of Juan Diego Cuauhtlatoatzin.

Fr. Eduardo Chávez, who has accumulated extensive documentation on scientifically inexplicable phenomena related to the image at the Higher Institute for Guadalupan Studies, says the message of Mary's apparitions is significantly more important than any miracle. The message is not only to Mexicans, but to people of all continents, cultures, races, and nations – a summons to build a civilization of love.

DURING HIS VISIT to the Shrine of Our Lady of Guadalupe, Pope Francis prayed before the miraculous image of the Madonna in the little room behind the image. During his homily that same day he said: "We look to our Mother with eyes that express our thoughts: there are so many situations which leave us powerless, which make us feel that there is no room for hope, for change, for transformation. Hence it is worthwhile to be silent for a while and look upon her, gaze at her long and calmly, saying that which that other son had said, he who so loved her."[19]

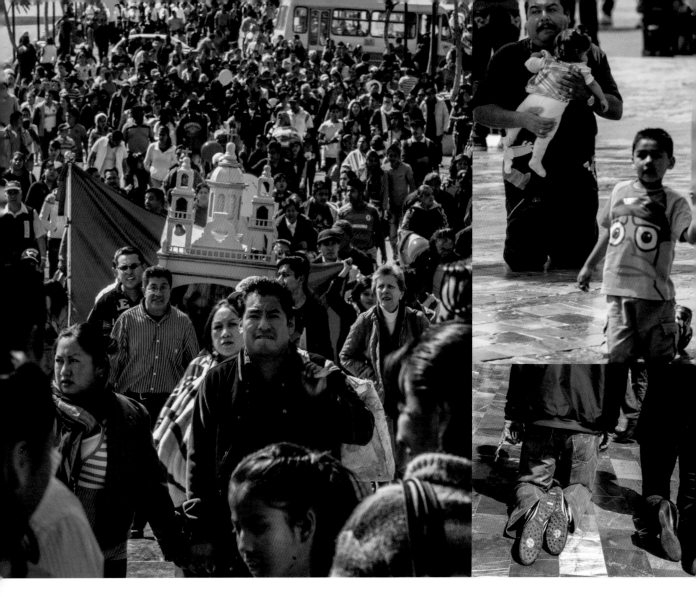

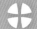

A NEVER-ENDING STREAM of believers visit the Shrine of Our Lady of Guadalupe with their requests and thanks.

Pope Francis appeared in Guadalupe in February 2016. While on the plane to Mexico he stated that he was going there to look Our Lady in the eyes. During his homily at the shrine he said that just as Mary had once sent Juan Diego on a mission, so today all the faithful are her messengers. He emphasized that a Christian's vocation was to feed the hungry, give drink to the thirsty, clothe the naked, visit the sick, and comfort the afflicted.

After Mass Francis asked to have time for personal prayer before the Image of Our Lady of Guadalupe. So he was invited to the little room behind the image. As the image is on a mobile frame it was possible to turn it to face the honourable guest. Hence he was able to pray in silence before Our Lady for twenty minutes, as did all those gathered in the shrine.

Our Lady of Guadalupe put an end to human sacrifices and ended the rule of the civilization of death. She brought her Son, who replaced all human sacrifices. So it is not surprising that the pregnant Mexican Madonna is the patron of pro-life move-

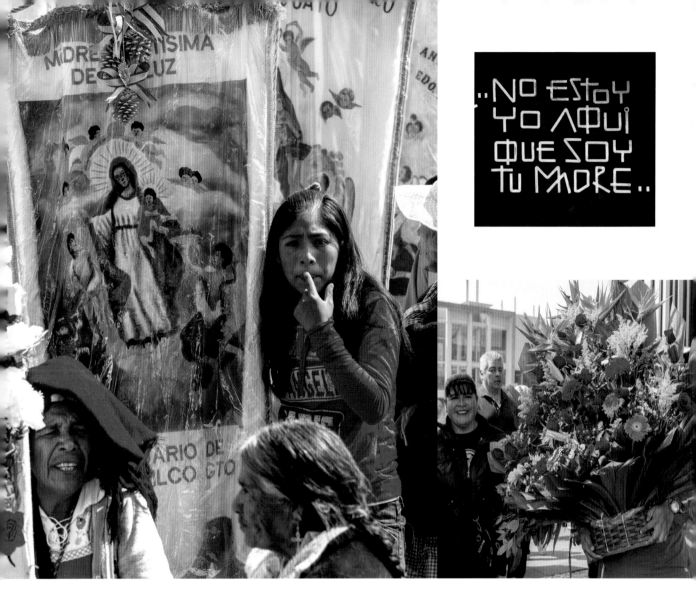

..NO ESTOY YO AQUI QUE SOY TU MADRE..

A SPECIAL TYPEFACE, combining an Indian and Latin style, was created for the new basilica

ments all over the world. Demonstrators parade her image during protests at abortion clinics on all continents. They believe that her image and intercession can bring people to their senses.

Fr. Eduardo Chávez wrote that one could find representatives of all races, cultures, and nations in the face of Our Lady of Guadalupe. They form one people that is beyond all divisions, God's family, sharing a common language, that is, a language of love. A new civilization is emerging out of that community, which John Paul II called a "civilization of life".

This message, contained in the image, draws millions of people to the Mexican shrine from all over the world. However, its impact inheres not only in its content, but also in its form. Hence Zbigniew Treppa, a Polish researcher, the author of *Mexican Symphony*: *The Guadalupe Icon*, writes:

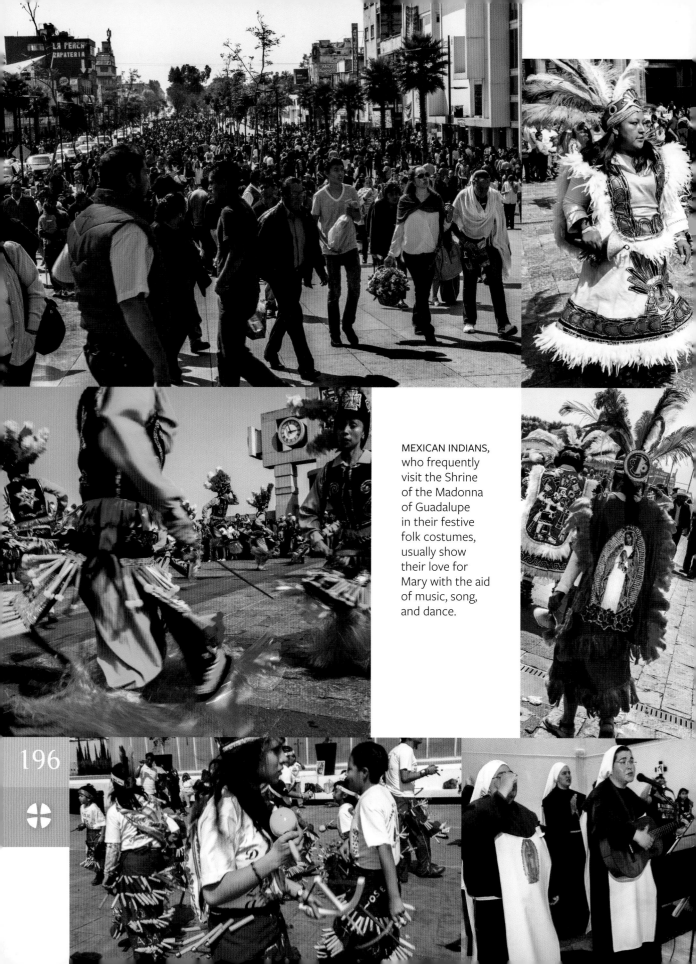

MEXICAN INDIANS, who frequently visit the Shrine of the Madonna of Guadalupe in their festive folk costumes, usually show their love for Mary with the aid of music, song, and dance.

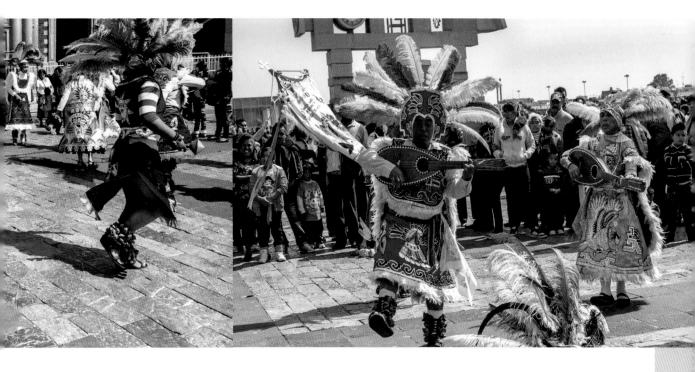

PILGRIMAGE **CENTER**

THE SHRINE OF OUR LADY OF GUADALUPE has a special place in the sacred geography of the world, for it is the world's most frequently visited pilgrimage center, with over 20 million pilgrims yearly. It is worth comparing it with other such centers:

NOTRE DAME Cathedral, Paris – **13.5 million**

SACRÉ-COEUR Basilica, Paris– **10.5 million**

ST. PETER'S Basilica, Rome – **7 million**

BASILICA of Our Lady of the Rosary, Lourdes – **6 million**

SHRINE of Padre Pio, San Giovanni Rotondo – **6 million**

COLOGNE Cathedral – **6 million**

BASILICA of St. Francis, Assisi – **5.5 million**

ST. MARK'S Basilica, Venice – **5.5 million**

BASILICA of Our Lady of the Rosary, Fatima – **5 million**

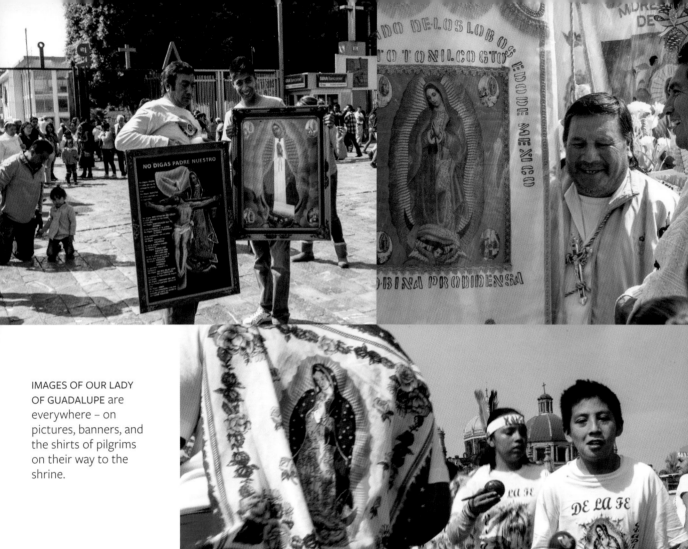

IMAGES OF OUR LADY OF GUADALUPE are everywhere – on pictures, banners, and the shirts of pilgrims on their way to the shrine.

MUCH HAS CHANGED in Mexico over the last 480 years, but one thing has stayed the same – crowds of people heading to Tepeyac Hill to see the Madonna of Guadalupe.

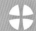

The Image of Our Lady of Guadalupe does not cease to astonish people of Western civilization, people who put excessive trust in the exact sciences. This Mexican icon continues to yield new details to this day, thanks to the most up-to-date research equipment. A question arises: What determines that this image of the Queen of Heaven, who, during the Spanish conquest of America, "obscured the sun" of the Indian's old faith, and who is simultaneously the precursor of the "Woman clothed in the Sun" of the Book of Revelation, lives on beyond the constrictions of cultures and eras? What determines that it reveals new, or rather, invariably the same but

still relevant contents, except that, as it turns out, "stored" in the structure of the image, as if specially destined for our times and – one might suppose – future times too? There seems to be no doubt that the life span of the image and its constant relevance for all cultures and eras is determined by the supernatural nature of the image. Supernatural, that is, transcendental, in this case transcending all the limits that man might want to set to that which is of a supernatural character. In an "empirical" language, the singularity of this image is determined by the fact that is not of a human hand.[20]

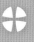

A Challenge for Science

A Challenge for Science

The Image of Our Lady of Guadalupe
has attracted the attention of
scholars for several centuries.
Even today scholars from all over
the world take an active interest
in it: mathematicians, physicists,
geographers, physicians, and so forth.
All of them speak of its mysteries.

Mexico City

MEXICO

IMAGE OF
OUR LADY OF
GUADALUPE
– object of
veneration
for the
faithful,
a mystery for
scientists.

202

Over the centuries this image has been examined numerous times. The first systematic studies were carried out by a group of physicians and painters (1633–1666). Precision research instruments, however, were not then available to register some of the phenomena connected with the image. Such instruments appeared in the twentieth century and inspired a Mexican, Fr. Mario Rojas Sánchez, to approach the image in a new way.

He assumed that as the image was a sort of message, some parts intelligible to the Indians, other parts to the Europeans, then it might well

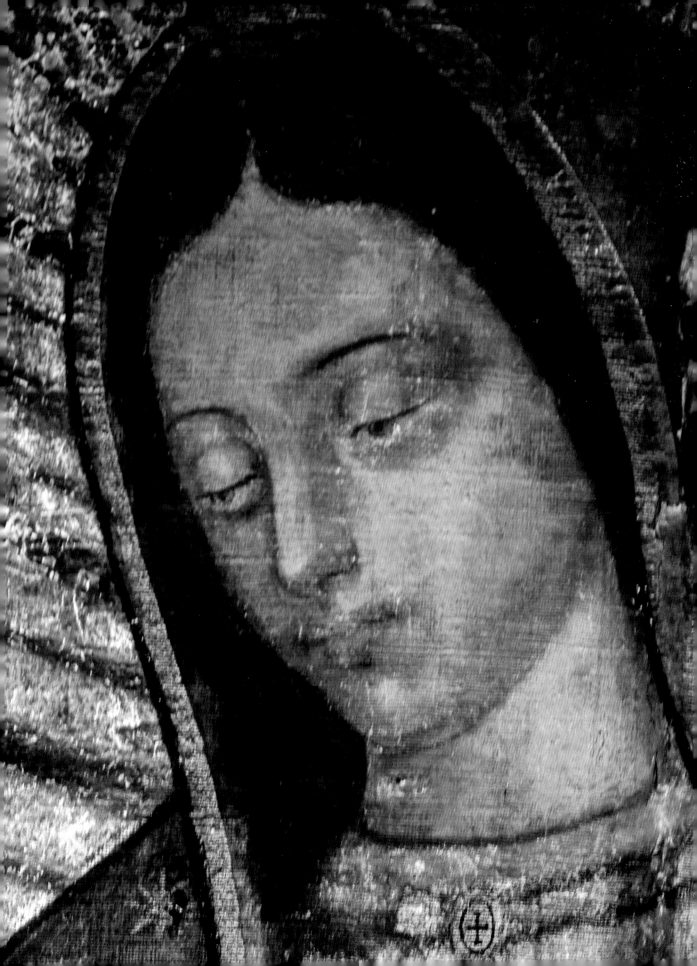

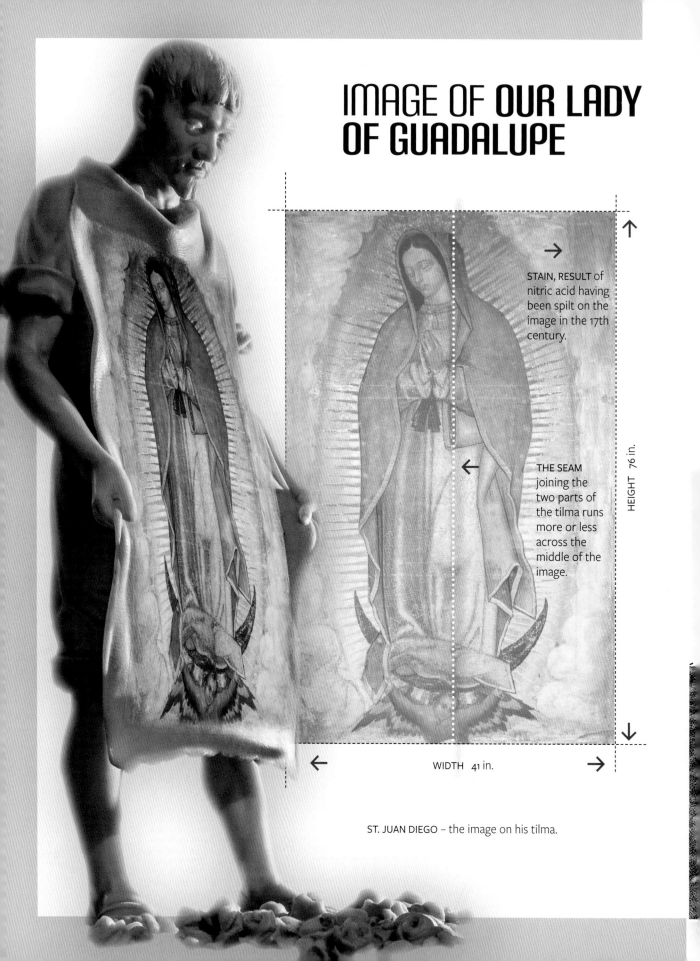

IMAGE OF **OUR LADY OF GUADALUPE**

STAIN, RESULT of nitric acid having been spilt on the image in the 17th century.

THE SEAM joining the two parts of the tilma runs more or less across the middle of the image.

HEIGHT 76 in.

WIDTH 41 in.

ST. JUAN DIEGO – the image on his tilma.

contain certain information that was decipherable scientifically. Hence, in 1988, Fr. Rojas decided to do a surprising experiment. The layout of the mountain flowers on Our Lady's tunic intrigued him; he wondered if the layout matched any patterns in nature.

This inquisitive priest placed a map of Mexico on the image. He arranged it so that the quincunx, the flower of the sun – a symbol of divinity and transcendence – on Mary's womb corresponded to Tepeyac Hill (on the map), where the apparitions of Our Lady occurred in December 1531. To his amazement, he discovered that some of the mountain flowers on the tunic corresponded to certain volcanoes in Mexico.

It turns out that the flower on the right sleeve of the Madonna's tunic corresponds to the Iztaccíhuatl volcano (17,158 feet), the one on the left corresponds to the Popocatépetl volcano (17,887 feet), and the one under her neck to the La Malinche volcano (14,635 feet). In addition, the star

FOLLOWING PAGES: the Image in all its splendor.

MARY'S EYES – diameter of the irises is 5/16 in.

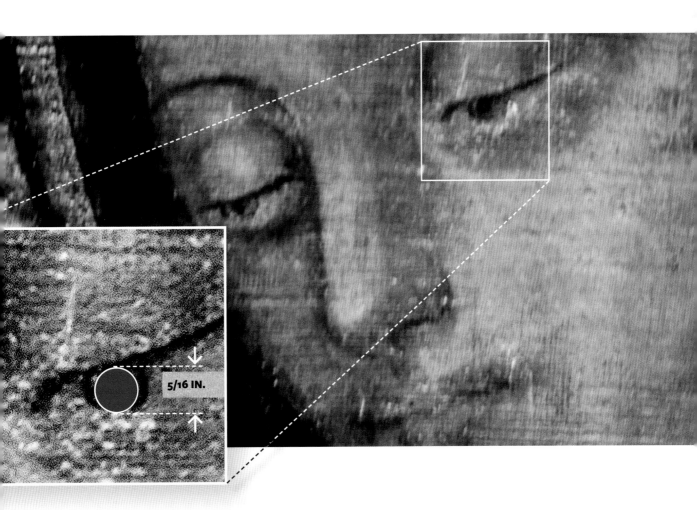

5/16 IN.

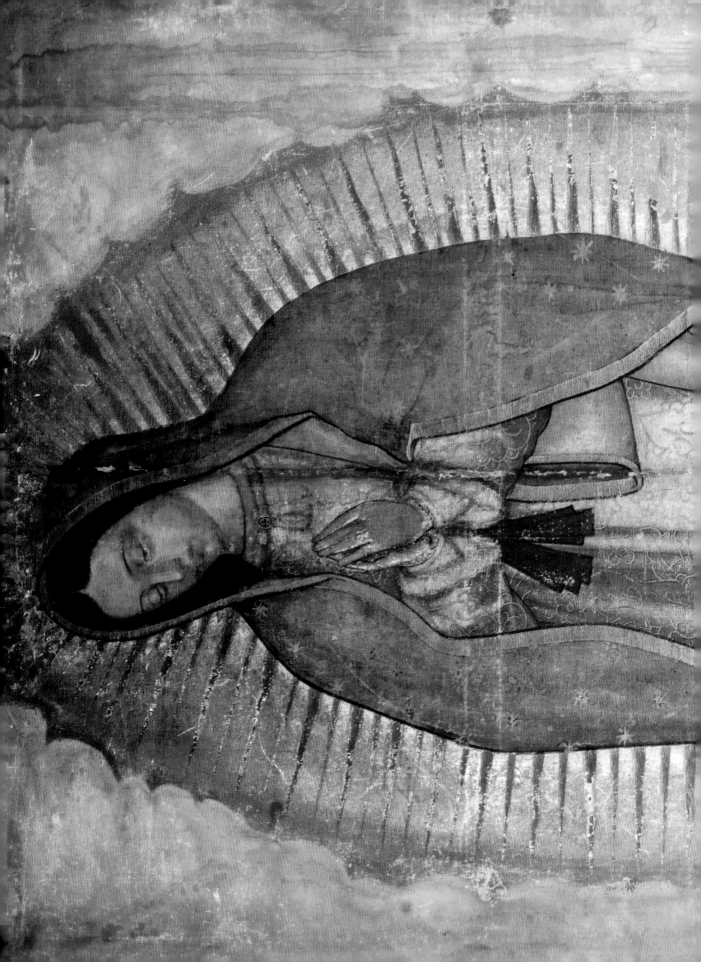

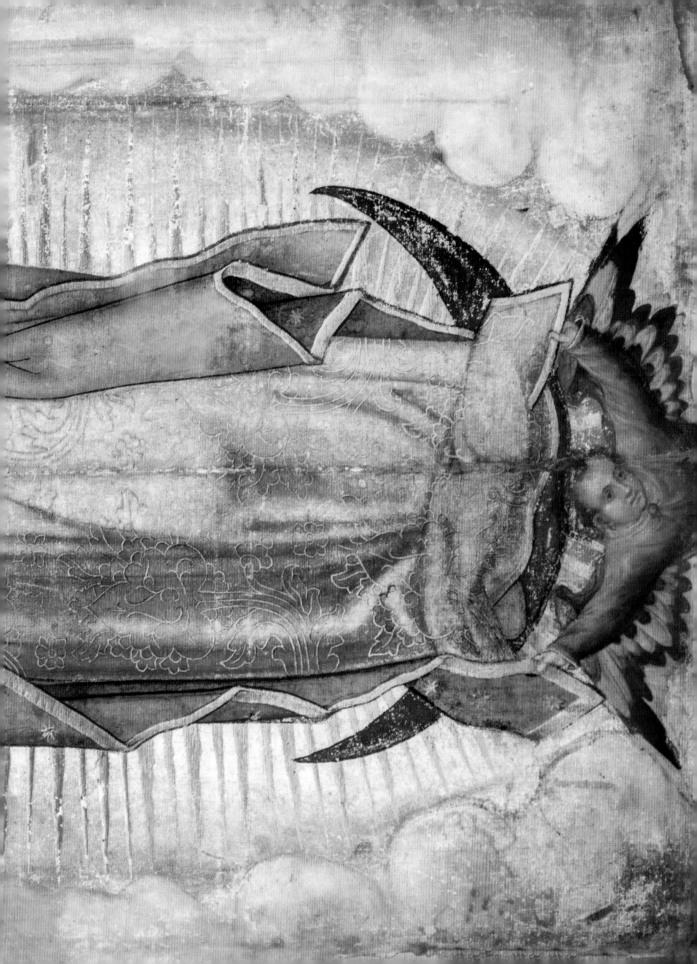

SUNRISE IN
Mexico – from
outer space

IDEOGRAM
MAP of the sky
(as seen by
Europeans). The
Corona Borealis
(Northern Crown)
constellation is in
the center.

on Mary's right arm corresponds to the summit of Cerro de Chignautla (8,398 feet), the one on her head to another mountain, Pico de Orizaba (18,490 feet), while the gold-encircled-cross brooch under the neck of the Madonna's tunic corresponds to the summit of Nauhcampatépetl (Place of Four Mountains, 14,048 feet).

Two decades later, a Mexican mathematician, Prof. Fernando Ojeda Llanes, from the Yucatán Peninsula, decided to verify these findings. In 2008, he published a work in which he stated that the correspondence of distinctive points on the map of Mexico, like mountains and volcanoes, to particular elements in the image, like flowers or stars, was – applying Fr. Mario Rojas' methods – less than 70 percent. Prof. Ojeda, however, had not treated Fr. Rojas' work with disdain, for he acknowledged that the priest's intuition was right, but that his method was flawed. So he decided to modify his predecessor's work.

First, he used significantly more precise satellite maps, based on a Google Earth computer program. Secondly, he aligned a map of Mexico on the image somewhat differently, so that the quincunx corresponded to Cerro de Estrella (Star Mountain), one of the most important geo-

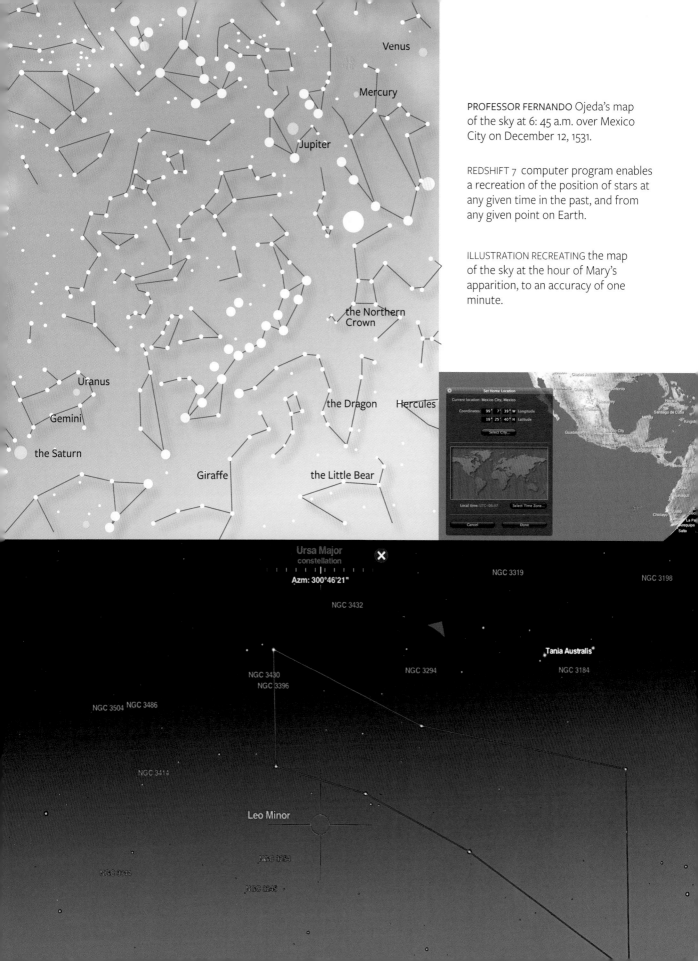

Venus

Mercury

Jupiter

the Northern
Crown

Uranus

Gemini

the Saturn

Giraffe

the Dragon Hercules

the Little Bear

PROFESSOR FERNANDO Ojeda's map of the sky at 6: 45 a.m. over Mexico City on December 12, 1531.

REDSHIFT 7 computer program enables a recreation of the position of stars at any given time in the past, and from any given point on Earth.

ILLUSTRATION RECREATING the map of the sky at the hour of Mary's apparition, to an accuracy of one minute.

Set Home Location
Current location: Mexico City, Mexico
Coordinates: 99° 7' 39° W Longitude
 19° 25' 40° N Latitude
Select City...

Local time: UTC−06:37 Select Time Zone...

Cancel Done

Ursa Major
constellation

Azm: 300°46'21"

NGC 3319 NGC 3198

NGC 3432

Tania Australis

NGC 3430 NGC 3294 NGC 3184
NGC 3396

NGC 3504 NGC 3486

NGC 3414

Leo Minor

CONSTELLATIONS ACCORDING to the Aztecs. Amongst them are 1) Mamalhoaztli (Seven Sisters) and 2) Citlalcolotl (Scorpio).

THE AZTECS saw the sky in a completely different way from the Europeans. They arranged the stars in different constellations and used different naming conventions. Some constellations were identical, for example, Scorpio and the Seven Sisters. They called the latter the Fire Drill, which was used to create new sacred fire every 52 years.

210

✠

AS THE Aztec calendar had 20 months, the Indian zodiac had 20 signs: Crocodile (Cipactli), Wind (Ehecalt), House (Calli), Lizard (Cuetzpallin), Serpent (Coatl), Death (Miquiztli), Deer (Mazatl), Rabbit (Tochtli), Water (Atl), Dog (Itzcuintli), Monkey (Ozomatli), Grass (Malinalli), Reed (Acatl), Jaguar (Ocelotl), Eagle (Cuauhtli), Vulture (Cozcaquautli), Earthquake (Ollin), Knife (Tecpatl), Rain (Quiahuitl), and Flower (Xochiti).

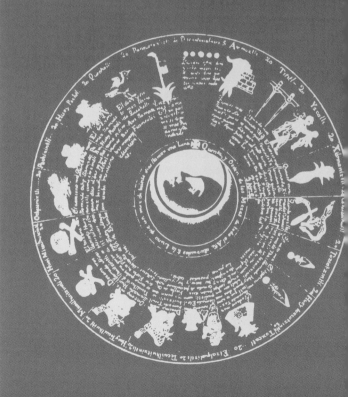

The constellation map shows the following labels: MB3, Corvus, Crater, NGC 3621, Antlia, Vela, Pyxis, Hydra, NGC 3109, Sextans, NGC 3521, Leo, Leo Minor, NGC 2903, Cancer, Canis Mir

1531 Dec 12 06 : 45 : 00

graphical points in the Aztec religion. It was precisely on this summit that the solar deity cult priests observed whether the sun would rise for the next cycle. When it rose, they lit fires as a sign that the world would continue to exist. Now, the Stations of the Cross are celebrated on this summit every Good Friday.

It turned out that Prof. Ojeda Llanes' alignment of the map yielded amazing results. The mountain flowers on the tunic corresponded to certain mountain summits and volcanoes: La Malinche, Papayo (11,942 meters), Popocatépetl, Tepeyac, Jocotitlán (12,887 feet), the Valle de Bravo volcano complex (to 11,482 feet), Chinchinautzin (11,404 feet) and Nevado de Toluca (15,387 feet); while the star on the Madonna's head corresponded to the Pico de Orizab mountain. This time, according to Prof. Ojeda Llanes' mathematical calculations, the correspondence was of the order of 92.9 percent. Did any of the cartographers of the sixteenth century, when the image of Guadalupe came into existence, have

THE SKY OVER MEXICO CITY at 6:45 a.m., on December 12, 1531. In actual fact, the stars were not visible, as it was dawn.

techniques and instruments to create an equally precise map? Neither the Aztecs nor the Spaniards, to whom Mexico was then terra incognita, achieved such precision.

However, if we treat this information as part of the pictogram message, and interpret it as the Aztecs usually interpreted their codes, then it reads as follows: Our Lady of Guadalupe has become part of the Mexican landscape, an intrinsic part of the land. A new Sun has been born of her womb, hence a new era in world history.

Fr. Mario Rojas also decided to examine the arrangement of the stars on the fabric. He invited an astronomer, Dr. Juan Romero Hernandez Illescas, who happened to have an observatory, to cooperate with him. Their investigations, throughout the whole of 1981, showed that the arrangement of stars on the image resembled the star systems that had stretched out over Mexico in December 1531, when the apparitions of Our Lady of Guadalupe occurred.

In time, however, specialist computer programming enabled reconstructions of star systems that were visible at any given moment in the past, and from any given point on earth. Thus it was established that the stars in the image of Our Lady of Guadalupe correspond to

TWO MEXICAN astronomers, Eddie Salazar Gamboa and Daniel Flores Gutierrez, confirmed Fernando Ojeda's discovery.

PROF. FERNANDO OJEDA LLANES made extraordinary discoveries concerning the image of Our Lady of Guadalupe.

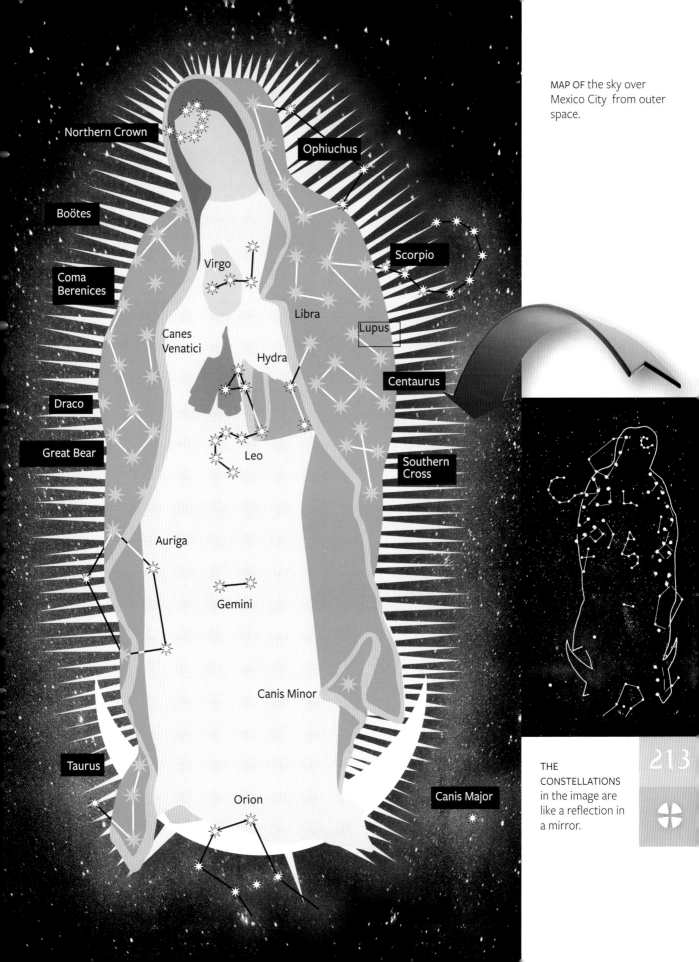

Northern Crown

Ophiuchus

Boötes

Scorpio

Coma
Berenices

Virgo

Libra

Lupus

Canes
Venatici

Hydra

Centaurus

Draco

Leo

Southern
Cross

Great Bear

Auriga

Gemini

Canis Minor

Taurus

Orion

Canis Major

MAP OF the sky over
Mexico City from outer
space.

213

THE
CONSTELLATIONS
in the image are
like a reflection in
a mirror.

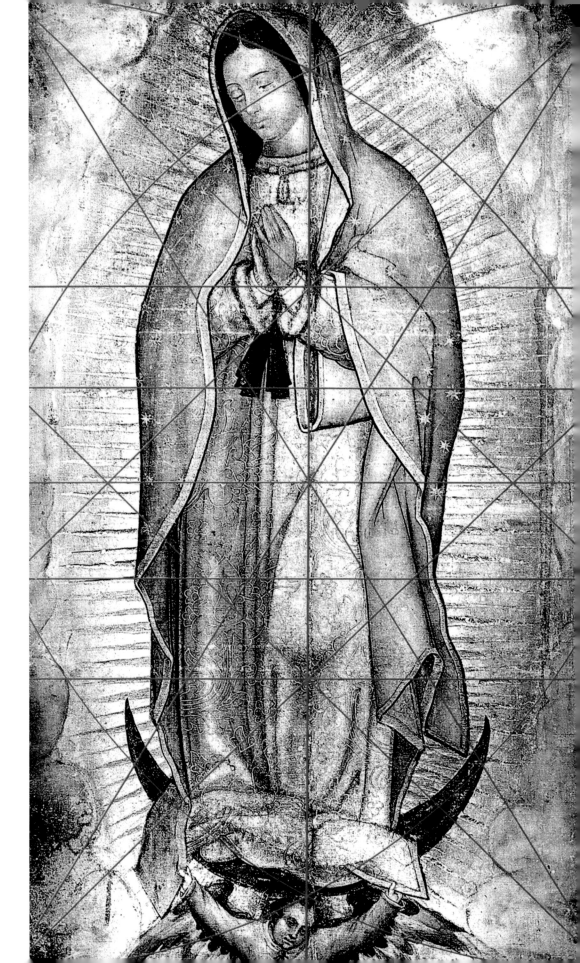

PROF. FERNANDO OJEDA LLANES, a mathematician, states that a geometric perfection, present in the world of nature, can be seen in the image.

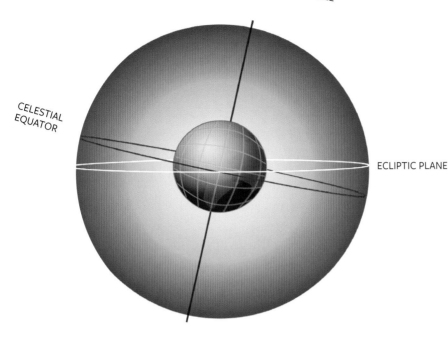

NORTH CELESTIAL POLE

CELESTIAL EQUATOR

ECLIPTIC PLANE

OUR LADY'S HEAD
is inclined at the same
angle as the earth's
axis.

SOUTH CELESTIAL POLE

the star systems that were over the capital of Mexico at 6:00 a.m. on December 12, 1531. An analysis of Antonio Valeriano's *Nican Mopohua*, the oldest historical document on the Guadalupe apparitions, shows that it was probably at that exact moment when Juan Diego unfurled his tilma (an everyday outer garment, similar to a wide shawl, which was worn by sixteenth-century Indians) before Bishop Juan de Zumárraga. Had he done so five minutes earlier (6:40 a.m.), or five minutes later (6:50 a.m.), the sky above them would have differed and, for example, the Corona Borealis constellation (Northern Crown) would not have adorned Mary's head as well as it does in the image.

It was of great significance to the Aztec priests that the Corona Borealis corresponded to the Madonna's head, the Virgo constellation to her virgin heart, and Gemini to her knees. Equally important was the fact that the event was on the winter solstice – from that morning on, every day was longer and longer. To the Indians it was a symbolic day, an awakening from death to new life.

Though European civilization was superior to Indian civilization in many respects, it was not the case in regard to astronomy. The Aztecs had a more precise calendar; therefore they knew that the winter sol-

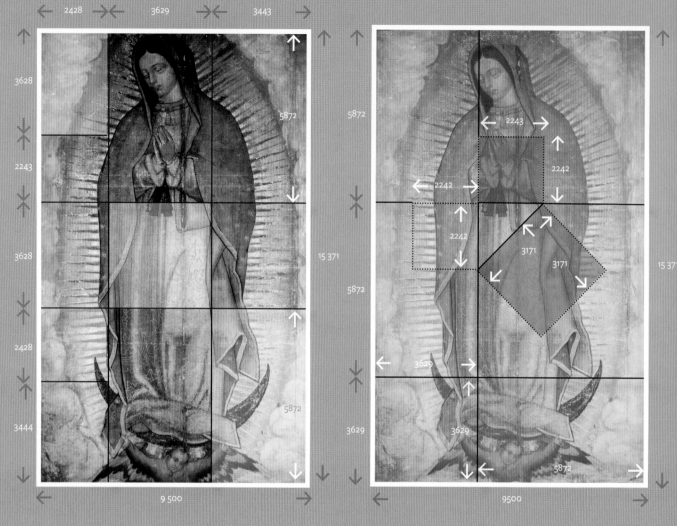

FIBONACCI
SEQUENCE

PROF. FERNANDO OJEDA LLANES
discovered a geometrical arrangement
in the image, the Fibonacci sequence.

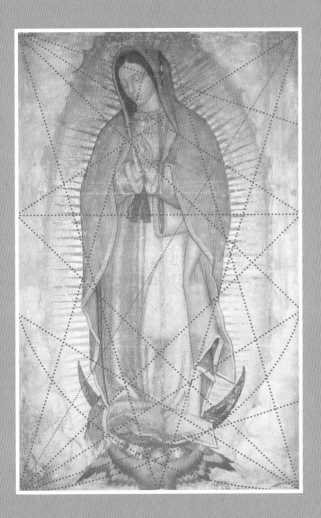

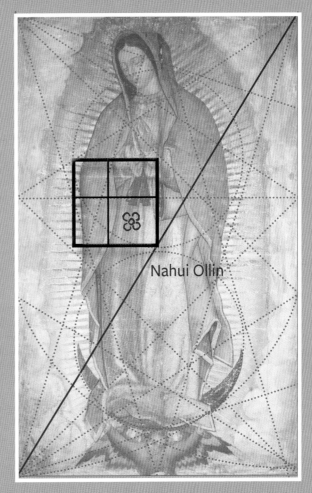

Nahui Ollin

Nahui Ollin

KEPLER'S TRIANGLE

PROF. OJEDA LLANES also isolated the Kepler triangle in the image, an example of a golden ratio.

φ^2

φ

1

0, 1, 1, 2, 3, 5, 8...

1 + 2 = 3 8 + 13 = 21
2 + 3 = 5 13 + 21 = 34
3 + 5 = 8 21 + 34 = 55
5 + 8 = 13 34 + 55 = 89

1/0 = 0
1/1 = 1
2/1 = 2
3/2 = 1,5
5/3 = 1,6666...
8/5 = 1,6
13/8 = 1,625
21/13 = 1,61538...
34/21 = 1,61904

2
3
5
8

8 × 8

13 × 13

2 × 2

3 × 3

$$\frac{a+b}{a} = \frac{a}{b} = \varphi \qquad \varphi = \frac{1 + \sqrt{5}}{2} = 1{,}6180339887\ldots$$

GOLDEN **RATIO**

IN 1202, AN ITALIAN MATHEMATICIAN, Leonardo of Pisa, known as Fibonacci, introduced a series of numbers to Western European mathematics, the Fibonacci sequence, where each number is the sum of the previous two numbers, for example, 1,2,3,5,8,13,21, and 34. It turns out that in this sequence, the ratio between the two following numbers (ad infinitum) always comes to 0.618.

Ancient architects and artists used this number and intuitively called it the "golden ratio", the secret of the proportion between the length, width, and height of a building. It is the basis of the harmony in Egyptian pyramids, Greek temples, Romanesque and Gothic cathedrals, and Renaissance art. We see it in the Arch of Constantine, Leonardo da Vinci's paintings, and Stradivari's violins.

Later, scholars discovered that the golden ratio is found – as an ordering principle – not only in geometry, but also in chemistry, physics, mineralogy, botany, and zoology; mammals, fish, birds, and butterflies are based on this principle. It is in accordance with the Fibonacci sequence that tree trunks, branches, and leaves grow.

Prof. Fernando Ojeda Llanes also discovered the golden ratio in the image of Our Lady of Guadalupe.

a b

a + b

A MOUNTAIN FLOWER ▶ – part of the image of Our Lady of Guadalupe.

stice was, to the Spaniards, on December 12. The Old Continent then followed the flawed Julian calendar, which lost one day every 128 years. This was not corrected until 1582, when Pope Gregory the Great introduced a new solar calendar – the Gregorian calendar.

The discovery concerning the stars in the image was confirmed by two Mexican astronomers: Daniel Flores Gutierrez, from the National Autonomous University of Mexico, and Eddie Salazar Gamboa, from the Autonomous University of Yucatán. With the aid of the Redshift 7 computer program, they compared the locations of the twelve constel-

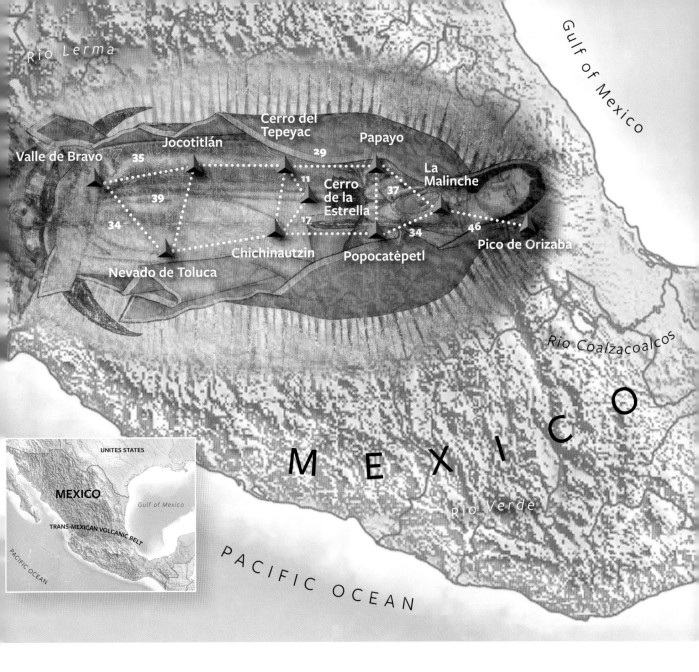

lations in the image with a map of the sky over Mexico at precisely 6:45 a.m. on December 12, 1531. It turned out that seven of the constellations showed a 100 percent correspondence, two 95 percent, and the remaining three 99 percent, 94 percent, and 91 percent.

Dr. Juan Romero Hernandez Illescas also discovered a certain idea that is expressed in the image, an example of classical iconographic harmony in the configuration of the figure of Our Lady, a circle, an ellipse, and a cross. In 2008, Professor Fernando Ojeda Llanes confirmed these findings and added that the image exemplifies the golden ratio.

MEXICAN **VOLCANOES**

TWO OF THE THREE HIGHEST VOLCANOES, Popocatépetl and Iztaccíhuatl, are but 43 miles from Mexico City. According to Aztec mythology, they were formerly two lovers: a warrior and a princess. Iztaccíhuatl died of despair when she learned that Popocatépetl had been killed in battle. But this turned out to be untrue, and on returning from the war Popocatépetl took his beloved's body to the mountains to bury her and himself. However, the gods took pity on them and changed the lovers into two mountains – she is dormant, while he spits out fire and stones.

Iztaccíhuatl has indeed been dormant for a long time, while Popocatépetl is still active, with 19 eruptions recorded since 1347. The latest phase of activity began in 1994. From that time the summit has been inaccessible to tourists, who are only allowed within a few miles of it, as the path is closed and guarded by soldiers. The volcano's biggest eruption was in 2000, when 40,000 people had to be evacuated.

THE EL CHICHÓN volcano last erupted in 1982, killing 2,500 people.

POPOCATÉPETL VOLCANO (Popo) became active in 1994, after being dormant for a long time.

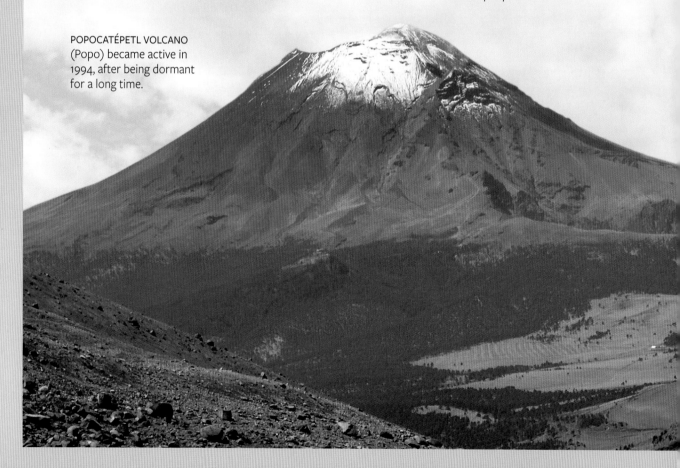

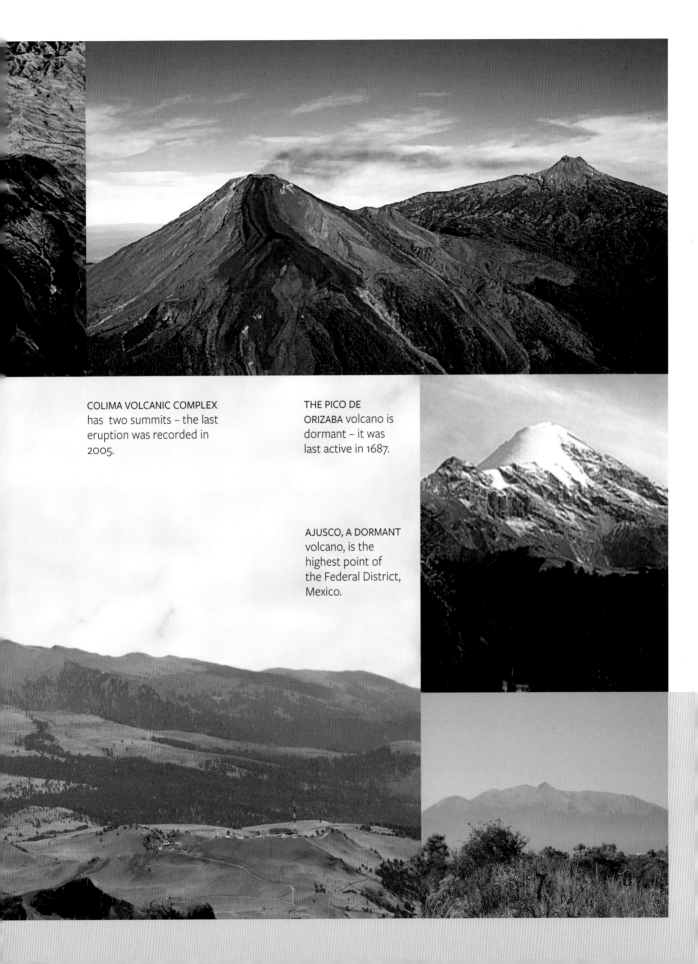

COLIMA VOLCANIC COMPLEX has two summits – the last eruption was recorded in 2005.

THE PICO DE ORIZABA volcano is dormant – it was last active in 1687.

AJUSCO, A DORMANT volcano, is the highest point of the Federal District, Mexico.

THOUGH PYTHAGORAS was the most outstanding mathematician of ancient times, he saw himself as a philosopher. He was the first to use the word "philosophy".

PYTHAGORAS' INTUITIONS inspired Prof. Ojeda's research into the image of Our Lady of Guadalupe.

Dr. Illescas decided to concentrate on the mathematical connotations contained in the image. Our Lady's head is inclined about 23.5 degrees to the right, the same inclination as the earth's equatorial plane to the ecliptic plane. If this were no accident, then perhaps it signified an act of humility and subordination to God, in that it was an imitation of the earth's inclination and dependence with regard to the sun.

Prof. Ojeda made another interesting discovery, inspired by the writings of Pythagoras, who stated that mathematics reminds one of a square, the sides of which represent arithmetic, geometry, astronomy, and music. This did not give Prof. Ojeda peace of mind. He – also a university lecturer in mathematics – discovered certain elements in the image: elements of geometry (the golden ratio, with a wheel, an ellipse, and a cross); of astronomy (star constellations on Our Lady's mantle); and of arithmetic (calculations concerning mathematical correlations between the reflections of the figures in Mary's eyes, the flowers on her clothes, and a map of Mexico). But he did not find any references to music, whereas it was an important part of Our Lady's apparitions. After

STAFF PLACED on the image of Our Lady of Guadalupe.

MUSIC NOTATION – the result of Prof. Ojeda's experiment (accessible below).

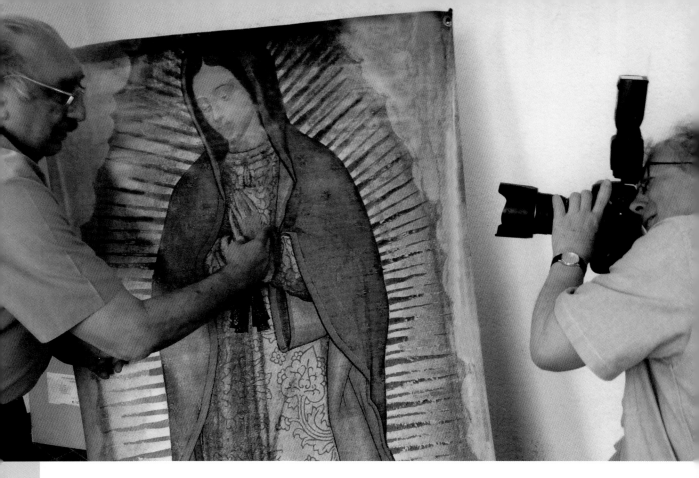

FERNANDO **OJEDA**

ON DECEMBER 11, Prof. Fernando Ojeda Llanes from Yucatán presented the results of his research on the image of Our Lady of Guadalupe at the Vatican. He first presented his mathermatical, geographical, astronomical, and musical findings to Pope Francis personally, and then he gave a lecture to a 1,000 people, including cardinals and bishops from the Roman Curia, as well as from both Americas. Prof. Ojeda sees his presentation at the Vatican as the crowning achievement of his virtually 25-year scientific adventure with the image of Our Lady of Guadalupe. It began in 1990, when, on the eve of Juan Diego's beatification, critics claimed that the Indian hero never existed. Prof. Ojeda decided to determine the truth or falsity of the allegation. After he had convinced himself of the historicity of Juan Diego, he began an interdisciplinary study of the 1531 image. His work resulted in several books, published in cooperation with, for example, the Higher Institute for Guadalupan Studies.

IN HIS STUDY in the town of Merida in the Yucatán peninsula, Prof. Ojeda shares his research on the image of Our Lady of Guadalupe with Janusz Rosikoń.

all, Juan Diego mentioned that his meeting with Mary began with his hearing strains of celestial music coming from the summit of Tepeyac Hill.

Prof. Ojeda decided to follow this up. He divided the image into two on a computer monitor – exactly along the seam that ran down the middle of the image. As there were forty-six stars, he came up with a mathematical model according to which he aligned twenty-three vertical lines on each part of the image. He then transformed the parts into a staff and changed all the stars and flowers into notes. This was, as he himself stressed, a purely mathematical operation. However, it turned out that the notes he had arranged produced a perfect musical harmony.

Later there was an attempt to see whether or not a similar result could be achieved on copies of the image by well-known artists, for example, Miguel Cabrera, Manuel Osorio, and Juan Patricio Morlete Ruiz. But all of them were not true to the original, locating the stars on Mary's clothes somewhat otherwise, the notes then making a discordant sound.

It was also decided to check whether a perfect harmony could be achieved by aligning a stave on a somewhat different arrangement of the star systems, one that mirrored the sky on December 12, 1531, though not at 6:45 a.m., but at 6:40 a.m. or 6:50 a.m. It turned out that even a five-minute difference,

MUSIC NOTATION – the result of Prof. Ojeda's experiment makes a perfect musical harmony.

DIRECT ACCESS to the image is through a special chapel at the rear of the basilica altar. The image is in a closely guarded room with armor-plated doors; it is not accessible to pilgrims and tourists.

and a slight shift of the star constellations, resulted in the computer recording a discordant sound instead of melodic music. Thus perfect musical harmony could only be achieved when the notes conformed to the arrangement of stars in the original image, and so, in accord with a map of the sky over the capital of Mexico on December 12, 1531 – but only at 6:45 a.m.

The professors investigating the phenomena concerning the famous Mexican apparition and image are cooperating with the only scientific research center of its kind, the Higher Institute for Guadalupan Studies (Instituto Superior de Estudios Guadalupanos – ISEG). Its director, Fr. Eduardo Chávez Sánchez, stresses that science has not as yet said its last word concerning the enigmatic elements of the extraordinary image, such as the amazing discoveries concerning Our Lady's eyes.

GUADALUPAN SCIENTIFIC CENTER

THE HIGHER INSTITUTE FOR GUADALUPAN STUDIES (*Instituto Superior de Estudios Guadalupanos* –ISEG) is close to the Basilica of Our Lady of Guadalupe. It is a scientific research center engaged in exploring the phenomena connected with this unique image. It was established in 1998 and linked with the canonization process of Juan Diego, who was beatified by Pope John Paul II in 1990. Several years later, however, revelations were published in the press, repeated by some of the Mexican clergy, that Juan Diego had never existed, and that he was but a figment of the imagination. Hence the Church set up a special historical commission to investigate doubts in the matter.

There were three eminent Mexican historians in the commission: Fr. Fidel González Fernandez, Fr. José Luís Guerrero Rosado, and Fr. Eduardo Chávez Sánchez. In 2001, Fr. Sánchez was appointed postulator during Juan Diego's process. The commission finally came to the conclusion that Diego's existence was without doubt a historical fact. Pope John Paul II canonized him on July 31, 2002.

The historical commission was the germ of the new institution. In 2003, as many myths and misrepresentations had accrued as to Guadalupe, Norberto Cardinal Rivera Carrera decided to set up a center that would carry out scientific research concerning the phenomena connected with the apparitions and the image of Our Lady of Guadalupe. Thus arose the ISEG, a center with which numerous historians, archaeologists, ethnographers, mathematicians, astronomers, and ophthalmologists cooperate. The institute circulates information on its discoveries, organizes numerous international congresses and seminars, produces films, and issues publications. Fr. Eduardo Chávez Sánchez, the best-known expert on Guadalupan studies, has been the director of the institute from the outset.

METROPOLITAN OF Mexico City, Norberto Cardinal Rivera Carera – initiator of the Higher Institute for Guadalupan Studies.

FR. EDUARDO CHÁVEZ SÁNCHEZ – the greatest contemporary authority on the image.

Mystery of the Eyes

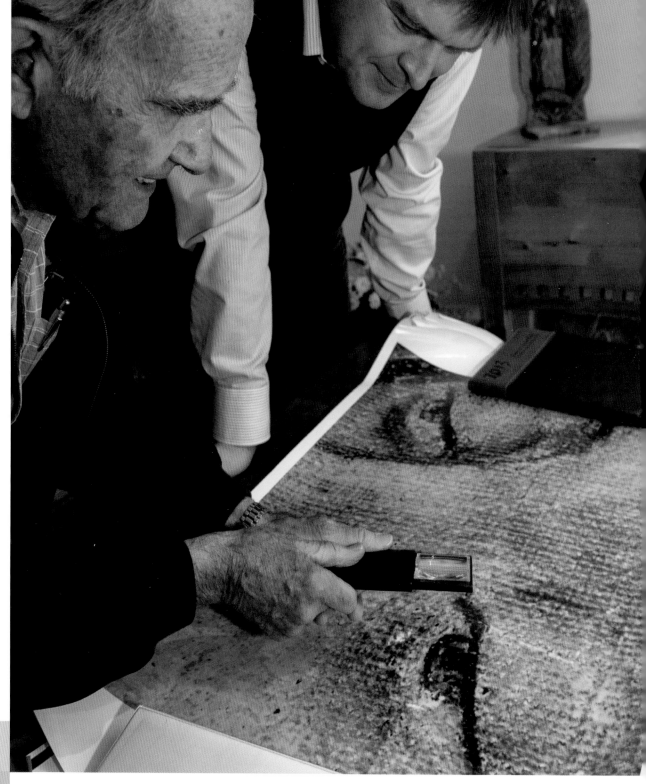

JOSÉ ASTE TÖNSMANN, in his laboratory in Cuernavaca, showing Grzegorz Górny
Our Lady's eye through a magnifying glass.

CHAPTER 7

Mystery of the
Eyes

Digital technology has moved
science forward. It has enabled
a Peruvian engineer, José Aste
Tönsmann, to magnify greatly
the eyes in the image and see the
extraordinary scene that is contained
inside.

Tönsmann's grandfather left Germany in the nineteenth century to settle in
Peru. He himself moved to Mexico in the 1970s and started work at IBM's scientific
research center. One day he came across an article in *Vision*, a Spanish magazine
published in the United States, and learned that human figures had been discerned in
the eyes of Our Lady of Guadalupe. Tönsmann felt a shiver of excitement. If such a
discovery had been made with but a magnifying glass, then much greater possibilities
awaited anyone who had access to the most up-to-date computer technology. So in
1979 he decided to look into the matter.

The Peruvian engineer did not then know that research into the phenom-
enon concerning the Madonna's eyes had been going on for a number of
years. The official photographer at the Basilica of Our Lady of Guadalupe,
Alfonso Marcue Gonzales – who had taken photographs of the image when

TÖNSMANN
AND
COLLEAGUES –
Tönsmann as
a young IBM
worker in the
1970s.

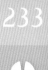

233

ALFONSO MARCUE, official photographer at the Basilica of Our Lady of Guadalupe, was the first to discover the image in Mary's eyes.

MARCUE SAW the reflection of a man in Mary's eye on an enlarged black-and-white photo.

it had been returned to the basilica in 1929 after three years in concealment – was the first to detect something in Our Lady's eyes: the upper part of a bearded man in her right iris. However, on account of the strained relations that then prevailed between the Mexican authorities and the Church, it was decided not to make the discovery public. The next discovery was on May 29, 1951, when another official photographer at the basilica, José Carlos Salinas Chávez, discerned the clear outline of a man in Our Lady's right eye through a magnifying glass. When he informed Archbishop of Mexico Luis Maria Martinez about his discovery, the archbishop decided to set up a special scientific commission to examine the phenomenon. However, he did not come to know of its results as he died in February 1956. His successor, Archbishop Miguel Dario Miranda, invited a group of well-known Mexican ophthalmologists to examine the image.

One of the doctors was Javier Torroella Bueno, whose patient was Salinas Chávez. When the photographer told him of his discovery during an appointment, the ophthalmologist told him that it was physically impossible for an image to have been reflected in Mary's eyes. However, he decided to have a look at the image himself, to convince the photographer that he was indeed mistaken. On Easter

JOSÉ CARLOS SALINAS CHÁVEZ' enlargement of Our Lady's iris.

SALINAS ISOLATED the figure (bust) of a man in Mary's eyes. The actual size of the irises in the image is 5/16 in.

5/16 IN.

AN OPHTHALMOSCOPE

THE EYES IN THE IMAGE OF OUR LADY OF GUADALUPE
have been examined by about 20 ophthalmologists, who used an ophthalmoscope to examine the fundi of the eyes. The ophthalmoscope was invented in 1851 by Hermann von Helmholtz (1821–1894), who was one of the first to articulate the first law of thermodynamics. Modern ophthalmoscopes emit laser beams to scan eyeballs.

Tuesday 1956, Dr. Bueno examined Mary's eyes through a magnifying glass. To his amazement he saw that they reacted like the eyes of a live person, and he also discerned the face of a bearded man in both irises.

Another Mexican ophthalmologist, Rafael Torija Lavoignet, using an ophthalmoscope, carried out three much more detailed examinations of the eyes – on February 16 and 20, and on May 26, 1958.

Lavoignet related later that one could see the upper halves of people in the corners of both eyes, and that that kind of distortion, as well as the site of the optical image, was identical to that of a normal eye. He explained that when the light of an ophthalmoscope was shone into the pupil of a human eye a light reflection appeared in it. Observing the reflection, and altering the ophthalmoscope's lens appropriately, one could see an image at the back

ALFONSO MARCUE, photographer, before the image in the old basilica.

RAFAEL TORIJA LAVOIGNET'S drawing of the man's head that he saw – through an ophthalmoscope – in Mary's eye in 1957.

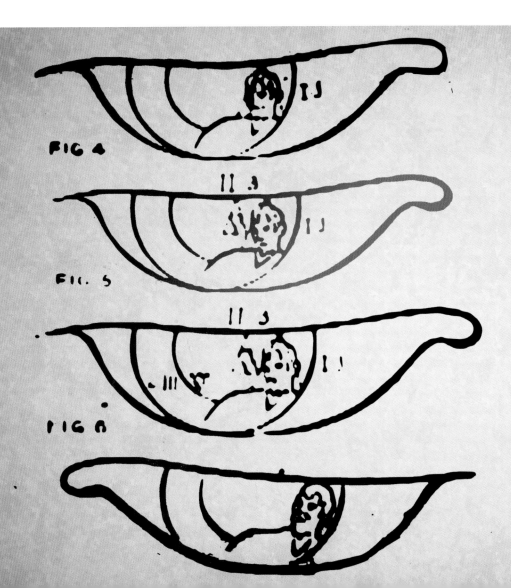

DR. JAVIER
TOROELLA BUENO
was the first
of the many
ophthalmologists
to examine Our
Lady's eyes in the
image.

of the eye. He was shocked when the same light reflections appeared on Our Lady's pupils. The pupils were lit up with diffused light, giving one the impression of a concave surface. Lavoignet pointed out that it was impossible to attain such a reflection on a flat surface.

Using an ophthalmoscope, Lavoignet examined many eyes in the various copies of the image – depicted by the use of various techniques – as well as their photographic copies, and he did not find a similar reflection. It turned out that in the image, Our Lady's eyes were like live human eyes, unlike the paintings of the Madonna by Raphael, Murillo, or Van Dyck.

This discovery by the Mexican ophthalmologists was possible thanks to a German physicist, Hermann von Helmholtz, who had worked out a theory of eye accommodation in 1880. A question arises: How could an artist have applied this law in a sixteenth-century painting?

Dr. Lavoignet confirmed Dr. Torroella Bueno's observation that the upper part of the same bearded man was visible in both of Mary's eyes, though it was not identical as, according to ophthalmologists, it was the result of the natural curve of the cornea. This asymmetry was in conformity with the discoveries of John Evangelist Purkyně and Luis Joseph Sanson in the nineteenth century, and which can be verified on a live eye. No artist could possibly achieve such an effect.

So Dr. Lavoignet concluded that the Madonna's eyes reacted like those of a live person. He even noticed that the bearded man's arm and hand, being partly in the iris, and partly in the pupil, caused a stereoscopic effect.

In the following years Bueno's and Lavoignet's discoveries were confirmed by other ophthalmologists: Ismael Ugalde Nieto, Jaime Palacios, Guillermo Silva Rivera, and Ernestina Zavaleta.

In 1962, an American couple, Charles and Isabelle Wahlig, examined the image in Mary's eyes. He was an ophthalmologist, and she was an optician. With a 25x enlargement of the image they noticed two more figures beside the bearded man.

In 1974 and 1975, Dr. Enrique Graue, a Mexican ophthalmologist, confirmed the findings of his predecessors. He related that when he looked through an endoscope into the inner part of the eye, he could not get rid of the impression that it was a supernatural phenomenon. When using the ophthalmoscope he at times wanted to ask Mary to look upwards a little, because her eyes were so like those of a live person.

THREE-DIMENSIONAL VISION

STEREOSCOPIC VISION, observed in Our Lady's eyes in the image, is characteristic of some mammals, including humans, but it has never been observed in any well-known works of art. It arises when two eyeballs, directed in the same direction, reflect two very similar images, out of which the brain forms one image.

Horopter

Panum's fusional area

PURKYNĚ-SANSON EFFECT

THE EFFECT OBSERVED IN THE EYES OF THE IMAGE OF OUR LADY OF GUADALUPE was named after two scientists, the Czech anatomist John Evangelist Purkyně (1787–1869) and the French ophthalmologist Louis Joseph Sanson (1790–1841), who were the first to discover and describe the effect. It pertains to the question of how light is reflected from various parts of the eye. When we observe focused light beams passing through the eye at an angle, we can see four reflections: from the outer and inner surfaces of the cornea, and from the anterior and posterior surfaces of the lens. Unlike the others, the last image is inverted. This is only observable in living organisms, not in pictures, particularly not in one where the iris measures but 5/16 in.

A Mexican surgeon, Amado Jorge Kuri, examined the Madonna's eyes in August 1975 and published a formal expert opinion. He too noticed the Purkyně-Sanson effect, and he acknowledged that one could discern in the irises a male figure with a clearly visible head, neck, and right hand. Summing up, he declared that Mary's eyes, though it seemed to be absurd, did indeed look like those of a live person.

Dr. Eduardo Turati Alvarez, an ophthalmologist, carried out examinations in December 1975. He not only confirmed the previous doctors' discoveries, but also added to their findings. He stated that the image in Mary's irises could not be the result of any known painting technique, whereas it recalled, he noted, the reflection of an image that was analogous to one that a live eye registers. Thanks to the Kodak Company, which made its best photographic equipment available for the examinations, Alvarez concluded that the image in the Madonna's eyes gave one the impression that it was "stuck" or "printed" on the fabric, and not painted. Using better equipment than that of his predecessors, Alvarez clearly saw two other, somewhat smaller figures beside the bearded man.

In 1976, Dr. Javier Torroella Bueno, an ophthalmologist who had examined the image over a period of twenty years, confirmed that a bearded man was visible in both irises. The fact that a reflection of the same man was in both eyes ruled out – in his opinion – the possibility of an optical illusion.

TÖNSMANN BEGAN to examine the image in the 1970s using computers of the time.

DIVISION of the black-and-white photograph of the image into 10 kinds of squares, depending on their blackness.

240

| 0 | 1 | 2 | 3 | 4 | 5 | 6 | 7 | 8 | 9 |

2	0	0	0	2	0	0	0	0	0
3	1	0	1	4	5	5	4	2	0
3	1	1	4	4	5	5	6	5	2
4	2	3	5	5	5	6	5	5	4
5	3	2	5	5	5	4	5	4	4
3	3	2	4	4	5	4	5	5	6
6	4	1	4	5	5	6	7	7	8
7	4	2	2	4	6	6	8	8	8
5	4	3	2	5	6	6	7	8	8
7	6	4	2	3	5	6	7	7	8
6	7	6	3	2	4	5	6	7	7

JOSÉ ASTE TÖNSMANN looking at the enlargement of the image through a magnifying glass, thanks to which the details in Mary's eyes are clearer.

241

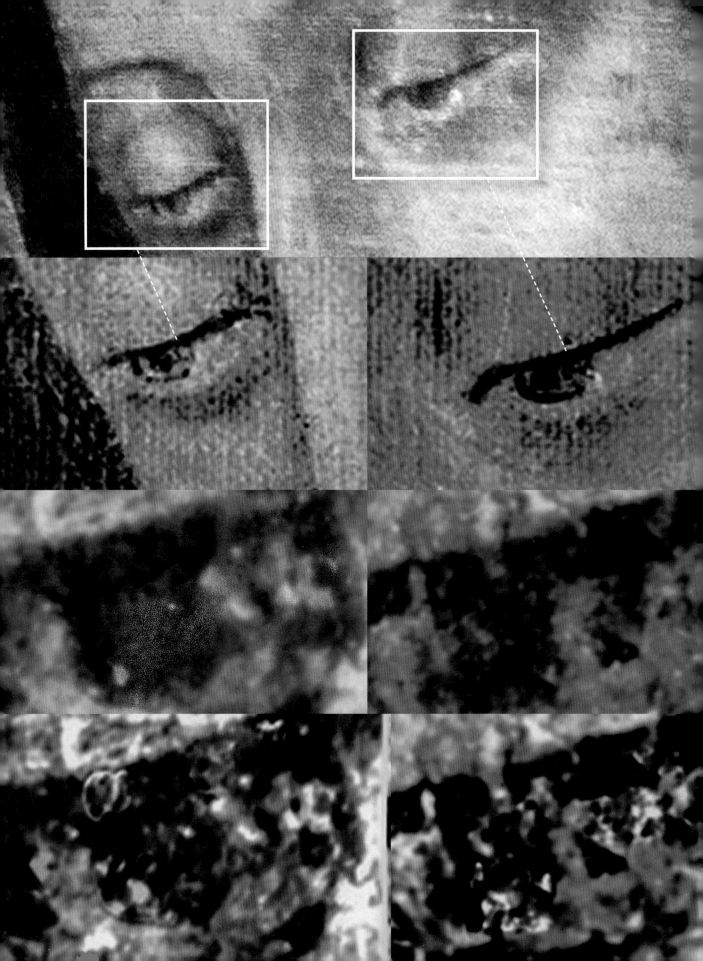

The difference between the two images in the eyes, exactly in accord with the principles of optics, also argued against the possibility of an optical illusion.

In 2008, the aforementioned Mexican mathematician, Fernando Ojeda Llanes, on the assumption that the same figures, and their positions, were in both irises, decided to work out to what degree they were in accord with the principles of projection and reflection that are characteristic of human vision. It turned out that – observing all the laws of optics – the images in both eyes showed a correspondence of 98.45 percent.

There is no other similar phenomenon in the world. This image measures 76 inches × 41 inches. Our Lady herself is 56 inches from head to foot, while the diameter of her irises is a mere 5/16 inch. So it is no small wonder that no one managed to see the image in the Madonna's eyes for over four hundred years. No painter on earth could have possibly painted such a precise image on such a small surface, observing a virtually 100 percent conformance with the laws of optics, which were not known until the nineteenth century.

SEQUENCE OF successive enlargements – Mary's eyes with an ever clearer image in them.

TÖNSMANN SHOWING the group scene in Mary's irises in the image on his computer screen.

243

TÖNSMANN'S ENLARGEMENT of the image in Our Lady's right iris.

SEVERAL FIGURES visible in Our Lady's pupil.

Research on the image, however, saw a great breakthrough with the coming of digital technology. In 1979, José Aste Tönsmann was able to enlarge the eyes in the image as much as two thousand times, and thus discover more scenes in the irises, scenes that observed all the rules of optics, as in a live human eye.

Tönsmann, a Peruvian, set up a laboratory at home, where he pored over photographs for days on end. He could not sleep for many nights. He hung up two enlarged photos of Mary's eyes on a wall, at which he gazed for hours. The equipment he used distinguished eight, and later sixteen shades of grey; the more precise they were, the clearer the particular figures. But he had doubts as to whether they really were human figures or whether they were but an illusion.

For there is a psychological phenomenon called pareidolia. Barrie Schwortz, an American researcher on the Turin Shroud, explains the essence of pareidolia thus:

Well, it is seeing something that does not exist. For example, a face on the moon. Of course that is not so, but it seems to some that they really do see a face there, as the brain and eye work closely with each other – it is a subconscious process. When one looks at various shapes (particularly random shapes) the brain automatically attempts to comprehend what is seen, seeking similar images in the memory. When it finds something similar, then we begin to "see" it. Not long ago, during one of my lectures on the Turin Shroud, a girl stood up and said that when she looked at the scourge marks on Jesus' back, marks visible on the Shroud, she saw the face of a screaming

man. Why? Because she is God-fearing, and because she has a great love for Jesus. She was not lying, for she believed that which she had in her heart. Such is pareidolia. Even scholars who are not specialists in imaging fall victim to this phenomenon, as a pair of eyes does not make us experts in imaging nor in visual perception, just as a pair of hands do not make us surgeons. Hence people are prone to optical illusions, which easily mislead our visual – mental perceptions; it is quite simply one of man's limitations."[21]

Fortunately one can protect oneself against pareidolia. Barry Schwortz explains: "There are people, for example, interpreters of photographs, who analyze aerial reconnaissance or satellite photographs. They are known as photo-interpreters, and have been specially trained to accurately identify details in satellite photos. They are taught to distrust what they see. They have to discern what actually exists, and not what they see, or what they think they see. Non-specialists in imaging are prone to interpret things incorrectly."[22]

ENLARGEMENT OF Our Lady's right eye allows one to see the group scene in it.

$$X_d = a + bX_i + cY_i$$

José Aste Tönsmann analyzed microscopic and satellite photographs. So he was experienced in interpreting such photos. His doubts, however, arose from something else: he had access to photos of the image of Our Lady of Guadalupe, but they were not of the highest quality.

In 1981, he participated in a scientific seminar, where he presented the results of his research, but he made it clear that he could not guarantee them 100 percent as he did not have access to the original image. The archbishop of Mexico City approached him after the lecture and asked him what he needed for his research. Tönsmann told him that he would like to see the image personally. He soon had direct access to it. The armored glass was removed, and the Peruvian first looked at the Madonna's eyes through a magnifying glass and then took photos of the highest quality, to be used for further enlargements.

The enlargements not only showed the bearded man, but also twelve other people. Thanks to a computer technique, Tönsmann also managed to isolate many smaller details, for example, a squatting Indian's sandal laces (120 microns in width), as well as his ornate earring (barely 10 microns thick).

Thirteen people are visible in both the Madonna's eyes. Together they form a group scene, which José Aste Tönsmann decided to identify. On the

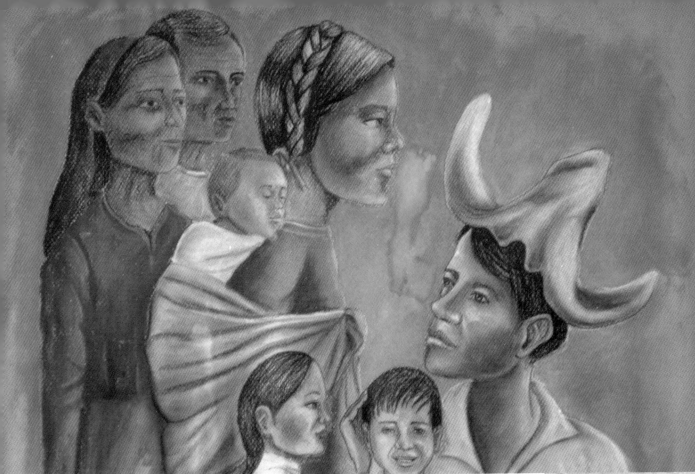

basis of an analysis of the aforementioned sixteenth-century historical document, the *Nican Mopohua*, written by Antonio Valeriano, he put forward the theory that the scene depicted in the eyes was the very moment when – on December 12, 1531 – Juan Diego was showing Bishop Juan de Zumárraga Our Lady's image on his tilma.

So let us follow the Peruvian researcher's interpretation of the image (a drawing of which is on page 249). The first figure, on the left, is a kneeling Indian with a high forehead, highlighted thanks to his hair being tied back. Indians wore their hair thus in the sixteenth century, as one can see, for instance, in the paintings in the Cerrito Chapel on Tepeyac Hill. His earring is also visible, a local custom of that time.

To the right of the Indian there is a bearded man who – according to Tönsmann – is most probably Bishop Juan Zumárraga, as he is very similar to Miguel Cabrera's eighteenth-century painting of him. Behind the bishop can be seen another man's head, which looks like the bishop's assistant. We know from historical sources that the bishop had a translator, a certain Juan Gonzales. In Tönsmann's opinion, it is Gonzales who is standing behind the bishop.

A 16TH-CENTURY DRAWING – confirmation that Indians wore cone-shaped hats.

Juan Diego – according to Tönsmann – is sideways, wearing a conical hat. Drawings in the sixteenth-century *Codex Mendoza* depict Indians wearing the same sort of hat.

The fifth person is a black woman. Her presence in New Spain in 1531 would seem to have been highly improbable to some, but we know from documents that Hernán Cortés took African slaves with him to America. It also seems not to be insignificant that Bishop Juan Zumárraga left instructions in his will to free two servants, black slaves, after his death – husband and wife, Mary and Pedro.

The sixth figure, on the right, is a bearded man. His figure, on account of being the closest to the observer, seems to be the largest. Hence it was the first to be discerned – by Alfonso Marcue Gonzalez in 1929 and by José Carlos Salinas Chávez in 1951. The latter thought it was Juan Diego, but according to specialists that was impossible, as Indians were not bearded. Charles Wahling put forward a different interpretation. He conjectured that the said man was the then newly appointed general administrator of Mexico, the bishop of Santo Domingo, Ramírez y Fuenleal. According to historical documents, it appears that he was Bishop Juan de Zumárraga's guest on December 12, 1531. José Aste Tönsmann did not incline to any version as to the identity of the man. However, he discovered a group of seven people at the central point of the image, in Mary's pupils. It seems to be a family, parents and five children, but its identity is as yet unknown.

THE FIGURE of an Indian in Mary's eye. On the right is a drawing of the man.

248

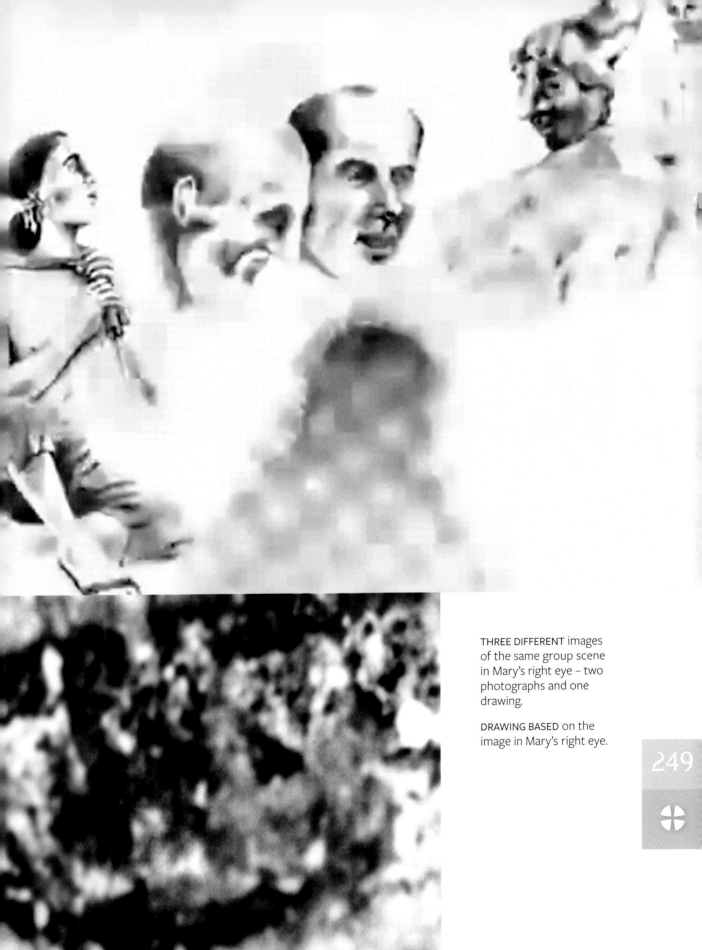

THREE DIFFERENT images of the same group scene in Mary's right eye – two photographs and one drawing.

DRAWING BASED on the image in Mary's right eye.

249

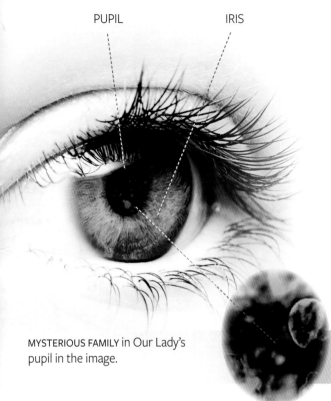

PUPIL IRIS

LIKE THE APPLE
OF ONE'S EYE

TO BE THE APPLE OF SOMEONE'S EYE is to be most precious to that person. In Old English, the word "apple" in this context meant "pupil". Hence the discovery that the image of a family had been recorded in Our Lady of Guadalupe's pupils has led some that to see that Mary surrounds families with a special solicitude. Preachers underline that the said image was not coincidentally discovered at a time when the family is being subjected to various attacks from all sides, when its hitherto status in contemporary societies is being more and more frequently undermined.

MYSTERIOUS FAMILY in Our Lady's pupil in the image.

THE UNIDENTIFIED family in Mary's eyes is the most puzzling element in the image – no historical sources mention it.

José Aste Tönsmann says that it is the only known case of such a reflection. And as to how it came about, he says that science is unable to explain it.

Some specialists have criticized Tönsmann's findings. According to them, on account of the microscopic size of the supposed figures, it is not possible to determine whether the forms isolated by Tönsmann were reduced reflections of human figures or, perhaps, an accidental multiple reflection of grains of silver. However, the experts who personally undertook to verify his research could not undermine his conclusions. One of those who did not believe in his discovery was his former boss at IBM's scientific research center, Luis Martínez Negrete, a declared atheist. So in 2006, two canons from the Basilica of Our Lady of Guadalupe, Fr. Eduardo Chávez Sánchez and Fr. José Luís Guerrero Rosado, asked him to check the credibility of his former subordinate's research; for it would have been difficult to accuse a non-believer of succumbing to a sanctimonious illusion. To his surprise, he had to confirm all Tönsmann's conclusions, both as to the properties of the eyes, and as to the group scene in the irises.

This is not the only unsolved riddle connected with the image of Our Lady of Guadalupe, as the issue of the unusual properties of the tilma itself has not been clarified to this day.

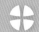

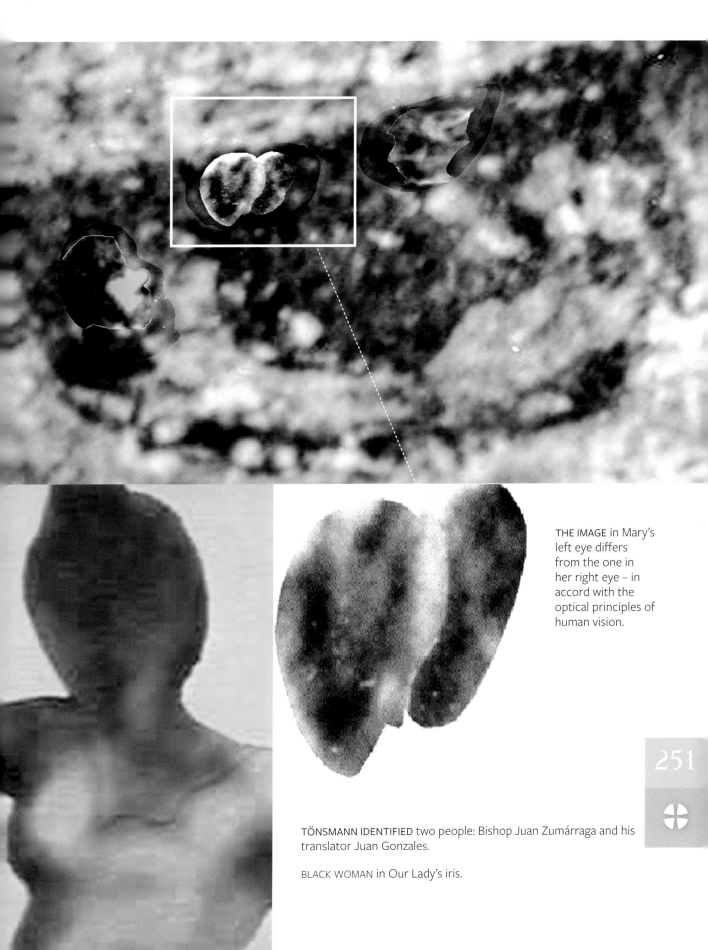

THE IMAGE in Mary's left eye differs from the one in her right eye – in accord with the optical principles of human vision.

251

TÖNSMANN IDENTIFIED two people: Bishop Juan Zumárraga and his translator Juan Gonzales.

BLACK WOMAN in Our Lady's iris.

Indestructible Material

Indestructible Material

Laura Irene Castillo Basurto spread out her arms and said: "In this matter science is helpless. It is not possible to explain it, even by invoking the laws of nature and all the knowledge that is available to man." She added: "It simply had no right to occur."

254

FR. BACHILLER
Miguel Sánchez'
1648 publication
on the image
of Our Lady of
Guadalupe.

Basurto specializes in laboratory diagnostic testing of works of art, especially of historical canvases. She is Mexico's most outstanding expert on valuable textiles, and she even makes traditional cloth on old looms herself. The image of Our Lady of Guadalupe has been of interest to her – as a scientist – for over twenty years.

It is a well-known fact that this image, the most famous image of Mary on the American continent, is from the sixteenth century (1531). Like any other valuable work of art it has been subject to scientific examinations – which usually yield answers to most of the questions raised – yet in this case there are more riddles and doubts.

UNDYED AGAVE
thread against the
background of the
colorful image.

255

LAURA IRENE Castillo Basurto, an expert on textiles, presenting Grzegorz Górny with a piece of agave cloth.

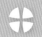

The extraordinary durability of the image's material remains unexplained. The image is on a tilma, which when wrapped around the arms served as a coat, and when worn on the front was used as a bag. Woven from agave thread, it was of very low durability and quickly wore out. It generally fell apart after twenty, at most forty years. No other agave material from the sixteenth century exists, whereas the tilma with the image of Our Lady of Guadalupe on it has lasted intact for virtually five centuries. Art conservators point out that the material has no serious defects or any signs of aging.

The durability of the image is yet more extraordinary when one takes into account the fact that it had been displayed for over one hundred years (1531–1647) without protective glass against the smoke of candles and incense, and other atmospheric effects. It was kept in extremely unfavorable conditions: marshy and moist terrain, close to a salt lake, above which rose nitrate fumes. ▶

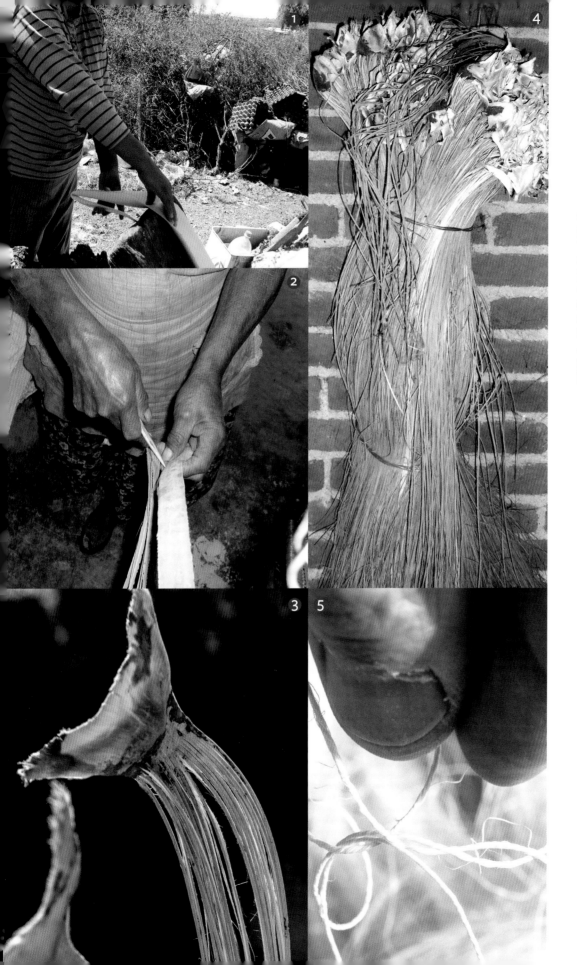

AGAVE THREAD
production process:
1) making stiff leaves
more flexible by
pulling them over the
edge of a stone, 2)
slitting the leaves, 3)
selecting fibers from
the leaves,
4) drying the fibers,
5) obtaining threads
from the dried fibers.

257

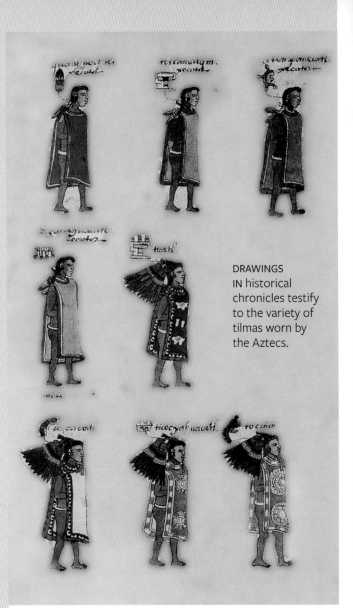

DRAWINGS IN historical chronicles testify to the variety of tilmas worn by the Aztecs.

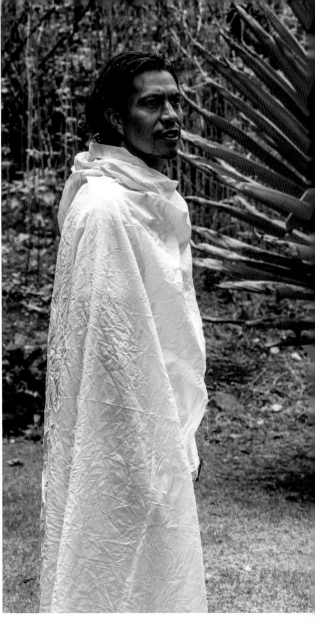

VARIANTS OF tilmas worn by pre-Columbian Aztec men indicated their social status.

YOUNG PERSON
dressed in a "maxtlatl" (loincloth)

PEASANT
("macehualtin") in a short tilma

NOBLEMAN
("pipiltin") of high status or a warrior

RULING CLASS
and clerical attire

LESS POPULAR
way of wearing a tilma

WAR OUTFIT

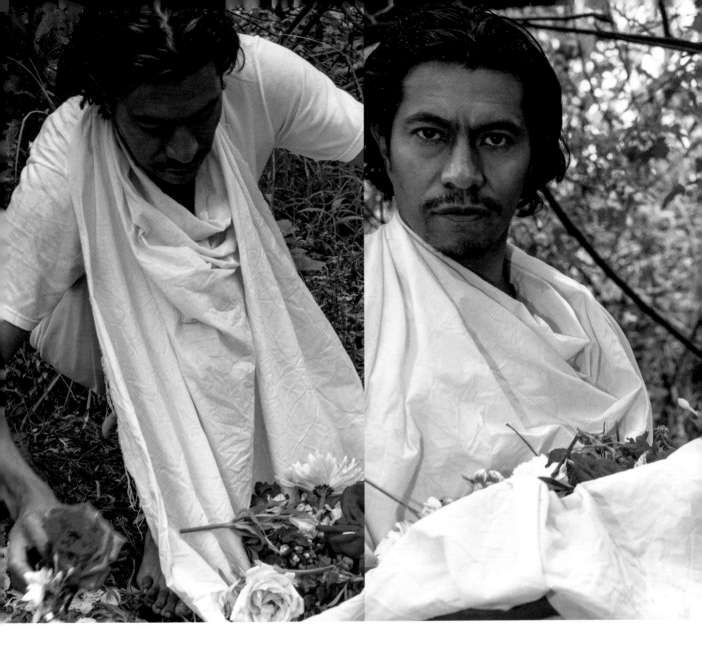

HOW A TILMA WAS WORN

CLOTHING attested to an Indian's status. The rich, and those of noble birth, could wear ankle-length tilmas of various colors. The poor had to be content with white knee-length tilmas. After the conquest things changed, and less wealthy Indians could wear longer tilmas.

When the Spanish first arrived in Mexico, an Indian's day-to-day clothing was most often of two parts, that is, a tilma and a "taparabos" (a loincloth). The Spanish added a new element, which quickly became popular, that is, knee-length pants. They also introduced the custom of women covering themselves above the waist.

A CONTEMPORARY INDIAN demonstrating how to wear a tilma, and how to arrange flowers in it – as did St. Juan Diego in 1531.

259

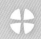

LOOMS used by the Indians to produce material from agave.
Today, such looms can be seen only in museums.

During one flood, the chapel where the image was kept was swamped with three feet of water, which caused the walls to crumble.

During that time multitudes of pilgrims touched the tilma, kissed it, rubbed their rosaries and medallions on it, and even nestled their faces against it. The painter Miguel Cabrera recalled that in 1753 he himself saw pilgrims touch the image with five hundred various objects in just two hours. Yet no marks at all were left on the material. It is all the more remarkable since the tilma – as an expert evaluation by Prof. Philip S. Callahan in 1979 showed – had never been preserved in any way.

In 1789, the material was examined by a team led by a well-known mathematician, Dr. José Ignacio Bartolache, who decided to carry out a comparative experiment. He commissioned eight artists to paint eight copies of Our Lady of Guadalupe on tilmas, and to place them close to the original. It turned out that all the copies fell apart after several years. The most durable lasted barely eight years.

That is not all. In 1791, when the forty-pound frame was being polished, nitric acid was accidentally spilt on the upper part of the image. The caustic substance should have immediately burned a hole in the delicate material, but only barely visible stains appeared, which faded in time. And what is more, the person responsible for the accident wiped the image with a rag, which should have caused more damage, but it did not.

A STRONG caustic substance not only burns holes in cloth, it causes necrosis, or charring, when it comes in contact with human skin.

EFFECTS OF nitric acid accidentally spilt on the image in 1791.

261

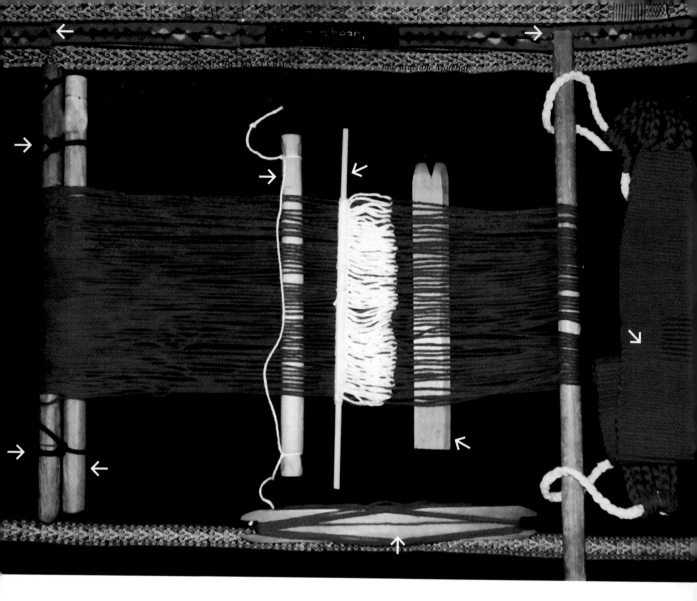

INDIAN LOOMS were very narrow, hence larger clothes had to be made from several pieces of cloth sown together.

Laura Castillo takes a piece of agave material out of her bag. Today hardly anyone in Mexico, apart from elderly Indian women, produces this material, which has been supplanted by wool or cotton. It is simply unprofitable to make – the process is long and arduous, and the cloth deteriorates quickly. Castillo makes it on old looms, so as to have her own comparative samples. The material, like the tilma displayed in the Basilica of Our Lady of Guadalupe, has been woven so loosely that one can see things through it.

Laura Castillo decided to check the durability of the material. She put a piece of tilma on the roof of a building so as to expose it to climatic effects. The material completely fell apart in just several months. Another piece of material, which she had isolated from the natural environment, quickly began to decompose because of bacteria.

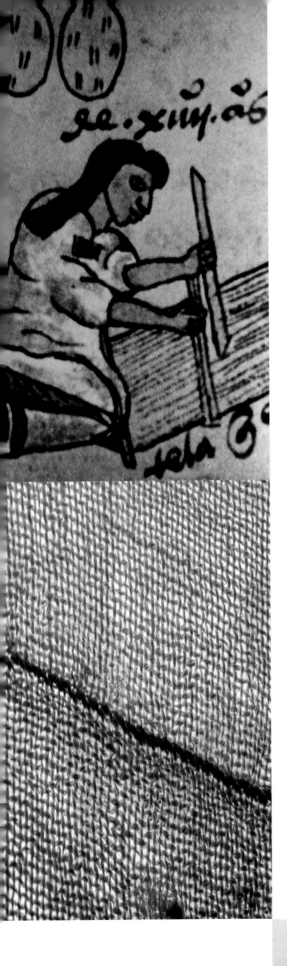

A USEFUL CACTUS

IN 1976 TWO MEXICAN researchers, Dr. Sodi Pallares and Dr. Roberto Palacios Bermúdez, identified the fiber that was used to make the tilma on which the image of Our Lady of Guadalupe is depicted—agave.

The Aztecs called the agave a "century plant", which they used for many things: thatch for roofs, paper, cloth, and twine. They used its spines for needles and drawing pins, its roots and leaves for meals, and its fermented liquid, "pulque", to drink.

AGAVE IS a common element in the Mexican landscape.

The image of Our Lady of Guadalupe has reacted in a totally different way. Studies by Mariano Fernandez de Echeverria y Veytia in the second half of the eighteenth century showed that no dust had adhered to the image and that it had not been damaged by insects.

This is not the only fact that amazes scientists. As pre-Columbian Indian weaving looms were not large, they produced only narrow cloth. In order to have wider cloth it was necessary to sew two pieces together, as is the case with the cloth depicting Our Lady of Guadalupe. It is divided by a vertical seam, which does not encroach on Mary's face or hands. Though the two pieces of material are tacked together, rather than tightly sown, it has not torn. In 1751, Miguel Cabrera, the aforementioned painter, noted that the extremely fine agave thread that had tacked the two pieces of material together for two centuries had not only resisted the natural force of gravitation, but also the weight of both pieces of much thicker and heavier material.

It is also highly significant that although the image had been examined by many conservators, they were unable to give a definitive opinion as to how the work arose. The only thing that has been established is the impossibility of determining the technique that was used. The first detailed expert opinion, dating from the middle of the seventeenth century, concluded that only God knew the secret of that work.

In 1751, the abbot of the Basilica of Our Lady of Guadalupe, Manuel José Rubio y Salinas, commissioned six painters to examine the image, led by the already mentioned Miguel Cabrera, the most outstanding artist of the New

MIGUEL CABRERA'S painting (1758) of Archbishop of Mexico Manuel José Rubio y Salinas.

LAURA CASTILLO and a photographic reproduction of the image.

A TILMA is so loosely woven that we can see through it.

265

✛

Spain colonial period. After five years they published a study in which they came to a surprising conclusion: the tilma had not been sized or primed, so that one could see things through the material. That surprised them, as material made of agave fiber is so loosely woven that one would be unable to paint on it without treating it first.

In the twentieth century, the image was examined numerous times. In 1936, the abbot of the Basilica of Guadalupe, Feliciano Cortés Moro, gave Bishop Francisco de Jesús Maria Echevarrii, from Saltillo, several threads from the tilma as relics. Two of the threads – pink and yellow – were sent to Germany, to the head of chemistry at Heidelberg University, Prof. Richard Kuhn, who won a Nobel Prize two years later. He was not able to identify any existing types of mineral or vegetable pigment on them, nor did he find any trace of synthetic dye. He stated in his evaluation that the fibers had not been painted; that they were quite simply colored.

AGAVE CLOTH is
now a true rarity
even in Mexico; it is
unprofitable to make,
primarily because of its
lack of durability.

267

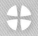

INFRARED IMAGINING did not reveal brush strokes on the image.

MONUMENT OF DR. ISAAC OCHOTORENA, a Mexican chemist who worked on the image.

PROF. RICHARD KUHN (Noble Prize winner), a German chemist who analyzed threads from the image.

In 1946, Dr. Isaac Ochotorena, of the Institute of Organic Chemistry at the National University of Mexico, verified that the tilma was of the sixteenth century, while Dr. Manuel Garibi Tortolero, of the Institute of Biology, on examining it under a microscope, did not find even the slightest trace of a brush stroke.

In 1979, scientists from University of Florida, Philip S. Callahan and Jody B. Smith, carried out infrared analyses of the image that could detect the minutest details under the surface. They confirmed the observations of Miguel Cabrera's team of experts from the eighteenth century: there were no signs whatsoever of a provisional sketch on the tilma. Apart from that, no traces of brush strokes were found – with the exception of a few places where minor alterations had been made.

For it turned out that in the sixteenth century some unknown pious artists decided to highlight some elements in the image with more intensive paint. Hence they added silver to the moon and touched up Mary's sash. But it was precisely these parts that began to darken and to peel. They also added new elements to the

image, such as cherubs and a crown on Our Lady's head. Fortunately these additions were removed later. The crown was removed during the restoration of the image in 1895, but we can see it on numerous copies of the eighteenth and nineteenth centuries.

Prof. Callahan's examinations also revealed an unusual optical effect on the tilma, diffraction. Close up, Mary's face seems to be white, but olive at a distance. The American scientist noticed that the same effect – changes of color depending on the viewing angle – was to be found in nature, e.g., on the smooth surfaces of bird, butterfly, and beetle wings.

Prof. Tanco Becerra had already noticed the diffraction phenomenon in 1666, though he could not explain it scientifically. The effect is comprehensible in the case of living beings, but a mystery in regard to the image. An understanding of the structure of colored fibers may well provide an answer.

Analyses of the image during the 1960s showed that the structure of the surface recalls that of a photographic film – the outer

THE IMAGE THROUGH THE EYES OF A PAINTER

MIGUEL CABRERA (1695–1768), a full-blooded Indian from the Zapotec tribe, was the most outstanding painter in the history of the Viceroyalty of New Spain (today's Mexico) in the colonial period. He was famous for many religious paintings, the majority of which were commissioned by the archbisop of Mexico City or by the Jesuits. He also painted many portraits of important personages, for example, the nun and writer Sr. Juana Inés de la Cruz.

Cabrera, together with five other painters, examined the image of Our Lady of Guadalupe (1751–1756), the results of which were published in a report entitled *American Marvel*. Cabrera also painted the three best-known copies of the image: one for Pope Benedict XIV, one for Archbishop Manuel José Rubio y Salinas of Mexico, and one for his own use, to serve as a model for further copies.

Cabrera stated that the image gave one the impression that four techniques had been used in the work: Mary's face and hands – oil; her tunic, the angel, and the mist – tempera; the mantel – watercolor; and the white background – fresco. He was most amazed by the tunic's gold gilding, its application, which looked like dust woven into the fabric. He stated that there was no known technique that could achieve such an effect.

After having examined the tilma, Cabrera wrote that he was certain that even the most talented and professional painter would not be able to copy the image of Our Lady of Guadalupe on an unprimed canvas of low quality, using the same techniques that were applied to the tilma. Numerous copyists created reproductions on well-prepared canvases, using oil paints, yet their work left a lot to be desired.

MIGUEL CABRERA painted the three most famous copies of the image, but he was not fully satisfied with any of them.

part is as delicate as silk, while the inner part is rough, like material woven from cactus fiber. Scientists had the impression that they had discovered the Polaroid technique on sixteenth-century cloth.

The image's extraordinary properties eliminate the possibility of a faithful copy being painted. Miguel Cabrera had come to that conclusion in the eighteenth century. He had painted more copies than anyone else, but none of them – as he himself admitted – came close to the original as regards fidelity to detail. Jose de Ibarra, an outstanding New Spain artist, was of a similar opinion. He thought that no one would be able to produce a faithful copy of Our Lady of Guadalupe.

So the image is unique in the history of world iconography. According to Laura Castillo, it is contrary to all the rules of art. Images are usually depicted on one piece of material, but this one is of two pieces sown together. Artists also begin with a provisional sketch, paying particular attention to the proportions of the human face, yet there is no trace of that in this case. It also lacks a primer and a protective varnish. Without an appropriate primer, the tilma ought to have decomposed long ago, and unvarnished, it ought to have deteriorated from the effects of smoke and other pollutants. However, despite the passage of time, the image has not faded; it has not begun to peel or crack and its colors are still intense.

Such properties continue to be mysteries to scientists. They are unable to identify the technique used or the source of the paints. They are also unable to explain the durability of the agave fabric. According to Prof. Bruno

THE INSTANT CAMERA (Polaroid) technique, though not known of until the 20th century, was discovered in the image.

VARNISHING, PRIMARILY with resinous substances, prolongs durability. The image shows no signs of having been varnished.

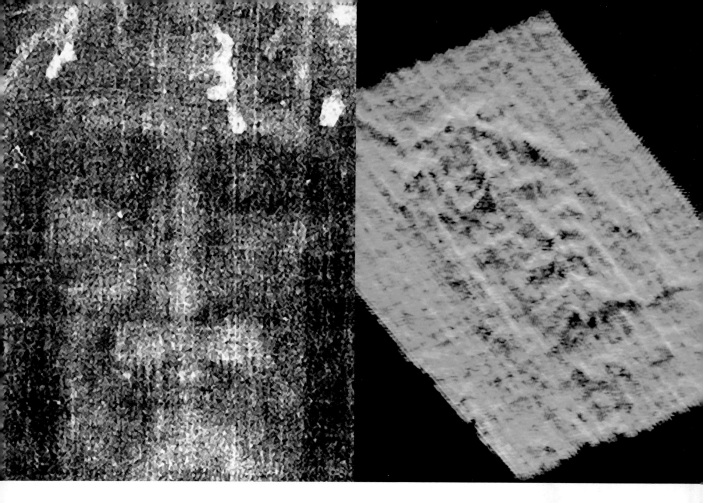

THE IMAGE of Our Lady of Guadalupe, like the Turin Shroud and the Veil of Manoppello, is regarded as "acheiropoietos", not made by human hands.

Fabbiani, a retired lecturer in optics at the Turin Technical University, there are only two known canvases whose properties are not subject to the laws of physics: the Turin Shroud and the image of Our Lady of Guadalupe.

Prof. Philip S. Callahan, a biophysicist from the University of Florida, had a similar impression. He said that his research on the image was the greatest experience of his life. He mentioned that when he approached it he was seized by a feeling that was akin to what scientists had when they examined the Turin Shroud. In his opinion there is no merely physical explanation for the origin of the image; he but sees a supernatural explanation.

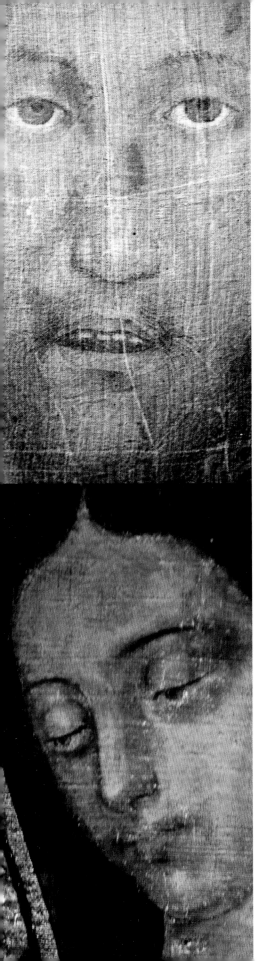

NOT MADE BY HUMAN HANDS

MONIKA LASCURAIN'S DOCUMENTARY FILM, *The Turin Shroud and Juan Diego's Tilma* (2008), contains many discussions with scientists cooperating with the Mexican Center of Sindonology and the Higher Institute for Guadalupan Studies. She concluded that both images are "acheiropoietos", as their origins could not be scientifically established. The Institute of Border Sciences in Innsbruck, Austria, the world center for the analysis of paranormal phenomena, came to the same conclusion. In 2013 the founder, Andreas Resch, published *Die Wahren Weltwunder*, in which he put forward the theory that the two images of Jesus – on the Turin Shroud and on the Veil of Manoppello – and the image of Our Lady of Guadalupe were not the work of a human being. Hence he suggested that they be seen as acheiropoietos, that is, not made by human hands.

Monica Lascurain presenting her film, *The Turin Shroud and the Image of Our Lady of Guadalupe*, to Grzegorz Górny.

CHRONOLOGY OF RESEARCH
ON THE IMAGE

1633–1666 THE FIRST SYNTHETIC studies by a group of physicians and painters. The final report , signed by Prof. Tanco Becerra, attracted attention to the diffraction effect on the material.

1751–1756 A GROUP OF MEXICAN PAINTERS, led by Miguel Cabrera, could not, after 5 years research, determine the technique that was used to produce the image.

1789 A MEXICAN MATHEMATICIAN, Dr. José Ignacio Bartolache, published the results of an experiment that confirmed the unparalleled durability of the agave material used for the image.

1929 ALFONSO MARCUE GONZALES, a Mexican photographer, was the first to discover the image in the eyes of the Madonna of Guadalupe.

1936 PROF. RICHARD KUHN, a German chemist and Nobel Prize winner, could not identify the dye on the fibers of the image.

1951 JOSÉ CARLOS SALINAS CHÁVEZ, a Mexican photographer, saw an image in Mary's eyes on a photographic enlargement.

1956 A MEXICAN OPHTHALMOLOGIST, Dr. Javier Torroella Bueno, using a magnifying glass, confirmed the discoveries of Marcue Gonzales and Salinas Chávez.

1957–1958 DR. RAFAEL TORIJA LAVOIGNET, a Mexican ophthalmologist, was the first to examine Our Lady's eyes in the image with the aid of an ophthalmoscope and discovered the stereoscopic effect.

1962 AN AMERICAN MARRIED COUPLE, Charles Wahling, an ophthalmologist, and Isabelle Wahling, an optician, in enlarging the image of Mary 25 times, discerned new details in the Madonna's irises.

1975 DR. EDUARDO TURATI ALVAREZ, a Mexican ophthalmologist, confirmed that the reflection of the image in Mary's eyes is analogical to one that a live human eye registers.

1979 PROF. PHILIP S. CALLAHAN, an American biophysicist, discovered, with the aid of infrared radiation, that there was no sign of the use of a paintbrush on the image.

1979 JOSÉ ASTE TÖNSMANN, a Peruvian engineer, began examining Mary's eyes with the aid of computer techniques. In time, having enlarged the Madonna's eyes 2,500 times, he discovered a group of 13 people.

1981 DR. JUAN ROMERO HERNANDEZ ILLESCAS, a Mexican astronomer, demonstrated that the arrangement of the stars in the image resembled the one that was to be found over Mexico on December 12, 1531.

1988 FR. MARIO ROJAS SÁNCHEZ, a Mexican priest, initiated a new way of examining the image. He placed a map of Mexico on Mary's image and discovered a conformity of iconographic and geographic elements.

2003 THE HIGHER INSTITUTE FOR GUADALUPAN STUDIES was established in Mexico City, and Fr. Eduardo Chávez Sánchez, a historian, became its director. The Institute's task is to explore the scientific phenomena connected with the image.

2006 LUIS LUIS MARTINEZ NEGRETE, a Mexican engineer, confirmed José Aste Tönsmann's discovery concerning the group scene in Our Lady's eyes.

1979 PROF. FERNANDO OJEDA LLANES, a Mexican mathematician, discovered the golden ratio in the image, and on the basis of the arrangement of the symbols in the image he also produced a musical notation.

BIBLIOGRAPHY

JERZY ACHMATOWICZ, *Nican Mopohua. Główne źródło studiów nad objawieniami guadalupiańskimi w Meksyku w 1531 roku*, Wrocław 2010

PAUL BADDE, *Maria von Guadalupe. Wie das Erscheinen der Jungfrau Weltgeschichte schrieb*, Berlin 2004

BERNARDINO DE SAHAGUN, *Historia General de las cosas de Nueva Espana*, Mexico 1982

NIKODEM BOŃCZA-TOMASZEWSKI, "Kolumb – sługa Apokalipsy" in *Ozon* 2006

Brevísima relación de la destrucción de las Indias, colegida por el obispo don fray Bartolomé de Las Casas o Casaus, de la orden de Santo Domingo, Sevilla 1552

EDUARDO CHAVEZ, *La Verdad de Guadalupe*, Mexico 2012

EDUARDO CHAVEZ, *La Virgen de Guadalupe y Juan Diego en las Informaciones juridicas de 1666*, Mexico 2002

EDUARDO CHAVEZ, *Santa Maria de Guadalupe reto para la ciencia, la historia y la fe*, Mexico 2008

HERNAN CORTES, *Cartas de Relacion*, Madrid 2003

BERNAL DIAZ DEL CASTILLO, *Historia verdadera de la conquista de la Nueva Espana*, Madrid 1632

DIEGO DURAN, *Historia de las Indias de Nueva Espana e Islas de Tierra Firme*, Mexico 1995

ANDRZEJ FRANCISZEK DZIUBA, *Matka Boża z Guadalupe*, Katowice 1995

MIRCEA ELIADE, *Fragments d'un journal I*, Paris 1973

ESTUDIOS de la historia de la filosofía en Mexico, Mexico 1963

MARIA FRANKOWSKA, *Mitologia Azteków*, Warsaw 1987

JAN GAĆ, *Meksyk*, Pelplin 2009

GERONIMO DE MENDIETA, *Historia Eclesiastica Indiana*, Alicante 1999

FIDEL GONZALES, EDUARDO CHAVEZ, JOSE LUIS GUERRERO, *El Encuentro de la Virgen de Guadalupe y Juan Diego*, Mexico 1999

GRZEGORZ GÓRNY, BARRIE SCHWORTZ, *Oblicze Prawdy. Żyd, który zbadał Całun Turyński*, Warsaw 2013

JOSE LUIS GUERRERO, *Flor y canto del nacimiento de Mexico*, Mexico 1980

JUAN HOMERO HERNANDEZ ILLESCAS, *La Virgen de la Guadalupe y la proporción dorada*, Mexico 1999

HISTORIA minima de Mexico (El Colegio de Mexico, ed. Victor Urquidi), Mexico 1974

FERNANDO DE ALVA IXTLILXOCHITL, *Nican Motecpana*, in: **ERNESTO DE LA TORRE VILLAR, RAMIRO NAVARRO DE ANDA**, *Testimonios Históricos Guadalupanos*, Mexico 1982

JOLANTA KLIMOWICZ, *Meksyk – miasto trzech kultur*, Warsaw 1974

GRZEGORZ KUCHARCZYK, "Pod znakiem Chrystusa Króla" in: *Polonia Christiana* 8/2009

MIGUEL LEON-PORTILLA, *El reverso de la conquista. Relaciónes aztecas, mayas e incas*, Mexico 1964

MIGUEL LEON-PORTILLA, *Los antiguos mexicanos a traves de sus crónicas y cantares*, Mexico 1961

WINCENTY ŁASZEWSKI, *Cud Guadalupe*, Radom 2007

WINCENTY ŁASZEWSKI, *Tajemnica Guadalupe*, Radom 2011

VITTORIO MESSORI, *Vivaio*, Milan 1995

JEAN MEYER, *La Cristiada*, Mexico 1975

JEAN MEYER, *La Revolución Mexicana*, Mexico 2004

Nauczycielski urząd Kościoła a religie, ed. Ireneusz Sławomir Ledwoń OFM, Piotr Królikowski, Lublin 2015

FERNANDO OJEDA LLANES, *Musica, Astronomia, Aritmetica y Geometría en la Imagen Guadalupana*, Mexico 2010

KONSTANTY OSIŃSKI, *Autoportret z Guadalupe*, Warsaw 1999

OCTAVIO PAZ, *El laberinto de la soledad*, Mexico 1959

MARIO ROJAS SANCHEZ, Juan Homero HERNANDEZ ILLESCAS *Las estrellas del manto de la Virgen de Guadalupe*, Mexico 1983

JOSE ASTE TÖNSMANN, *El Mensaje de sus Ojos*, Mexico 2011

TORIBIO DE BENAVENTE, MOTOLINIA, *Historia de los Indios*, Alicante 2000

TORIBIO DE BENAVENTE, MOTOLINIA, *Memoriales o Libro de la Nueva Espana y de los naturales de ella*, Mexico 1971

ZBIGNIEW TREPPA, *Meksykańska symfonia: ikona z Guadalupe*, Warsaw 2006

GEORGE C. VAILLANT, *Aztecs of Mexico: Origin, Rise and Fall of the Aztec Nation*, Garden City 1941

GEORGE WEIGEL, *Witness to Hope*, New York 1999

THOMAS E. WOODS JR, *How the Catholic Church Built Western Civilization*, Washington 2012

FAUSTO ZERON-MEDINA, *Felicidad de Mexico*, Mexico 1995

ENDNOTES

1. *Nican Mopohua*, translation provided by D.K. Jordan, pages.ucsd.edu/~dkjordan/index.html.
2. Wincenty Łaszewski, *Tajemnica Guadalupe*, Radom 2011, p. 157.
3. Jan Gać, *Meksyk*, Pelplin 2009, pp. 130–132.
4. Nikodem Bończa-Tomaszewski, "Kolumb – sługa Apokalipsy", *Ozon* 26/2006.
5. Quoted in ibid.
6. Ibid.
7. Wincenty Łaszewski, *Tajemnica Guadalupe*, Radom 2011, p. 19.
8. Jan Gać, *Meksyk*, Pelplin 2009, pp. 187–88.
9. Heinrich Denzinger – Peter Hünermann, *Enchidrion symbolorum, definitionum et declaracionum de rebus fidei et morum*, Ignatius Press 2012, 1495.
10. *Nauczycielski urząd Kościoła a religie*, ed. Ireneusz Sławomir Ledwoń OFM, Piotr Królikowski, Lublin 2015.
11. Ibid.
12. John Paul II, homily during a Mass in Mexico City, January 26, 1979, Libreria Editrica Vaticana 1979, w2.vatican.va.
13. John Paul II, speech during the general assembly of the Latin American Episcopal Council (CELAM) in Puebla, Mexico, January 28, 1979, *L'Osservatore Romano*.
14. John Paul II, statement during a meeting with Indian representatives in Culiacán, January 20, 1979, *L'Osservatore Romano*.
15. John Paul II, homily during the beatification of Juan Diego Cuauhtlatoatzin at the Sanctuary of Our Lady of Guadalupe, May 6, 1990, *L'Osservatore Romano*.
16. Pope Francis, homily at St. Peter's Basilica, Rome, December 12, 2014, *L' Osservatore Romano*.
17. Ibid.
18. John Paul II, homily during the canonization of Juan Diego Cuauhtlatoatzin at the Sanctuary of Our Lady of Guadalupe, July 31, 2002, *L'Osservatore Romano*.
19. Pope Francis, homily during a Mass in Mexico City, February 14, 2016, Libreria Editrica Vaticana 2016, w2.vatican.va.
20. Zbigniew Treppa, *Meksykańska symfonia: ikona z Guadalupe*, Warsaw 2006, p. 140.
21. Grzegorz Górny, Barrie Schwortz, *Oblicze Prawdy. Żyd, który zbadał Całun Turyński*, Warsaw, 2013, p. 118.
22. Ibid., p. 122.

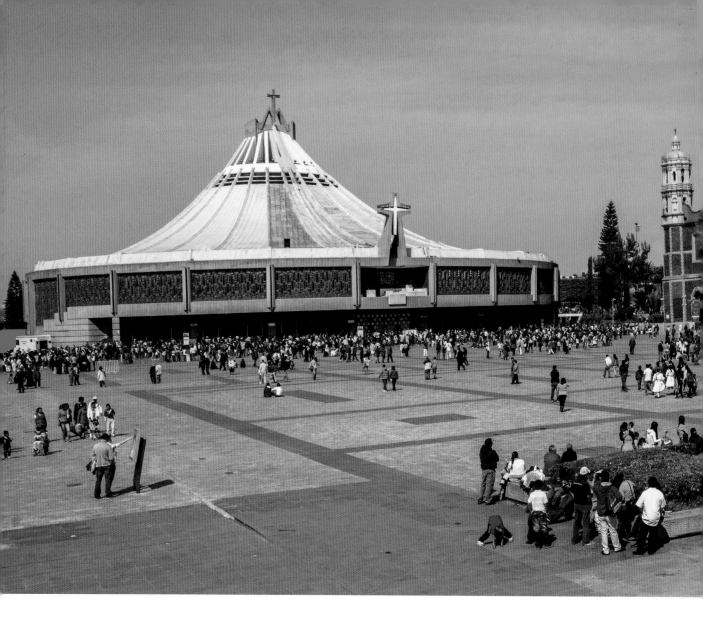

ACKNOWLEDGMENTS

THE AUTHORS AND EDITORS wish to thank the following people
for their help in the realization of this book:

Norberto Cardinal Rivera Carrera

Kazimierz Cardinal Nycz

Rev. Dr. Eduardo Chávez Sánchez – The Higher Institute for Guadalupan Studies (ISEG)

Rev. Dr. Jarosław Szymczak – Institute of Studies on the Family

Prof. Fernando Ojeda Llanes

Dr. José Aste Tönsmann

Laura Irene Castillo Basurto

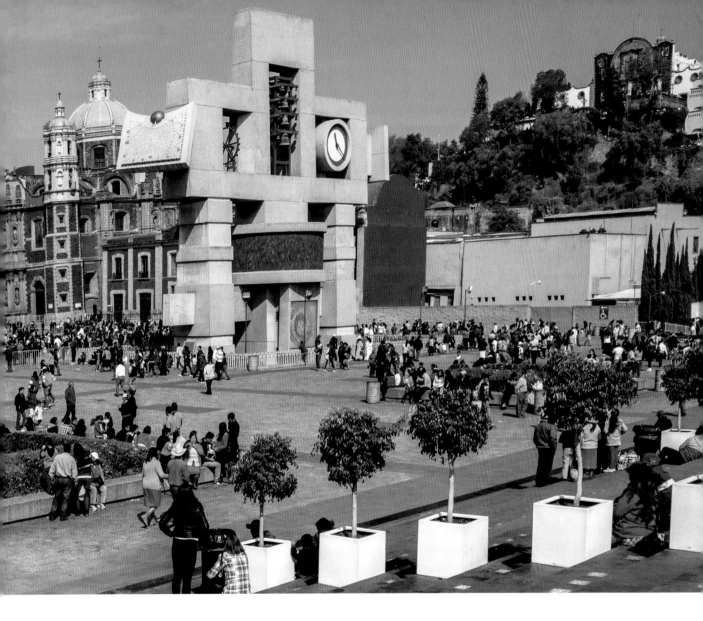

Beatriz Gonzáles and José Luis García Chagoyán, Humberto Agustín
Vanegas Bastida, Mark Adamski, Cucha de Aste, Xavier Bordas, Karen
Castillo and Vicente Fenoll, Catherine Chorzewska, Deyra Kelly and Antonio
Musi, Cecilia Jiménez and Felipe Latapí Clausell, Hans Van Luit, Alejandro
Hernández, Hermanos and Hermanas de San Juan Diego, Eddie Salazar
Gamboa, Marco Antonio García, Roberto Garza-Castillon and Soraya Nuñez,
Marychu Fernández and Juan Manuel González, Carolina Guevara, Mónica
Lascurain, Wincenty Łaszewski, Fr. John O'Dogherty, Paul Skibiński, Wojtek
Stebelski and Cristina Urrutia de Stebelski, Fr. Paul Stępkowski OSPPE,
Janusz Szymczak, Ron Tracz, Andrew T. Walther, Sławomir Wawer, Jessica
Wolf, Fr. Raphael Zawada OSPPE

Polish edition *Sekrety Guadalupe*
Published 2015 by **Rosikon Press, Warsaw, Poland**

Text © 2012 by **Grzegorz Górny**
Photographs © 2012 by **Janusz Rosikoń**

Graphic design, maps, and illustrations by **Maciej Marchewicz**

Collaboration **Jan Kasprzycki-Rosikoń**

English translation by **Stan Kacsprzak**

Editing by **Mary Murphy**

Editing of agency photos **Bernard Lipiński**

Photographs: ©Fotolia.com: 2, 230, 239 ©reineg; 132 © Erica Guilane-Nachez; 200 © rgbspace; 208 © Sergey Kamshylin; 208 © Enrico G. Agostoni; 213 ©typomaniac; 225 ©Eyematrix; 226, 191 © INFINITY; 236 © Lisa F. Young; 250 © by-studio; 269 © Arto; 271 ©yossarian6; Wikipedia: 6, 17, 18, 21, 22, 37, 45-47, 51, 68, 69, 72–75, 77–80, 82, 83, 93–98, 102, 110–119, 122–139, 141–146, 148–150, 156, 157–159, 163–165, 167, 170–172, 174, 176–179, 185, 191, 212, 215, 221–223, 226, 229, 236, 238, 247, 254, 265, 268, 270; 27 Rev. Jarosław Szymczak; 160, 181 ©Pedro Meyer; 172, 175, Cristiada; 184 © EAST NEWS/AFP; 186, 187, 190 © Grzegorz Gałązka; 188 ©PAP; 189 © AP Photo/Mosconi; 192 © BEW Aventurier Partick, 193 © Servizio Fotografico – L'Osservatore Romano; 236 Marcue's Family Archive; 257, 263 Laura Irene Castillo Basurto; 272 © 1997 Barrie Schwortz Collection STERA, Inc.

Rosikon press

ISBN 978-1-62164-115-5
Library of Congress Control Number 2016932418